imaging the
imagination

Gallery

The stillness of paintings!
Move stealthily so
as not to disturb.

They are not asleep.
They keep watch on
our taste. It is not they

are being looked at
but we by faces
which over the centuries

keep their repose. Such eyes
they have as steadily,
while crowds come and

crowds go, burn on
with art's crocus flame
in their enamelled sockets.

R. S. Thomas (from *Destinations*, 1985)

AN EXPLORATION OF THE RELATIONSHIP BETWEEN THE **IMAGE** AND THE **WORD** IN THE **ART OF WALES**

imaging the imagination

Editors **Christine Kinsey** and **Ceridwen Lloyd-Morgan**

Foreword by **M. Wynn Thomas**

Gomer

First impression 2005

ISBN 1 84323 433 5

Designed by Stephen Paul Dale.

This book is published with the financial
support of the Welsh Books Council.

Printed in Wales at Gomer Press,
Llandysul, Ceredigion.

Front and back cover from left to right:
details from
John Selway: As I rode to sleep (2003)
Philip Nicol: Bend (2004)
Sue Williams: Wish U were here 1 (2003)
Shani Rhys James: Caught in a Mirror (1997)
Brendan Burns: No. 1 Work in progress (2004)
Christine Kinsey: Yr Adwy 3 (2004)
Iwan Bala: Gwales (2003)

Contents

Acknowledgements

In preparing this volume as part of the META project, the editors have been especially grateful for the support of Simon Thirsk, Chairman, Bloodaxe Books, advisor to our project; Lynne Crompton, Administrator, Oriel Queen's Hall Gallery, Narberth, who administered the META exhibition, and Philip Nicol, Bayart, Cardiff, who facilitated the first meeting and discussions. Our thanks are also due to all those who have helped us in formulating and developing our ideas, particularly Don McInnes, Researcher, Department of Mathematics, Manchester University, Robert Jarman, Lecturer in Psychology, the Open University, Sian Edwards, Gilly Adams and Ned Thomas. Without the hard work and enthusiasm of our contributors and the support of the team at Gomer, our plans would never have come to fruition.

Foreword

M. Wynn Thomas *'Once it was the colour of saying',*

wrote Dylan Thomas, that had

'soaked [his] table the uglier side of

a hill.' The self-styled Rimbaud of

Cwmdonkin Drive may well have had

in mind a celebrated line from the

great French poet's 'Voyelles'

(Vowels): 'A, noir; E, blanc; I, rouge;

U, vert: O, bleu: voyelles'.

But the young Thomas would have also found encouragement much nearer home for conceiving of language in the painterly terms of a rich palette of vowels and consonants: two of his friends in the 'Kardomah Gang' at Swansea were Alfred Janes and Mervyn Levy, young painters excited like him by the way modernist experimentation had broken down traditional barriers within and between art forms. One of the most distinguished of Welsh modernist painters was Ceri Richards, another figure of the 'Greater Swansea' area and near contemporary of the Kardomah Gang. He found in Thomas's 'process' poems, full of the violent dialectic of life and death, biomorphic images electrifyingly similar to those that restlessly invaded his own canvasses, and accordingly produced in 1945 a famous set of lithographs for Tambimuttu's *Poetry London*, based on 'Do not go gentle into that good night.' So moved was he by Thomas's death that through elaborate marginal decoration he turned his copy of Thomas's poems into a modern equivalent of an illuminated manuscript; and his 1956 elegy took the form of new, intensely intimate lithographic meditations on 'Do not go gentle.' At much the same time, his close creative friendship at Pennard with Thomas's old friend Vernon Watkins resulted in luminous visual responses to Watkins's major 'Music of Colour' poems and led, in due course, to a sustained memorial tribute to Watkins in the form of a remarkable late set of quietly vibrant prints.

Nor does the dialogue between image and word in the Swansea area end there. One Sunday morning in the 1930s, a teenager attending morning service at Ebenezer chapel, Dunvant, was mesmerized by the eruption into those austere surroundings of a rainbow couple – Ceri Richards had come home to visit his family, bringing his colourfully-dressed artist-wife with him. That teenager was John Ormond Thomas who, as John Ormond, went on to become one of the most accomplished poets of post-war Wales. Beginning by dreaming of becoming an artist, he ended up an internationally distinguished television film-maker, two of whose masterpieces were filmic portraits of Ceri Richards and of Kyffin Williams. And his lifelong sensitivity to form, texture and colour found mature expression in two magnificent poems that were energized and informed by his passion for painting. The first, 'Salmon', was dedicated to Ceri Richards and reproduces, on its own verbal terms, the metamorphosing dynamic that was at the heart of the painter's work. The second, 'Certain Questions

for Monsieur Renoir', is a dizzying verbal tour de force as Ormond rises to the intoxicating challenge set by 'La Parisienne', a composition which he experiences as a sensual love poem to the colour blue:

> The eyes are bells to blue
> Inanimate pigment set alight
> By gazing which was passionate.
> So what is midnight to this midinette?
>
> Ultramarine, deep-water blue?
> Part of a pain and darkness never felt?
> Assyrian crystal? Clouded blue malachite?
>
> *Blue of a blue dawn trusting light.*

An outstanding example of *ekphrasis* (poems that aim to 'reproduce' paintings), this would grace the pages of *Voices in the Gallery* (London 1986), Dannie Abse's anthology of poems responding to pictures in the Tate.

The complex interaction between image and word that is a feature of the work of this 'Swansea group' could be reproduced across languages, across decades, across genres and right across Wales. One of the lost treasures of Wales is the background painting John Elwyn produced in 1945 for the Lampeter staging of Kitchener Davies's great dramatic poem/poetic drama, *Meini Gwagedd* ('The Stones of Desolation'). What Emyr Humphreys learnt during his 'Chelsea period' from his friendship with the emergent young painters Terry Frost and Patrick Heron was translated into the form of his major novel, *Outside the House of Baal*, built out of blocks of narrative consciously juxtaposed to form an abstract composition of contrasting tones and textures of experience. (Years later, Humphreys's work, in its turn, came to help shape the visual world of Iwan Bala.) A similar deep structural correspondence between text and painting is found in Tony Conran's 'gift poems' to artist-friends such as Victor Neep and Paul Davies. Indeed, the Beca group's graphic visualisation of Wales as a process of endless reshapings and reconstructions has been seminal to Conran's important late work.

Glyn Jones, who had once dreamed of being a professional painter, chose to make Trystan, the central figure of his classic novel *The Valley, the City, the Village*, into an artist. That way, Jones had an excuse for indulging his own preternatural gift for a clairvoyant pointillism of vision and expression: 'two or three grey, half-wetted pebbles by the water, or the patterns of nailed working-boots in the mud, or even a few square inches of the sunlit shade wall'. Through the reluctant modernist Trystan, the novelist is also able to wrestle, at a safe psychic distance, with that passion for radical experimentation that filled Glyn Jones, a product of Welsh Nonconformity and a committed Welsh socialist, with guilt. He also felt guilty at his delight in the sheer sensuality of language ('I fancy words'), and this, too, is projected onto Trystan, as visual artists, whose work was palpably sensual and lacking in social usefulness, had traditionally been viewed with suspicion in puritan Wales.

One of the most illustrious of Welsh poets, R. S. Thomas, is also the most often illustrated: a 1995 exhibition at Plas Glyn-y-Weddw featured tributes by nineteen artists. The fascination was mutual. Thomas produced a body of 'painting poems' increasingly concentrating on non-representational painting and including the underrated collection *Ingrowing Thoughts*. With its analysis of a Salvador Dalí drawing as depicting 'Eve's ruse', this body of work was typically masculine in character. This was a settled feature of Thomas's response to art, perhaps reflecting how his earliest published poetry had originated in jealousy at the established reputation of his artist-wife, Mildred Eldridge – a jealousy that seems to surface obliquely in his readings of paintings. From Rodin's crude boast that his sculptor's tools were his penis, to recent critical dissection of 'the male gaze', gender has been a hot topic in the field of visual art. And it is the feminisation of art that is one of Gillian Clarke's central concerns. She finds her alter ego as poet in figures like Shani Rhys James and Georgia O'Keeffe, who 'floods the skies over southern plains/ with carmine, scarlet, with the swirl of poppy-silk': this is a radical repainting of the portrait of the female artist as Scarlet Woman. From painters like O'Keefe, Clarke learnt an aesthetic of parturition: a poem is best formed and delivered by trusting to the sensuous, plastic medium of language. A similar concern with the sensuous imperatives to which female artists distinctively answer is at the heart of Manon Rhys's novel *Cysgodion* ('Shadows'), which sets a modern woman's life in revealing counterpoint to that of Gwen John.

To cross over from English into Welsh is to enter a rich new field of creative discourse about art. Euros Bowen, Bryan Martin Davies, Alan Llwyd, R. Gerallt Jones – these, and many more, have conducted sustained dialogues in their work with painters and with paintings. The recent National Eisteddfod initiative of inviting poets to address any images of their choice from the *Celf a Chrefft* ('Arts and Crafts') pavilion builds, therefore, on long established practice. There seems, in both the Welsh and English writing of Wales, to have been an intensified (and reciprocated) interest in recent years in initiating and maintaining a dialogue with art and with artists. This may be a tribute to the electric liveliness of the current art scene in Wales; or it may be an example of literature repositioning itself in the supposedly visual and post-linguistic culture of the postmodern present. Whatever the reason, it has resulted in important achievements by poets such as Tony Curtis, the range of whose work includes interviews with painters, collaborations (an important feature, too, of the work of Jeremy Hooker), and poems and sequences focusing on photographs and paintings. An answering impulse is felt in the work of artists like Ivor Davies and Iwan Bala. Set against the historical background sketched above, it is this impressive contemporary culture of two-way 'translation' between the arts forms that makes the appearance of a pioneering book such as *Imaging the Imagination* so welcome and so timely.

M. Wynn Thomas *CREW, University of Wales, Swansea, November, 2004*

Introduction

Christine Kinsey

The theme of this book is the inter-relationship between visual and written language in the art of Wales, and the creative processes artists and writers use to mediate their experiences and find a language to express their vision.

From the beginning, the purpose and intention of compiling this book and the related exhibition, META, has been to open a debate about the relevance of painting to the developing culture of Wales, by suggesting that we need not subscribe to the assertion made in the wake of Postmodernism that 'painting is dead', but that the role of painting has changed and that by looking specifically at the particular inter-relationship between the image and the word in the art of Wales, we could offer an alternative view.

The first step in planning the META exhibition and this book was taken in 1999. META, a touring exhibition initiated and curated by Christine Kinsey,[1] and showing collaborative work by painters and poets, was seen as a way of offering an insight into the creative process. In his introduction to the catalogue, Simon Thirsk wrote: 'The act of bringing together artists and poets raises their potency – and our critical awareness to meta (or higher) levels. This is an aesthetic demand that the poetry and art be appreciated in totality.'[2] Artists and writers question our assumptions about reality, and the following chapters aim to explore the work of artists (primarily painters) and writers to provide an overview within an historical and contemporary context, as well as focusing on a selection of individual artists in the respective chapters on David Jones, Gwen John, Ceri Richards, Brenda Chamberlain and Ernest Zobole. For some artists Wales has been a place of birth, childhood and formative influences; for others, attracted by the landscape, it has become an adopted home; whilst for others it may represent a life-long journey of discovery as they explore the diversity of language and the spiritual, social and political history of this country.

In her historical overview, Ceridwen Lloyd-Morgan argues that although the scarcity of wealthy secular or ecclesiastic patrons meant that medieval manuscripts produced in Wales were less obviously ornate than their English or continental counterparts, they do nonetheless often feature less formal, more spontaneous kinds of decoration, reflecting the personal contribution of anonymous individuals to the process of production, and, later, the history of the book. She also brings to our attention artists and writers whose work has often been overlooked or forgotten and emphasises how in the last two centuries the twin forces of Nonconformism and the Eisteddfod 'lent tremendous status to the written word in the culture of Wales', but stresses that 'it is now a truism to state that the myth of a Wales devoid of visual culture is exactly that: a myth'.

The symbiotic relationship between the image and word in the work of David Jones leads us to a greater understanding of how each form is interdependent. As Anne Price-Owen suggests in her chapter, 'such synergy between both art forms is perhaps best articulated in Jones's painted inscriptions, which are the apotheosis of the union of image and word'. David Jones believed a painting should exist as 'a thing' and that 'it is the abstract qualities, however hidden or diverse, which determines the real worth of any work', and in his 1954 treatise on painting, he set out to explore a similar construct for his writing.

Gwen John's notes and letters form a written 'soliloquy', a way of expressing what she found difficult to speak in words, a way consistent with her chosen mode of living and working alone, of excluding interruptions. Ceridwen Lloyd-Morgan provides a glimpse of this artist's interior world, revealing the close relationship between her writing and her painting. The women in her paintings are often depicted reading, and in Gwen John's painstaking pursuit of the perfect colour and brush stroke, the figures are absorbed in words, while the artist engages in the task of committing the moment to canvas.

The lyrical and poetic voice of Ceri Richards sings out both in form and content in his paintings. In exploring the relationship between painting and poetry, especially the poetry of Dylan Thomas, he endeavours to capture the spirit of the word, a process that is very different from illustrating. In his chapter, Peter Wakelin describes how Ceri Richards designs the text into his compositions and embeds it in the

surface of the paint, emphasising symbol, metaphor, and line, to create 'unifying harmonies'. For Richards it was crucial that his vision was rooted in the natural world as he worked to break through the boundaries between music, poetry and painting, interweaving these languages into a visual form to create a metaphysical image that at once contained past, present and future. In the latter part of his life he based one of his most important series of works on Claude Debussy's piano prelude 'La Cathédrale Engloutie', the first of these paintings being completed while he was also designing the costumes for Benjamin Britten's opera *Noye's Fludde*.

'La Cathédrale Engloutie' also has its echo in the later career of Brenda Chamberlain. In November 1964 she was present at the Lamda Theatre in London for 'Dance Recital', a performance which included her poems, read by Dorothy Tutin, and dance by Robertos Saragas, one of the pieces being based on the Debussy prelude. Brenda Chamberlain had met the artists involved in 'Dance Recital' while living on the Greek island of Hydra; indeed she chose to live on islands for much of her life and spent as many as fourteen years on Ynys Enlli. Although she found inspiration living in these small communities, her vision remained intensely international. Jill Piercy's chapter explores the intertwining of these different threads, bringing to our attention previously unpublished text and images. For Chamberlain the attraction to both modes of expression was not without conflict: 'writing has always been for me an unhappy activity', she wrote, 'while painting almost invariably makes me happy'. It is perhaps in the pictures she produced using a combination of image and word that she found greatest satisfaction, a sense of 'wholeness'.

At first sight, it might seem unexpected that Ernest Zobole and Brenda Chamberlain should have shared a touring exhibition of paintings between 1963 and 1964. However, in his foreword to the catalogue, Tom Cross, who curated the show, emphasises that it was the artists' poetic and lyrical interpretations of their own particular place, which prompted him to bring together the work of these two artists. Ystrad Rhondda in the once-industrial heartland of the South Wales valleys was the 'particular place' for Ernest Zobole, hence his remarks that 'to love a place strengthens me, it becomes the material for my painting', and that coming back to the Rhondda was 'like getting back into a warm bed'. In a rare interview for BBC Wales in 1992, Zobole said 'Painting is a part of your life … your breathing I suppose … the whole reason for

existing.' During his time as a lecturer at Newport College of Art, his philosophy was 'do your talking or thinking with your medium', and this was encouraged in students' work-practice at that time. He held that view to the end of his life, but as Ceri Thomas's chapter demonstrates, the word, too, provided a rich source of inspiration for Zobole's work. The majority of his paintings are confessional, narrative images with himself as the central protagonist of a drama set in his particular place in the world; and in a recently discovered poem, now published for the first time, his total involvement in that community is reiterated. His work embodies his unique vision of the South Wales valleys, a view which cannot, however, be divorced from the wider European context. Like all significant art, it speaks of universal concerns.

Throughout this volume, the contributors explore from different perspectives the relationship between the image and the word in the work of artists who are primarily painters. In his contemporary overview, Osi Rhys Osmond continues that theme, acknowledging at the same time that nowadays there are almost unlimited means of making art. His essay raises the question 'What is art for?' in an age of ubiquitous verbal and visual stimuli. Discussing the nature of creativity and how the related thought-process is adopted by each of the contemporary artists under scrutiny, he examines the fundamental philosophical question about the way we organise our thoughts 'to bring into physical form (painting and poetry) those thoughts, images and realisations for which no other means of being apprehended exist' and argues that painting still has a vital role to play.

Although the essays in this volume focus on visual language, we should not forget that there are two aspects to the relationship between image and word. Many writers, past and present, whether practising in Welsh or in English, have collaborated with and been influenced by the work of visual artists. In Welsh, this process has been encouraged by the National Eisteddfod, as Osi Rhys Osmond notes in his chapter. Prominent among the poets active in this field is Mererid Hopwood, whose work has in turn influenced art, her poem 'Dadeni' ('Rebirth') having been incorporated into jewellery designed by Mari Thomas. Examples of Welsh responses to art have been made available in English in the recent anthology compiled by Menna Elfyn and John Rowlands, *Modern Welsh Poetry: 20th-century Welsh-language Poetry in Translation* (Tarset, 2003), which includes work by Elinor Wyn Reynolds who, like Menna Elfyn, collaborated with artists in the META exhibition.

Another recent poetry anthology, *The Pterodactyl's Wing* (Cardigan, 2003), edited by Richard Gwyn, has again shown that this two-way communication remains an important aspect of the work of many contemporary writers in English. Thus David Greenslade, for example, has worked closely with the artist Tim Davies, whilst Hilary Llewellyn-Williams's poem 'Menai', included in her collection *Greenland* (Bridgend, 2003), was inspired by a painting by Tracey Williams. As a poet himself, Richard Gwyn has similarly been involved in collaborations with visual artists from Wales, France and Spain. He took the title of his anthology from the poem, 'A Welshman to any Tourist'[3] by R. S. Thomas, a poet whose fascination with the visual arts culminates in poems that give a unique insight into the visual language used by artists ranging from early Italian painters to modernist masters. The American linguist Joseph Graham once stated 'that words do not take the place of thoughts. They occupy a different place.'[4] Could the same statement be made about visual images? If so, then what connects them? Is it the creative process born of thought, idea, knowledge and, crucially, imagination, that often misunderstood and mostly unexplored factor? The final chapter indicates a way to unravel the intricacies of the creative process and the way in which imagination plays a quintessential role for artists whose work involves both visual and written language.

In the following richly-illustrated chapters, the contributors, some of whom are artists themselves and all of whom are deeply involved with the image and the word, act as guides through the multilayered complexities of the interrelationship between painting and writing in the art of Wales. Although this book concentrates on why this interrelationship between two particular art forms is especially prevalent in Wales, it also shows that there are important aspects of this phenomenon that clearly places our culture within its European context and affirms the need for wider consideration. We hope that the present volume will stimulate further research, discussion and debate in this area, not only within Wales but also internationally.

[1] Administered by Lynne Crompton, Oriel Queen's Hall Gallery, Narberth, Pembrokeshire, it toured to five venues in Wales and to Arka Gallery, Vilnius, Lithuania.

[2] META. *Delweddu'r Dychymyg/Imaging the Imagination* (Oriel Queen's Hall Gallery, Narberth, 2001)

[3] R.S. Thomas, *Song at the Year's Turning* (London, 1955).

[4] Quoted in John Powell Ward, *The Poetry of R.S.Thomas* (Bridgend, 2001), p. 182

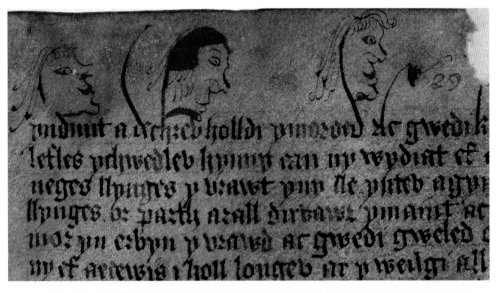

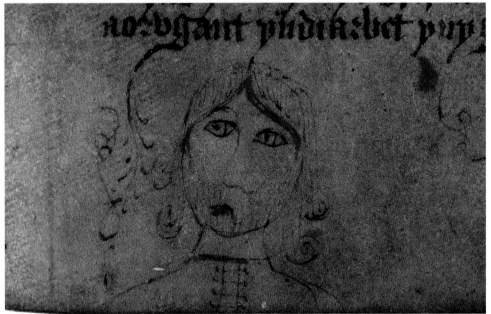

1. Profile heads added to ascenders, **15th cent.** (Peniarth MS 23C, f. 29)
2. Marginal drawing: bust of a young man, **15th cent.** (Peniarth MS 23C, f. 33ᵛ)

I

A Dual Tradition

CERIDWEN LLOYD-MORGAN

The coexistence of the visual image and the word as forms of expression was a commonplace in the medieval culture of Western Europe. Whether the word was written, or, more frequently, spoken or sung, the interplay between them was a constant feature of human experience.

Church attendance, which was expected of all Christians, made the individual a spectator of a performed ritual, where the robed priest acted his role according to a strict choreography, and the service took place against the setting of the church architecture. In the Middle Ages the interior of the church was not the monochrome, unadorned setting so often seen in surviving medieval churches in Wales today. Three-dimensional sacred images, whether in wood or stone, were often painted in polychrome, and many western European churches reinforced Christian teaching through mural paintings. In a poem referring to his mother, the fifteenth-century French poet François Villon describes how the pictures on the church walls were the Bible of the poor and illiterate, providing graphic illustrations of important subjects such as the Last Judgement, helping worshippers to understand better the words of the priest.[1] Survival of pictorial material from the medieval churches of Wales may be limited, thanks to Protestant zeal in the sixteenth and seventeenth centuries, but a visit to a church in Catholic Brittany, for instance, where such images have survived, or even a study of the *disjecta membra* still visible in Wales, can give some impression of the strongly visual impact of the place of worship.

By the fourteenth century, books were increasingly seen by the wealthy as a desirable possession, even a status symbol, whether or not they could read. Surviving manuscripts of Welsh provenance, whether ones copied in Wales or those copied elsewhere but known to have been used in Wales or by Welsh owners, tend to have far less visual imagery than those produced or owned in England, for instance, or France or the Low Countries, but this should not be taken as evidence that readers or owners here were less interested in visual art or less appreciative of it than their counterparts elsewhere. Instead that scarcity has probably more to do with the conditions of life within Wales, where a comparatively poor economy was periodically aggravated by prolonged periods of unrest and even war. Work such as the six leaves of full-page miniatures in the Llanbeblig Hours (Aberystwyth, National Library of Wales, NLW MS 17520A) produced almost certainly in the Caernarfon area and added to a classic late-fourteenth-century book of Hours, probably imported from England, shows that Welsh artists were perfectly capable of producing work of a good standard both artistically and technically, work considered good enough for a member of a landed family of

English descent and high status.[2] The book of Hours was the commonest type of devotional manuscript in the fifteenth century and one of the most likely to be decorated, combining text with visual imagery. In a salacious poem Hywel Dafi (*fl.* 1450-1480) depicts himself peeping through the keyhole at a girl in front of an image of the Virgin Mary, reciting – not reading – psalms from a book, a book of Hours or a Psalter.[3] The miniatures in such a manuscript were often used as an aide-mémoire by those who were not fully literate, especially since particular readings or prayers were associated with particular visual images. And if not all those commissioning or purchasing books of any kind could afford manuscripts with an extensive array of miniatures or even decoration, Welsh scribes, like their counterparts elsewhere, often added their own, unofficial pictorial elements.[4] Sometimes these images, usually drawings, will be at least partly functional, intended to draw the binder's attention to a catchword at the end of a quire, for example, or to emphasise a correction, such as making good an omission in the text. But more often they seem to be there purely for fun, perhaps to enliven the scribe's lengthy task, for it is certainly notable that they tend to be rarer in the final quire of a manuscript, suggesting that with the end in sight the scribe was less tempted to diversions. In these informal examples, which do not belong to any planned scheme of decoration, the drawing (for that is what they usually are) is often an extension of a letter form. The ascender or upward stroke of a letter such as *h* or *d*, or the descender or downward stroke of a *y* can easily be extended into the margin and transformed into a face, a profile head, a fish, or a monster, or the margin used for free-standing drawings (fig. 1 and 2). Even in a planned series of decoration, letter and visual image may be combined, for example the swan enclosed in a decorated initial in the late fifteenth-century *Llyfr Du Basing* (the Black Book of Basingwerk).[5] Other drawings might be added by later readers of a manuscript. Sometimes these illustrate a reference in the text, such as the handbell, horn and upset milk bowl added in a fifteenth-century manuscript of the *Itinerarium Cambriae* ('Journey through Wales') and *Descriptio Cambriae* ('Description of Wales') by Gerald of Wales.[6] These were perhaps intended to help the user to find the same place in the text at the next reading, but in some cases there is no obvious motive other than a desire for visual self-expression. Thus spaces in the margin or pages left blank might be filled with standard religious imagery such as a crucifixion scene (as in National Library of Wales, Peniarth MS 23C), or with faces, coats-of-arms, strange beasts, and ships (as in Cardiff Central Library, MS 1.218).

But an important use of pictorial annotations was to draw attention to a portion of the text. The commonest image in what is essentially a visual language of commentary is the pointing hand used as a nota bene mark. These may take very simple, stylised forms, perhaps little more than a squiggle, but at the other extreme may be drawn with very elaborate cuffs and sleeves as in National Library of Wales, NLW MS 3567B, an early-sixteenth-manuscript of Chaucer's *Treatise on the Astrolabe* produced for a member of the Edwards family of Chirk.[7] Each of the many drawings has a unique, detailed design. Other simpler forms, such as a cross or a flower, are also frequently found added by sixteenth- and seventeenth-century readers, who thus provided a visual system of commentary or indexing to a written text. Some manuscripts acquired layers of imagery over the centuries, as new readers added their own marks, sometimes drawing attention to older ones, each contribution helping to create a visual record of the user's role in the manuscript's history. Although some such marks can be identified as belonging to specific individuals, usually well-known scholars, others remain as anonymous as many of the medieval texts to which they were added.

During the eighteenth century, however, the relationship between image and word took a new direction with the emergence of Romanticism in Britain. Whereas in medieval Wales many prose texts have no indication of authorship and many of the tales seem to have evolved through a lengthy process of what might almost be called collective authorship over time, by the eighteenth century it had become normal for the status of the author or creative artist as an individual to be asserted, and personal experience, private as well as public, became a major literary theme. It is in this context that we see first emerging the artist-writer excelling in both visual and written forms of expression. Perhaps the earliest example of this phenomenon was the Carmarthenshire poet John Dyer (?1699-1758). He is now perhaps best known as a writer, for his poems 'Grongar Hill' (printed in 1727), 'The Ruins of Rome' (1740) and 'The Fleece' (1757) but his first career was as a painter.[8] He trained in London under Jonathan Richardson from 1721 until 1724, when he left to continue his studies in Italy, but he was already writing poetry and forming close links with literary as well as artistic communities before his departure. He returned from Italy a year later, intent on launching his career as a professional painter, but continued to maintain his literary activities. Poetry and painting were closely related rather than parallel occupations for Dyer. 'The Fleece',

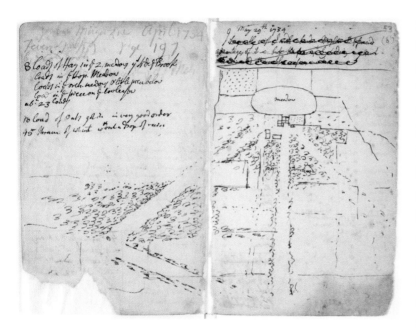

for example, reflects the visual impact on Dyer of the famous tapestries at Blenheim Palace, which he first saw in late 1721 or early 1722, whilst 'The Ruins of Rome' draws upon the visual impressions formed during his stay in that city and his Italian sketchbooks probably provided an important source for the poem. Even after being ordained as an Anglican priest in 1741, Dyer continued not only to write poetry but also to draw and paint. One of his last paintings, of his daughter Sarah, has been dated to about 1752-3; his poor health in his remaining years probably prevented him working in oils thereafter. His surviving notebooks confirm that for Dyer these two forms of expression were inseparable, in both literary and more practical contexts (fig. 3).

A generation later, Thomas Jones (1742-1803) of Pencerrig in Radnorshire, emerged as one of the most innovative painters of his generation. Like Dyer, he came from a Welsh gentry family and began his artistic apprenticeship in London before going to Italy. Jones not only documented with extraordinary vividness and sensitivity the Welsh landscapes which he knew so intimately, but also, during his stay in Italy from 1776 to 1783, painted street scenes of startling modernity. In addition, he was a remarkably gifted writer. Little of his written work was published in his lifetime, apart from some satirical verse, but at his death he left the manuscript of his *Memoirs*, compiled on the basis of the journal which he kept for much of his adult life.[9] This extraordinary work reveals him as an accomplished and charming story-teller with a keen ear for a telling phrase and a fine sense of timing, as well as a most endearing capacity for laughing at his

3. John Dyer, notebook entries (NLW MS 23294D, ff. 52ᵛ-3)

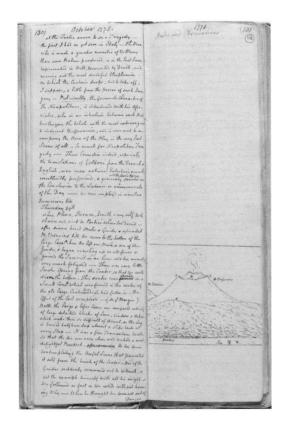

own misfortunes or foolishness. The surviving manuscript of *Memoirs*, which is full of corrections, additions and deletions, and where entire passages or episodes were revised or even completely rewritten, enables us to follow the complex and careful editorial process to which he subjected his first draft. The rewriting encompasses content, whether entire episodes or small details, and also style, as he makes minor adjustments to sentence structure or subtly changes the meaning by altering a single word. For Thomas Jones, then, polishing the final version of his *Memoirs* was not purely a pastime for his private amusement. It is clear that he was conscious of the effect of his prose on future readers and set himself high standards, whether or not he himself would have regarded the final product as literature. Interestingly, two of his surviving notebooks provide a lightly fictionalised account of his adventures as a young apprentice artist,[10] again suggesting that Jones wrote not only for himself but for an audience, even if he himself foresaw no audience beyond his friends or family. Not only do these autobiographical accounts reflect his life as an artist, they also occasionally include sketches, for example in the account of his visit to Vesuvius in October 1778, when even his skill with words perhaps seemed to him not quite enough to present a particular visual impression to the reader (fig. 4). Even in his account book, Jones combined sketches and notes, again reflecting the importance of both modes of expression.

Again in the nineteenth century, artists as diverse as John Gibson and Hugh Hughes proved to be fine stylists, Gibson in English and Hughes in Welsh. The successful sculptor John Gibson (1790-1866), who settled in Italy, wrote a remarkable series of autobiographical letters to his friend Mrs Margaret Sandbach

4. Thomas Jones, Pencerrig: *Memoirs* (NLW MS 23812D, ff. 117ᵛ-18)

of Hafodunnos Hall, Llangernyw, grand-daughter of his first patron, William Roscoe of Liverpool. Gibson first met Mrs Sandbach when she and her husband visited Rome in 1838, and soon afterwards she and Gibson came to an agreement that he would write regularly to her giving detailed accounts of his activities.

This information would provide her with the materials for writing a memoir of him. The letters he wrote her give detailed information not only on Gibson's own career but also on contemporary events in Italy, such as the political unrest in the late 1840s, and are occasionally illustrated (see fig. 5). Unfortunately Mrs Sandbach died in 1852 before the project could be realised,[11] but the letters survived and reveal Gibson as a lively narrator and fine stylist.

The painter and engraver Hugh Hughes (1790-1863), though born in the same year and within a few miles of John Gibson, followed a very different path to the sculptor, for he worked largely in Wales and within a Welsh-speaking context, yet he too demonstrates the same facility in writing as in visual expression.[12] As Peter Lord has noted, his diary reveals considerable literary gifts and there are passages seemingly composed self-consciously which suggest that Hughes had in mind the possibility of a wider readership than himself alone.[13] But his diary, which provides written notes for visual subjects as well as occasional sketches in the text, is only one example. Hughes's Nonconformist ideals, coupled with a strong sense of his identity as a Welsh-speaking and patriotic Welshman, led him to

undertake a number of publishing projects where image and word were combined in print, such as *Trioedd y Gwragedd* (1821), *Yr Addysgydd*, a series on which he began working with David Charles the younger in 1822, and *Pictures for the Million of Wales* (*c*1848), to name but a few. These published series, bringing together engravings and text for largely didactic purposes, were not, of course, unique in the history of nineteenth-century Wales. On the contrary, from Hughes's time onwards, visual imagery occupied a central role in religious and educational life in Wales, as the work of both Peter Lord and John Harvey has confirmed.[14] Even the influence of the illustrated Bibles intended primarily for children, or the classic family edition of Bunyan's *Pilgrim's Progress* and its Welsh translation, *Taith y Pererin*, should not be underestimated. These were the books that could be found in thousands of Nonconformist homes in late nineteenth-century and early twentieth-century Wales, in a curious and unconscious Nonconformist echo of medieval tradition.

Working in both visual and written media was not, however, the preserve of the indigenous artists of Wales in the eighteenth and nineteenth centuries. New arrivals in Wales, especially those who 'went native' to some degree, often display the same tendency. The Irish-born 'Ladies of Llangollen', Lady Eleanor Butler (1739-1829) and Sarah Ponsonby (1755-1831), had been educated in the mode then considered suitable for girls of aristocratic birth, where the emphasis was on languages, music, embroidery and a little genteel water-colour painting. But having escaped respectively marriage and the family duties of the spinster daughter to live together in domestic bliss at Plas Newydd, Llangollen, they were able to devote themselves, as instinctive and committed autodidacts, to developing their considerable skills as prose writers and as more than competent amateur artists. Their diaries, now rightly regarded as of literary value, are complemented by a wealth of other manuscripts to which they added illustrations, including charming vignettes of their home, Plas Newydd. There they also developed considerable skill in the applied visual arts of architecture and interior design as well as landscape gardening.[15]

A similarly determined development of the limited skills taught to the female gentry may be observed in the case of Augusta Hall (*née* Waddington), Lady Llanover (1802-96), who was born into an English family

settled in Monmouthshire but embraced the Welsh language and culture with the zeal of the convert. She is remembered today as much for her famous and highly influential series of paintings of supposed traditional Welsh costume as for her eisteddfodic poetry and her fiercely patriotic Welsh cookery book. In the latter, *The First Principles of Good Cookery* first published in 1867, which included some of her own illustrations, she adopted a literary technique similar to that used by Thomas Love Peacock in his satirical novels, where a narrative framework provides the vehicle for the discussion of ideas. Lady Llanover's 'Welsh hermit of the cell of St Gover', provides a fictional mouth-piece not only for the recipes and culinary advice, but also a didactic message celebrating an idealised, half-invented, tradition of Welsh kitchen economy.

Even in the early twentieth century, women of the upper classes found that their limited education might, when opportunity could be grasped, enable them to express a creativity which might otherwise be stifled. Although she was born into a family of prominent radical Liberal politicians, Alice Williams, or 'Alys Meirion' (1863–1957) of Castell Deudraeth, Meirionnydd, had the misfortune to be the youngest daughter, destined to be educated only at home. Then, unmarried, she was obliged to remain at home as a companion for her widowed mother until the latter's death in 1904. Mercifully released from the shackles of family duty, Alice, now well over forty years of age, escaped abroad to develop her skills as an artist. She became an accomplished water-colour artist, a member of the *Union des Femmes Peintres et Sculpteurs* and of the *Union des Aquarellistes* in Paris, where she lived for some time before the outbreak of the First World War. She continued to exhibit in London and Paris until the 1930s, when failing eyesight forced her to stop painting. But she was also a writer in the then-fashionable patriotic mode. Among her writings is a play, *Britannia*, staged in Penrhyndeudraeth and London in 1917, on the strength of which she was made a member of the Gorsedd of Bards at the Birkenhead Eisteddfod in the same year. Two years later she founded the Women's Institute's magazine, *Home and Country* and became its first editor.[17]

It is not generally realised that the best-selling romantic novelist Berta Ruck (1878-1978), a close friend of Alys Meirion, and like her the daughter of a Welsh-speaking landowning family from Meirionnydd, began her career as a professional artist.[18] But Berta Ruck was fortunate in having a proper education. With her family's support and later with a small scholarship, she studied in London, first at Lambeth School of

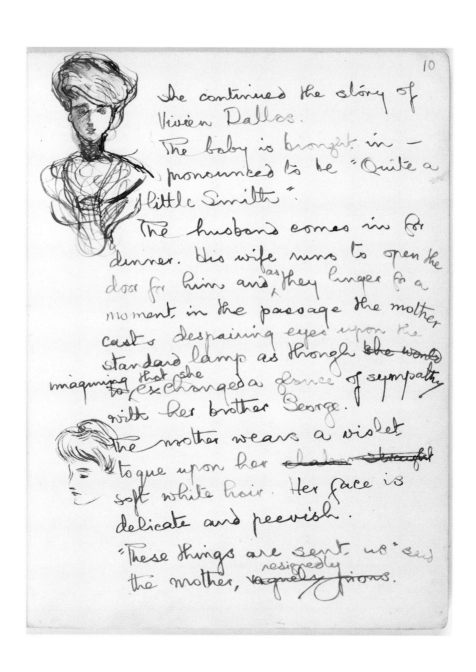

She continued the story of
Vivien Dallas.
The baby is brought in —
pronounced to be "Quite a
little Smith".
The husband comes in for
dinner. His wife runs to open the
door for him and, as they linger for a
moment in the passage the mother
casts despairing eyes upon the
standard lamp as though the words
imagining that she exchanged a glance of sympathy
with her brother George.
The mother wears a violet
toque upon her soft white hair. Her face is
delicate and peevish.
"These things are sent us" said
the mother, resignedly.

6. Berta Ruck, illustrated notes for a novel (NLW MS 23733C, f. 10)

Art and then at the Slade, before moving to Paris where she attended Colarossi's art school. On her return to London she began working as an illustrator for *The Idler*, and only began writing – first as a translator from German to English, then as a writer of fiction – to eke out her earnings as an artist. Since her career as a novelist and short-story writer quickly proved successful, for the rest of her life she concentrated on fiction. Nonetheless, she never abandoned her art. Some of her published works include illustrations by her and she occasionally designed dust jackets for her novels. One example is a presentation copy of *The Immortal Girl* (London, [1925]), now National Library of Wales, NLW MS 18954B), to which she has added nineteen original watercolour illustrations. But it is in her journals-cum-workbooks that the marriage of image and word is most evident.[19] She often used these notebooks to start drafting a novel or a short story, especially to work out the plot or to develop a particular character, incident or dialogue. Here real life and the life of the novel in progress often overlap, as journal entries are interspersed with notes of scenes or individuals she has observed and which will provide material for the written work in progress. Not infrequently it is through sketches that she is able to capture or define – 'get' is her expression – the kind of character she has in mind for her current work of fiction (fig. 6), for she seems to have always needed to *visualise* her characters very clearly. The combination of text and illustration which is a feature of her notebooks is not restricted to her work as a novelist, however. When the case against Saunders Lewis, Lewis Valentine and D. J. Williams for setting fire to the bombing school at Penyberth in Llŷn was heard at the Old Bailey in January 1937, Berta managed to secure a seat in the public gallery, where she not only took notes on the proceedings but also sketched the defendants in the dock.[20]

In the generation following that of Berta Ruck, Peggy Whistler (1909-59), the Border writer who took the pseudonym Margiad Evans, followed a similar path. Intent on becoming an artist, she had studied art at Hereford, and started her career making book illustrations and dust jackets, which she signed with her real name.[21] When she turned to writing, her alter ego Peggy Whistler continued to provide the illustrations and dust jackets (fig. 7) and she derived no little amusement from reviewers failing to realise the truth.[22]

Berta Ruck and Margiad Evans were at the height of their careers from the 1920s to 1940s. Although, as we have seen, we can trace a long tradition of the marriage of image and word in the culture of Wales, it

CREED

By MARGIAD EVANS

BASIL BLACKWELL OXFORD
1936

Frontispiece

is in the twentieth century that the greatest concentration is found of artists for whom the written text is an essential part of their activity. For some Welsh artists both forms of expression have, arguably, been of virtually equal importance. David Jones and Brenda Chamberlain, whose work is discussed by Anne Price-Owen and Jill Piercy respectively in this volume, are amongst the best-known examples. But in this category the list is almost endless. Ray Howard-Jones was not only a remarkable painter but also a respected poet whose work was published in the *Anglo-Welsh Review* and collected in *Heart of the Rock : poems 1973 to 1992*.[23] Robert Morgan (1921-94), the poet and former miner from Penrhiw-ceibr, first emerged as a writer in 1948, at the Miners' Eisteddfod in Porthcawl, where he won the short-story competition judged by T. Harri Jones.[24] But later, when working as a teacher, he turned to visual imagery to evoke his experiences as a working miner and of life in a Welsh mining community, providing illustrations and cover designs to accompany his poems, the work in each medium reinforcing the impact of the other.[25] By the time of his death, his prints and paintings had been widely exhibited and a retrospective exhibition was in preparation. His contemporary, Jack Raymond Jones (1922-93) from Swansea was the author of an acclaimed biography of Vincent van Gogh, *The Man who Loved the Sun* (1966), and a regular script-writer for the BBC, but in later life emerged as a painter of scenes of life in the working-class community of his childhood in the Hafod district of Swansea, in a style which gained him the (unwanted) sobriquet 'the Welsh Lowry'.[26] Further examples include the poet and illustrator Alison Bielski (b.1925), the poet-painter Alan Perry (b.1942) and Jonah Jones (1919-2004), who practised as sculptor, calligrapher, novelist and biographer.

7. Margiad Evans, *Creed* (1936), frontispiece and title page

Other visual artists have derived inspiration from literature and even incorporated letter-forms, words or portions of text in their paintings. An important mid-century example, Ceri Richards, discussed in greater detail below by Peter Wakelin, adds visual imagery to a printed text to create a new work, as well as celebrating visually themes from the poetry of Dylan Thomas and Vernon Watkins, or using text as part of the visual language of a painting or print. More recently Mary Lloyd Jones and Ogwyn Davies in their own very different ways have continued that tradition. Osi Rhys Osmond discusses other contemporary artists below. Others, notably Gwen John, as Chapter III shows, have combined words and images in sketchbooks and in writings intended for private use only.

A rather different model, closer to that of Thomas Jones, Pencerrig, is provided by Augustus John and Sir Kyffin Williams, both of whom are well known for their autobiographical writings. John (1878-1961), although first and foremost a painter, was a fine stylist in his youth, as is evident in his letters to friends such as his fellow students Ursula Tyrwhitt and Michel Salaman. These letters and those to Dorelia McNeill, his de facto second wife, often provide a further dimension to the written content by adding sketches, some quite detailed and carefully executed, often amusing, ironic or self-deprecating. Occasionally these may include sketches of work in progress, for example when he was painting the portrait of Chaloner Dowdall in his robes as Lord Mayor of Liverpool in August 1909 (fig. 8).[27] In later life, John's writing style sometimes tended towards the bombastic, but his two published collections of autobiographical essays, *Chiaroscuro* (1952) and *Finishing Touches* (1964) still reveal that he could wield the pen as successfully as the paint-brush. More recently, Kyffin Williams (b.1918) has also very successfully developed his writing as a complement to his painting. Having been first encouraged by others to commit to writing his colourful stories of his ancestors in *Across the Straits*,[28] he has become an engaging writer of autobiography, in *A Wider Sky* (1991), as well as providing an idiosyncratic yet informative commentary on his paintings and print-works in published volumes such as *Portraits* (1995) and *The Land and the Sea* (1998),[29] as well as in exhibition catalogues, all written with tremendous panache which tends to conceal the craftsmanship of his prose.

Of course the writer-artist is not unknown in other European cultures: William Blake, Isaac Rosenberg, Mervyn Peake and Adrian Henri in England, Victor Hugo in France and the German-speaking poet-

painters Hans Arp, Kurt Schwitters and Paul Klee are obvious and extremely diverse examples. What is so striking in the Welsh context, however, is the sheer numbers of those visual artists for whom the written word has been an essential part of their activity. A number have practised in both media, whilst even amongst those visual artists not known as creative writers, many developed their writing as an adjunct to their visual work. In other cases, such as Graham Sutherland or John Petts, the visual work is inspired by or derives directly from written, literary texts. The examples discussed briefly above are chosen more or less randomly, but deliberately include, as well as the famous, others who may be less familiar, especially to younger generations. Many others could have been included, as Wynn Thomas's foreword to this volume demonstrates.

To find examples, both historical and contemporary, is all too easy. The reasons for the importance of this phenomenon in Wales are less easy to establish. To describe it as a *tradition* might imply a conscious response by artists in each generation to a pre-existing cultural pattern, something which would be difficult to prove. In the Middle Ages the tradition is clearly *not* specific to Wales but part of a shared European culture, and even in the early modern period this was probably still the case. The concentration of examples from the nineteenth century onwards, however, is perhaps easier to account for and more culture-specific. Following the pioneering research of Peter Lord, it is now a truism to state that the myth

8. **Augustus John: illustrated letter** (NLW MS 22776D, ff. 97ᵛ-8)

of a Wales devoid of visual culture is exactly that: a myth. What is true, however, is that Wales, like Brittany and other smaller nations in western Europe, for much of the nineteenth century lacked the structures in which artists could train and then practise their profession, with support from moneyed patrons. Writers in either Welsh or English could make their way far more easily and without the need to travel far afield. A good basic education, honed by Sunday school and discussion groups such as the *seiat* (as it later developed) and the *cymdeithas lenyddol* (chapel literary society) could provide a springboard to journalism at a time when newspapers and periodicals, both secular and denominational, were extremely numerous and widely read. The many literary societies and eisteddfodau provided the apprenticeship for the budding poet. A career in the Church or Nonconformist ministry provided further opportunities for practising a word-based culture. Moreover, as women found, literature could be combined with domestic and family duties: Ann Griffiths at the turn of the nineteenth century composing her hymns on popular tunes, Elen Egryn in the late 1840s and early 1850s writing her lyric poetry while in domestic service.[30] In the late nineteenth century the massively influential women's temperance movement provided further outlets through magazines such as *Y Frythones* and *Y Gymraes*, both of which, incidentally, are lavishly illustrated and show concern for the visual impact of the printed text. When opportunities for formal education and work outside the home were limited, women from all social backgrounds would have found it easier to develop their skills as writers than as artists, except for the arts of sewing, knitting and embroidery which had low status as women's necessary work or at best as genteel pastimes.

Not only was the craft of writing easier of access, its role as the medium of both secular and religious teaching, side by side with the hallowed tradition of the eisteddfod, lent tremendous status to the written culture of Wales. The limited opportunities for art education and the slow evolution of the visual arts section of the National Eisteddfod must surely have contributed to this imbalance.[31] This did not, of course, prevent many committed Welsh artists, including those from within the Welsh-speaking community, from acquiring the necessary skills and practising them professionally. But artists like Hugh Hughes, Samuel Maurice Jones and J. Kelt Edwards were undoubtedly deeply influenced by the literary culture of the Welsh-speaking society from which they sprang and they made forceful use of the pen as well as providing visual content for books and periodicals. The extraordinary status accorded to word-based works, whether

written, recited or sung, may help to account for the very close relationship which developed between the two modes of expression within Wales, for even those whose primary career was in visual art could not escape being steeped in the literary culture from childhood onwards. In this sense it may not be inappropriate to speak of a tradition. The persistence of that tradition in the early twenty-first century, when the relationships between religion, education, society and the individual have changed beyond recognition, is particularly notable. The use of words, writing and the book made by artists such as Ivor Davies, Mary Lloyd Jones or Carwyn Evans in work commenting on their experiences as Welsh-speakers within a changing nation and a changing physical, social, technological and linguistic landscape, is at once nostalgic and radically contemporary. We hope that the present volume, which is seen as a preliminary exploration, will lead to further discussion and research.

[1] 'Ballade pour prier Nostre Dame', see François Villon, *Oeuvres*, ed. by Auguste Longnon & Lucien Foulet (Paris, 1967), pp. 40-1.

[2] It was almost certainly produced for the Isabella Godynogh whose death in 1413 is noted in the calendar. For a description of the manuscript, acquired by the NLW in 1960, see G. F. Warner, *Descriptive Catalogue of Illuminated Manuscripts* in the library of C. W. Dyson Perrins, (Oxford, 1920), vol. i, pp. 59-61; see also Daniel Huws, *Medieval Welsh Manuscripts* (Cardiff & Aberystwyth, 2000), pp. 19, 21, and E. J. M. Duggan, 'Notes concerning the "Lily Crucifixion" in the Llanbeblig Hours', *National Library of Wales Journal*, 27 (1991), 39-47.

[3] For text, see Dafydd Johnston, *Canu Maswedd yr Oesoedd Canol. Medieval Welsh Erotic Poetry* (Cardiff, 1991), pp. 58-61, lines 6-8. The description of the book as golden suggests an illuminated book of Hours; cf. Ceridwen Lloyd-Morgan, 'More written about than writing? Welsh women and the written word', in Huw Pryce (ed.), *Literacy in Medieval Celtic Societies* (Cambridge, 1998), pp. 149-65 (159).

[4] A full survey of visual images in surviving manuscripts of Welsh provenance, edited by Ceridwen Lloyd-Morgan, will appear in the *Index of Images in Medieval English Manuscripts* series (general editor Kathleen Scott) in 2006.

[5] National Library of Wales, NLW MS 7006D, p. 199, available in electronic form on the National Library's website at www.llgc.org.uk. Evidence now suggests that the manuscript was probably written not at Basingwerk Abbey in Flintshire, as was traditionally believed, but at another Cistercian house, Valle Crucis (Glyn-y-Groes) in Denbighshire.

[6] National Library of Wales, NLW MS 3024C, ff. 6, 9, 38.

[7] Manuscripts of this text are often illustrated with diagrams, but these are absent from NLW MS 3567B, which may have offered further encouragement to add pictorial elements.

[8] See Ralph M. Williams, *Poet, Painter and Parson: the life of John Dyer* (New York, 1956), and Belinda Humfrey, *John Dyer* (Cardiff, 1980). Dyer's notebooks, together with related notes and transcripts, are National Library of Wales, NLW MSS 23924-7.

[9] An example of his satirical verse, in English and Italian, was published in *The Gentleman's Magazine*, February 1797, p. 149, but the *Memoirs* were not published until 1951. A revised transcript of the *Memoirs*, together with a facsimile of that manuscript (now NLW MS 23812D) and two others is available on the National Library's website at http://www.llgc.org.uk/pencerrig/index_s.htm.

[10] National Library of Wales, Pencerrig Deeds & Documents, 306-7, dated 1786-8, contain 'The Trip to Calais, a Tale of former times, from a manuscript written in the year 1767'; see NLW Schedule of Pencerrig Deeds & Documents, p. 50.

[11] The task was eventually completed, using the letters, by Thomas Matthews some fifty years later.

[12] See Peter Lord, *Hugh Hughes, Arlunydd Gwlad* (Llandysul, 1995); on Hughes and Gibson, see ibid., *Gwenllian. Essays on the Visual Culture of Wales* (Llandysul, 1994), pp. 9-36.

[13] Lord, *Hugh Hughes*, p. 49. The diary is now National Library of Wales, Cwrtmawr MS 130A.

[14] See e.g., Peter Lord, *Hugh Hughes*, ibid., *Gwenllian*, and ibid., *Arlunwyr Gwlad. Artisan Painters* (Aberystwyth, 1993); cf. John Harvey, *The Art of Piety: the Visual Culture of Welsh Nonconformity* (Cardiff, 1995).

[15] The Hamwood Papers of the Ladies of Llangollen are now National Library of Wales, NLW MSS 22967-96, available on microfilm from Adam Matthew Publications. See also Ceridwen Lloyd-Morgan, 'A local institution: day-to-day life of the Ladies of Llangollen', *Planet*, 91 (Feb.-March 1992), 28-35, which includes an example of the illustrations in the Ladies' manuscripts.

[16] Reprinted with an introduction by Bobby Freeman (Tregaron, 1991).

[17] See entry in *New Dictionary of National Biography* (Oxford, 2004), s.n. Williams, Alice Helena Alexandra.

[18] Berta Ruck's own autobiographical works provide much useful information about her life and work, most notably *A Story-teller Tells the Truth. Reminiscences & Notes* (London, 1935); see also Ceridwen Lloyd-Morgan, 'Not just the Welsh Barbara Cartland: Berta Ruck (1878-1978) of Aberdyfi', *Journal of the Merioneth Historical and Record Society* (forthcoming, 2006).

[19] Now National Library of Wales, NLW MSS 23376-8, 23437B, 23523B, 23569-73, 23715-24, 23733-44, 23782B, 23790C (volumes covering the years 1906-January 1946), and Berta Ruck Papers 1-13 (1951-73). Six further volumes, dated 1928-37, are Library of the University of Delaware, Newark, USA, Special Collections Department, MS Collection 362.

[20] NLW MS 23571B, ff. 7-8.

[21] See Ceridwen Lloyd-Morgan, *Margiad Evans* (Bridgend, 1998), pp. 11-18.

[22] Ibid., pp. 42-3.

[23] Blewbury, 1993.

[24] The story, 'A Day's Work', was published in *Coal*, (Jan. 1949), pp. 24-5. For an overview of his career, see Roland Mathias, 'Robert Morgan', *Poetry Wales* 30/4 (1995), 4-5.

[25] Morgan published thirteen volumes between 1967 and 1992.

[26] See, e.g., [Menna Baines], 'Abertawe ddoe : lluniau Jack Jones', *Barn* 370 (1993), 19-21.

[27] National Library of Wales, NLW MS 22776D, ff. 97V-8; for further examples of his illustrated letters see Daniel Huws, 'Some letters of Augustus John to Ursula Tyrwhitt', *National Library of Wales Journal*, 15 (1967-8), p. 236 and plates 7-8, and Ceridwen Lloyd-Morgan, *Augustus John Papers at the National Library of Wales* (Aberystwyth, 1996).

[28] London, 1973, reprinted Llandysul, 1993.

[29] Both published by Gomer, Llandysul; see also Nicholas Sinclair & Ian Jeffrey, *Kyffin Williams* (Aldershot, 2004), which draws heavily on his writings.

[30] See Ceridwen Lloyd-Morgan & Kathryn Hughes (eds), *Telyn Egryn, gan Elen Egryn* (Dinas Powys, 1998), pp. xiv-xvii.

[31] Cf. Peter Lord, *Y Chwaer-dduwies: Celf, Crefft a'r Eisteddfod* (Llandysul, 1992).

9. David Jones: Ongyrede (1952)

II

David Jones 1895-1974
'In the beginning was
the Image …
… and the image was in
the imagination and
made manifest in poetry'

ANNE PRICE-OWEN *Among the first images to penetrate*

David Jones's imagination was that

of a bear. When he was seven

years old he made the pencil drawing

'Dancing Bear' (1903) (fig.10),[1] *where*

his talent for artistic expression is evident.

The proportions of the animal, the texture of its coat, and where the muzzle and chain tether denote the degrading situation of the animal, demonstrate the confidence of the young artist. Moreover, Jones's compassion for the creature is suggested by the softly defined lines and strokes articulating the beast and, because the creature fills the page, it appears as a figure of authority. The sketch was valued by Jones for the rest of his life, and heralds much of his future work. This is registered in his predilection for animals and also because the image of the bear became a potent symbol in both Jones's visual and literary works. It represented Arthur, the Once and Future king, a character who particularly appealed to Jones. Half a century later he remarked on a series of books from childhood, one of which he especially liked. It 'dealt with King Arthur's knights … And then *The Lays of Ancient Rome* became a favourite.'[2] Ultimately therefore, Jones's penchant for Arthur and Celtic myths and legends was concomitant with his fascination with the development and history of Western civilization.

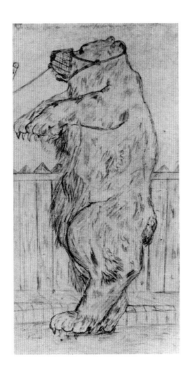

But of paramount importance to his treatment of both themes was the Christian religion. His reflections on the Eucharist was a result of several encounters. Firstly, from observations he made during the Great War and his service in the trenches, when he stumbled 'unintentionally on…[an improvised]…Mass in Flanders … I felt immediately that oneness between the Offerant and those troughs that clustered round him in the dim-lit byre – a thing I had never felt remotely as a Protestant'.[3] Secondly, during his studies at Westminster Art School between 1919 and 1921, he recalled that:

> The question of analogy seemed not to occur until certain Post-impressionist theories began to bulk larger in our student conversation … the more rewarding notions implicit in the post-Impressionist idea was that a work of art is a 'thing' and not (necessarily) the impression of some other thing. For example, that it is the 'abstract' quality in any painting (no matter how 'realistic') that causes that painting to have 'being', and which alone gives it the right to be claimed an art-work.[4]

10. David Jones: Dancing Bear (1903)

He subsequently met Eric Gill, and his conviction of the power of transubstantiation in the Catholic Mass convinced him to convert to the Roman Catholic faith in 1921.

The transubstantiation enacted in the Mass, the shape-shifting and metamorphoses of the mythical characters in Celtic literature, together with the evolution and mutations of history, accounted for Jones's perception of the world as a natural phenomenon in a perpetual state of flux, where the past impinges on the present. It was, he observed:

> A quality congenial and significant to me which in some oblique way has some connection with what I want in painting. I find it impossible to define, but it has to do with a certain affection for the intimate creatureliness of things … and yet withal a pervading sense of metamorphosis and mutability. That trees are men walking. That words 'bind and loose material things.'[5]

The mutuality and mutability oscillating between images and words was compounded by Jones's father being a printer's overseer who often brought work home with him. Accordingly, Jones 'was brought up in a home that took the printed page and its illustration for granted.'[6] Small wonder then, that the visual artist, so enamoured of his own imaginative vision, became as much committed to the word as he was to the image.

Twenty years after drawing 'Dancing Bear'(1903), the same creature was one of the first images to reappear as a simple wood-engraving (fig. 11),[7] when Jones joined Eric Gill's arts and crafts community at Ditchling, Sussex, to work as an illustrator. The simplicity of the engraving displays Jones's inexperience with an unfamiliar technique. However this simple, direct approach at the outset of his career was the foundation of his extremely sophisticated white-line engravings, such as those he executed for *The Chester Play of the Deluge* (1927). 'The Dove' (fig. 12)[8] is the final illustration of ten, and demonstrates Jones's mastery of the medium. The single outline which characterizes his early wood engravings has been transformed into a multitude of variant lines which give the impression of modelling, introducing a three-

11. David Jones: The Bear (1921)

dimensional illusion to the composition. The tree suggests renewed growth, the water transparency and movement, the hill solidity, the dove vitality. All are treated with care, where the texture of each indicates an integrity which befits their respective purposes. The caption beneath the engraving reads:

> My sweete dove to me brought hase
> a branch of olyve from some place

and confirms Jones's ability to translate text into image, according to his own vision.

Although Jones was working as an engraver, he did not forsake painting and drawing. His depictions were of landscapes and the people he encountered, whether in Ditchling, or later in Capel-y-ffin near Abergavenny, when he joined Eric Gill and his family following their move from Sussex in 1925. This was Jones's home until 1928, and his spell there was the longest time that he spent in Wales. It was also one of the most propitious times of his life. Dwelling in the shadow of the Black Mountains at Nant Honddu, he felt 'the impact of the strong hill-rhythms and the bright counter-rhythms of the *afonydd dyfroedd* which make so much of Wales such a "plurabelle".' [9]

Such a 'plurabelle' is manifested in 'River Honddu, Capel-y-ffin' (fig. 13),[10] which is a visual interpretation of Jones's considerations on traditional bardic poetry when

> … the bards of an earlier Wales referred to themselves as 'carpenters of song'. Carpentry suggests a fitting together and … the English word 'artist' means … someone concerned with a fitting of some sort … about 1924-6, I was at last understanding something of the nature of the particular 'carpentry' which most sorted with my inclinations and limitations.[11]

12. David Jones: The Dove (1927)

In his watercolour, the undulating arabesques of the hills create a sense of movement which is reflected in the swaying trees and the fulsome river. Everything fits together, all content is accommodated within the space, where even the clouds echo the rhythms of the landscape. Jones's increasing awareness of texture is distinctive here and shows the influence of the patterning techniques he practised in his engravings. The colour is heightened, which shows how Jones's liberation from the disciplined engraver's medium (where he was obliged to use a fine-edged burin to pierce the wood), prompted him to use colour in a freer, less restricted and more imaginative manner than in previous paintings. Conscious of this

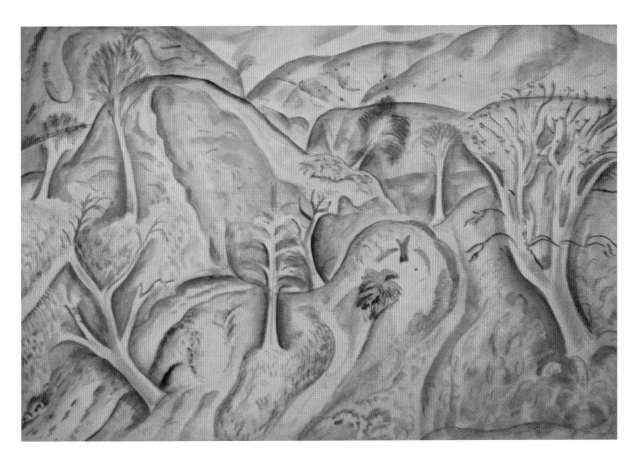

13. David Jones: River Honddu, Capel-y-Ffin (1926)

change in his approach to art, Jones confirmed that his previous work was 'stylized, conventionalized, and heavily influenced by theory, and of primitive Christian art.'[12]

This examination of his early visual work indicates a growing confidence in Jones's style. He rendered what he imagined was the intrinsic nature of the object under scrutiny, and didn't simply paint his physical vision of it, but endeavoured to endow the actual images he perceived in his surroundings with a sense of the spiritual presence which he believed is inherent in all things. Because the spirit is eternal and atemporal, his images bind the local to the universal and this unifying principle is embodied in his imagination and articulated in his art. Because each material thing is imbued with a spiritual presence, it transcended the physical being. In other words, because matter is composed of energy it is also immaterial, or metaphysical. In this, Jones acknowledged a debt to Eric Gill's

> clarifying ideas … The unity of all things became clear. A picture, no less than a candelabra or a hay-wain, must be a 'thing' with its own life and way of living - dependent on its own due proportion, proportion due to its own being.[13]

In addition, Jones also referred to the verbal medium, namely 'folk-tales of Welsh or Celtic derivation … to do with … [their] … appreciation of the particular genius of places, men, trees, animals.'[14] His continual references to literature are indicative of his mind-set, where the image and the word are compatible partners. His 1954 treatise on painting was what he set out to achieve in writing:

> … a painting ought to be: A 'thing' having abstract qualities by which it coheres and without which it can be said not to exist. Further, that it 'shows forth' something, is representational. If this was true of one art I supposed it to be true of another. I knew how the inter-stresses of the 'formal' and the 'contential' created so precarious a balance in the case of drawing or painting …
>
> I had yet to discover in what manner these nice problems of 'form' and 'content' occur in the making of a writing.[15]

Primarily however, he was preoccupied with the image, and in 1910 he went to Camberwell School of Art. When he left art school two years later, his decision as to how he would make a living was taken out

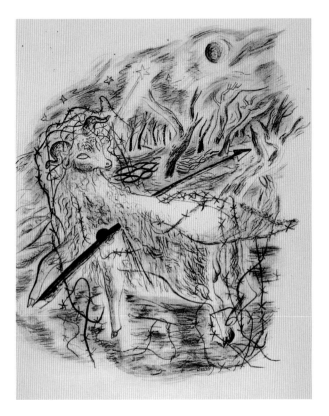

of his hands with the outbreak of the Great War, and in 1915, Jones joined the Royal Welch Fusiliers as a foot soldier. He fought on the Western Front and sustained a leg wound in the Somme offensive, at Mametz Wood. His war experiences contributed further to his conceptual development, and he retained vivid memories of his time in France.

His memories were reinforced by drawings he did at the Front, and they provided Jones with a visual diary and a record of some of the events, people and places which he encountered between 1915 and 1918. These impressions remained with Jones and accounted for his first 'attempt to make a shape in words.'[16] The fact that he didn't commence this work, an epic poem that he called *In Parenthesis*, until 1928 demonstrates a lengthy period of mental gestation which took nearly nine years to write. Initially, he envisaged an illustrated work, but in the end published the poem with just two illustrations: a Frontispiece (fig. 15)[17] and a Tailpiece, 'The Victim' (fig. 14).[18] Both reflect, illuminate and expand on the text: they are economic, imaginative versions of both the form and content of *In Parenthesis*, which T. S. Eliot regarded 'as a work of genius'[19] and which so remarkably evoked the Great War, Roman Britain and the Arthurian Legend.

These concepts are apparent also in Jones's illustrations for the book. Leafless trees with their limbs and branches hacked off are like dismembered figures in the background of the Frontispiece, where soldiers from different eras in history (according to the variety of uniforms) carry out their duties. The semi-naked

14. David Jones: The Victim (1937)

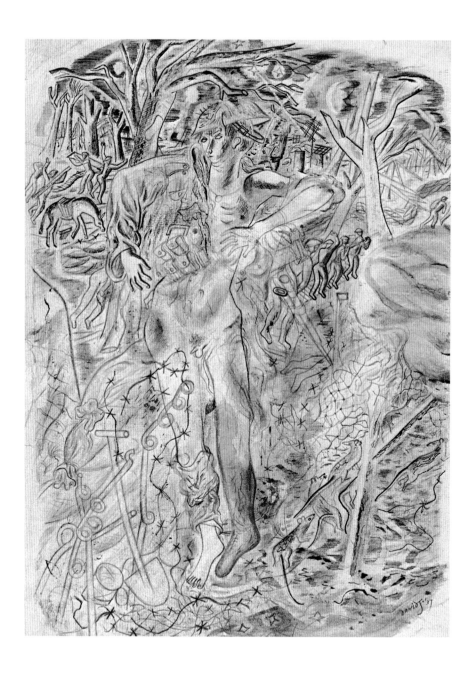

15. David Jones: Frontispiece to *In Parenthesis* (1937)

body of the main soldier caught in a thicket of barbed wire and tangled undergrowth becomes one with the trees behind him, his own uniform having been blown asunder. The exposed trunk of the soldier chimes with the bare tree trunks, and all are vulnerable creatures, like the rats and the weasel who are also the casualties of war, as delineated in both pencil (fig. 16),[20] and verse:

> you can hear the rat of no-man's-land
> rut-out intricacies,
> weasel-out his patient workings,
> scrut, scrut, sscrut,
> harrow-out earthly, trowel his cunning paw;
> redeem the time of our uncharity,
> to sap his own amphibious paradise.
> …
> blue-burnished, or brinded-back;
> whose proud eyes watched
> the broken emblems
> droop and drag dust,
> suffer with us this metamorphosis.[21]

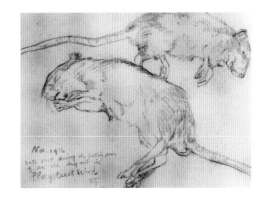

The language is deliberately ambivalent – Jones creates parallels with the soldier's task of shovelling earth, digging tunnels and laying duck-boards in the water-logged trenches. The short sentences and guttural vocabulary connote uneven, gasping breaths from the effort involved. Only the brief realization of the uncharitable intention of the conflict relieves the uncertain, jerky rhythm. The repetition of sounds in the last two lines, with their para- and internal rhymes, is an example of anglicized *cynghanedd*, reminding us that the rats, like the soldiers, undergo a transformation in this situation.

The central figure of the illustration is a vicarious Christ. Stripped naked, his body lacerated and bruised, with his arms forming a cross-bar, the soldier assumes the position of a cruciform. He is not rooted to the ground, but seems to hang as if from a tree, in the company of the instruments of the Passion, implied in

16. David Jones: Dead Rats, Ploegsteert (1916)

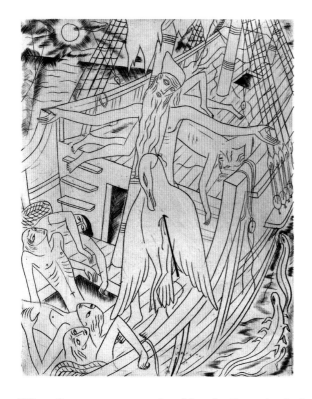

the barbed wire and the stakes, surrounding him. Is this day or night? There appear to be both sun and moon, and stars, in the picture, which concur with an eclipse, both literal and metaphorical.

The Tailpiece, 'The Victim' (fig. 14 above), is also an image of Christ in the form of the Agnus Dei. This is the lamb that was led to the slaughter, the sacrificial animal who is wounded with a spear, as was Christ on the Cross. Like his counterpart in the Frontispiece, the lamb is caught in a thicket, but his stance is heroic, rather than abject. Both drawings encompass the underlying theme of *In Parenthesis*, where the sacrifice of the soldier is a metaphor for Christ's ultimate oblation on the Cross, a vision verified by Jones's final quotations from the Bible at the very end of the poem. [22]

When Jones commenced writing *In Parenthesis*, he was engaged on designing a series of copper-plate engravings for Coleridge's *The Rime of the Ancient Mariner* (1929). Of the ten that he completed, the fifth 'The Curse' (fig. 17),[23] bears comparison with the Frontispiece. Jones illustrates the lines:

> An orphan's curse would drag to Hell
> A spirit from on high;
> But oh! more horrible than that
> Is the curse in a dead man's eye!
> Seven days, seven nights, I saw that curse,
> And yet I could not die.

17. David Jones: The Curse (1929)

In addition, Jones also evokes the lines:

> Instead of the cross, the Albatross
> About my neck was hung

by centring the Mariner on the ship's deck with his long bearded head bowed, and his arms outstretched in the pose of Christ on the Cross. The dead albatross hangs from his neck, an arrow having pierced its breast in much the same way that the spear struck the lamb in 'The Victim'. Hence, a double crucifixion[24] takes place on a vessel whose sails are tattered and where the naked bodies of the crew are strewn over the decks. In this forsaken scene, movement is implied by the tilt of the horizon line, the descending sun and also the lizards and watersnakes swimming past the ship, intimating that this forlorn state will pass. The resemblance between 'The Curse' and 'The Victim' is also echoed in *In Parenthesis*, where Jones describes the wounded soldier whose rifle is an impediment:

> Slung so, it swings its full weight. With you going blindly on all paws, it slews its whole length, to hang at your bowed neck like the Mariner's white oblation.[25]

Here Jones refers to his own predicament: he was the wounded soldier crawling through the undergrowth, worrying about ridding himself of his rifle. He was adamant that good art can only result from one's own experience, for 'only what is loved and known can be seen *sub specie aeternitatis.*'[26]

The foregoing works may be described as narrative. Just as *In Parenthesis* is a narrative poem where the historical events Jones deals with are situated in the temporal space of the action, so are the aforementioned visual works; they are renditions of particular places, events, things. The exception to this is the Frontispiece, with its multiple perspectives and its selective content and distortion. Significantly, it was made in 1937.

By that time Jones's art had advanced considerably. His style became intensely fluid owing to his adept handling of his medium. The fluidity of these pieces is compounded by Jones's desire to include some sort

18. David Jones: Petra in Rosenhag (1931)

of suggestion of the opposite of what it represents.[27] Accordingly, he couched many visual studies in alternative allusions, layering these images with multivalent meanings. In one of his most powerful paintings of his mature period, 1928-31, the quality of mutability, exchange and interchange is supreme. This is his watercolour of his one-time fiancée, Petra Gill who, although they never married, remained uppermost in his affections. By its title, 'Petra im Rosenhag' (fig. 18),[28] Jones imagines that Petra is a latter-day Virgin Mary in a rose arbour, sourcing a popular theme in Renaissance painting. Despite the implied movement in the overall design, Jones's madonna is statuesque and imbued with a sense of the eternal, appearing as a monument to the female sex. Petra is transformed into Mary amidst the wild flowers of her garden, despite the interior setting with its tables and chairs. The countryside advances from the outside and almost assumes control over the interior space. Yet the integrity of the interior and exterior are retained; each has its definitive space. The woman's floral patterned dress signifies that this is Flora, the Classical goddess of Spring, so that she and the Madonna are united in the guise of Petra within this strange otherworld with its 'transfiguring after-clarity',[29] as Jones records in *The Anathemata* (1952). It is a poem of 'commemorative *intention*'[30] concerning 'the blessed things that have taken on what is cursed and the profane things that somehow are redeemed'.[31] The central figure, the Lady of the Pool, is called 'Flora' by one of her lovers, even though her baptismal name is Elen Monica. The time of day is unspecific in the painting, and is equally vague in the text when she recalls an incident following a thunder-storm on a hot July day:

> In this wild eve's thunder-rain, at the batement of it, the night-shades now much more come on: when's the cool, even after-light. When lime-dressed walls, petals on stalks, a kerchief, a shift's hem or such like, and the Eve's white of us … [32]

The aggregate of her name is Elen, whose source, according to René Hague, is 'the cult-figure of the moon, tree-, and light-goddess'[33], whereas Monica, meaning Mother, is seen in Flora whose iconography in the painting is secured by the flowers tumbling about the dress that seem to be woven into its very fabric. Those in the vase on the right are superimposed on her left arm, and a profusion of leaves, stalks and tendrils embrace the figure.

The Christian overtones of the Renaissance theme simultaneously anticipate and also recollect the combination of personal and pre-Christian concepts which resonate in Jones's imaginative world. Instead of holding the infant Christ, Petra has a kerchief on her lap, which may symbolize the linen cloth of the Eucharist. In offering us petals from her lap, Jones establishes a further link with Flora who imitates the goddess's gesture in Botticelli's mythical masterpiece 'Primavera'(c1483). By examining the poetry in tandem with the painting, Petra, Eve, Elen and Flora are assimilated into one pre-Christian icon. The image of her is evoked in *The Anathemata*:

> Aunt Chloris!
>
> > d' sawn-off timbers blossom
> >
> > > this year?
>
> You should know.
>
> > Can mortised stakes bud?
>
> Flora! surely you know??
>
> You who decked die *Blumendame* and our Blodeuedd formed.
>
> > Lovely Flora
>
> how variant you are.
>
> > You can tendril and galloon
>
> chose queens, *im Rosenhage*
>
> had you no hand in
>
> > *this* arbour
> >
> > > too?[34]

The tangle of delicate lines and brushstrokes articulating this configuration echoes its verbal counterpart. The language creates its own patterns through rhythm, alliteration and rhyme. Jones puns twice in order to convey the solemnity of Calvary. The first pun on mortise signifies Christ's death on the Cross. The second, an auditory pun, is on arbour, wherein Jones connotes the Latin, *arbor*, meaning both tree and wood, but the spelling of 'arbour' makes clear that he is actually referring to the bower in which the

Renaissance madonnas are depicted. Hence, Jones creates an intricate and ironic image whereby Spring and the start of the cycle of life are linked to the death of Christ at the same time.

The floriate figure in both the verse and the picture exudes fecundity and abundance. As in much of his work, the season is not identifiable because Jones insists on integration and totality in order to transcend temporality. He achieves this through the rich variety of strokes and lines delineating Petra, who is imbued with a vitality so that she and the mass of organized decoration seem to pulse and sway with the thrust of Spring. In his text, Jones achieves the same atemporal feeling by the layout of the lines and by his references to the alternative names for Flora. Being in different languages, these correspond to their contemporaneous periods. Hence, in both art forms, Jones inclines towards a mystical world of miracles and mutability where Petra, alias Mary, is the sum of her pre-Christian foretypes.

Nativity, growth and nurture are the concerns of motherhood, and Jones creates a visual analogy with the organic motifs in the painting. There are no overt Christian references in the above verse where Flora's variance is emphasised by a catalogue of synonyms: Chloris, Blumendame, Blodeuedd [*sic*] and Rosenhage. This is a composite picture of Mother Earth as described in a later poem as 'Tellus of the myriad names [who] answers to but one name … [Moreover] … you must not call her but by that name/ which accords to the morphology of that place.'[35] In this painting that name is Petra.

Jones's long illustrated poem, *The Anathemata*, is centred on the Mass – it begins and ends with the celebration of the Eucharist. Divided into seven parts, each section contributes to the whole in an accumulation of concepts and images, all of which allude in some way to the core theme. In terms of space and time, the poem traverses all boundaries. Sections relate past events and the evolution of the world. There is no linear structure for the reader to use as an anchor. Jones starts in the present, turns his attention to the distant past, jerks us forward to recent history, introduces his own late family members, returns us to former times and places, among them Arthur's world, then the early Christian era before returning us to the present. This is not to suggest that the poem is a chaotic 'heap of all that … [Jones] … could find.'[36] Underpinning the entire work is a carefully structured pattern which knits together allusions and

correspondences which are not obvious on a first reading. By juxtaposing proper names, presenting comparative examples of characters such as we have observed with Petra, and by quoting, however obliquely, from the Christian liturgy and many other literary sources, Jones creates a confluence of continuity which ultimately conveys his understanding of the interrelationship of the entire universe.

In *The Anathemata* new methods emerge in his writing skills that are commensurate with his visual art. His paintings, where he eschews temporal settings and includes multiple perspectives, and where walls and windows appear to dissolve, express his way of gathering everything together. However, in doing so he apparently combines disparate elements to produce a new synthesis, a transformation. This gathering together is evinced in much of his later work which resonates with an extra dimension. This spatial quality enhances the transience and mobility inherent in the work. There is a dynamism at large, so that the things he depicts are on the verge of melting into other species. He is conscious of the entire surface on which he works. Even a superficial reading of his poetry reveals that the spaces on the page are functional, just as they are in his painting. Every word is deliberately selected and juxtaposed with either other words or spaces, and this results in collections of concentrated imagery and sound which may be measured against distinct pauses and blank areas of varying length. Thus the spatial pattern, so evident in his visual art, is of equal significance to the structure of his poetry, which continually echoes and evokes the language of his painting, and vice versa. Overall, the work is infused with anamnesis, that is a re-calling, or remembrance, of something loved. This is a feature Jones refers to when discussing a recently completed painting:

19. David Jones: Flora in Calix-Light (1950)

> … there is a sense in which I regard this water-colour which I have just completed as belonging *implicitly* to the same world of commemoration and anamnesis, as that to which *The Anathemata* belongs though here the *apparent* subject-matter is no more than some flowers in a glass *calix*.[37]

The painting's title, 'Flora in Calix-Light' (fig. 19),[38] speaks volumes. As a painter, Jones knew how important light is in effecting not simply tonal values and colour harmonies, but in manipulating our perceptions to help us to see his mind's vision. This returns us to the concept of transformation so cardinal to Jones's thinking where he addresses the theme of transubstantiation. Transubstantiation corresponds to the individual's change from one state to another, while also perpetuating the wider notion of shape-shifting and metamorphosis and their mythopoeic associations. These features, where the Mass and myth are united, are inherent in this great floral tribute, with a variety of flowers arranged in three glasses on a table, placed in front of a window. By its title, Jones connotes the mythical goddess Flora who is illuminated by the light of the flower's calix, or cup. The cup is also that of the Eucharist, so that Jones conflates the renewal of life in Flora with Christ. An examination of the motifs supports this idea, where the profusion of floral foliage reveals fronds and tendrils clinging to other stems and stalks, reminiscent of the thickets in the *In Parenthesis* illustrations. Cultivated blooms merge with wild flowers, and brambles and thorns allude to the Passion, thus contributing to the whole elusivity of the composition. Yet the window catches are defined sufficiently clearly for their curled ends to suggest that they too are instruments of the Passion. The table, spread with the white cloth signifies the altar, while a distant tree on the right implies the Crucifixion, as pre-empted by the Last Supper and commemorated in the Mass. But the interior of the Upper Room of the Last Supper, and the external environment of Calvary are linked by the element that sheds light on the painting, the window, of which Jones observed, 'I like the indoors outdoors, contained yet limitless feeling of windows …'[39] This is what admits the light that bathes the whole scene with a fragile translucence, similar to that of the insubstantial materials of the chalices and flowers.

Where Jones intimates the Crucifixion by painting three glasses in 'Flora in Calix-Light', he overtly alludes to the same subject in his painting of three trees placed on a hill. By titling this work 'Vexilla Regis' (fig. 20),[40] he refers to 'Two hymns … *Vexilla Regis Prodeunt,* "Forth come the standards of the King", a

very ancient processional hymn, in which are many allusions to the tree and the Cross, and to the Cross as a tree etc. and the other starting: *Crux fidelis inter omnes …*'[41]

The composition is crowded with motifs all of which, on the face of it, are a mix of figurative, man-made and natural elements. However, their added value resides in their symbolism. The trees are those that Jones drew from his window, but are embellished by his imagination which accounts for their additional accoutrements so that they re-present the three crosses on Calvary. The central tree is also the subject of the Anglo-Saxon poem *The Dream of the Rood*,[42] where the tree and the Cross are interchangeable, the poem being almost a paraphrase of the Latin hymn.[43] The hill in the background is the same Twmp that Jones drew at Capel-y-ffin with Welsh ponies grazing on its slopes. The rose around the trunk of the central tree is appropriated from other literary and visual works, as in 'Petra im Rosenhag' and 'Flora in Calix-Light', where it carries the same attendant symbolism. The season is indefinable, commensurate with Jones's desire:

> … to call to mind the bits of things that seem to me the high spots of what I feel characteristic in the arts of this complex island – it's to me always a **loving 'handled' 'textured'** free-flowing affair with a bit of-thunder-storm-behind-an-apple-tree – linear – tentative – not large – **packed** with life bit of a joke – speckled – like a large thrush's breast & spear points in a garden.[44]

20. David Jones: Vexilla Regis (1947)

In fact, because he draws on images, symbols and motifs which appear in much of his previous visual works, 'Vexilla Regis' expresses Jones's ideal of what a painting should be. They have a life of their own which he expresses depicting images as animated forms floating before our eyes. As we focus on each individual motif it seems to advance from the picture plane, but when we shift our gaze the same thing apparently recedes beneath the surface, so that we are constantly thwarted by the variant perspectives located in the framed space. This suggests that the continuum of time acts both as a simultaneous agent for the transient condition of Jones's image of the world, while also remaining its permanent, controlling influence. The poetry celebrates these temporal factors in that the concepts are ambivalently related to the past as well as the present, and frequently to both:

> … dreaming arbor
>> ornated *regis purpura*
> … the mortised *arbor*
>> dry-striped, *infelix*
> trophy-fronded
>> effluxed *et fulgida*[45]

The blend of present and past participles, of languages, quotations and contexts together with multivalent allusions, cross-referencing as well as typography, confirm that the passage of text, accompanied by an illustration on the same theme, is about both the hymn and the poem, which are the focus of 'Vexilla Regis'. Jones's technique in both disciplines may be compared to montage which combines disparate elements to produce a new synthesis, a metamorphosis.

This is why Jones can equate Arthur with Christ. In the title poem of *The Sleeping Lord and other Fragments* (1974),[46] which concerns Arthur who is the lord and bear, supported by 'the Bear's chapel',[47] he concludes the poem thus:

> does he ward the tanglewood
>> and the denizens of the wood

are the stunted oaks his gnarled guard
<div style="text-align:center">or are their knarred limbs</div>

strong with his sap?
Do the small black horses
<div style="text-align:center">grass on the hunch of his shoulders?</div>

are the hills his couch
<div style="text-align:center">or is he the couchant hills?</div>

Are the slumbering valleys
<div style="text-align:center">him in slumber</div>
<div style="text-align:center">are the still undulations</div>

the still limbs of him sleeping?
Is the configuration of the land
<div style="text-align:center">The furrowed body of the lord</div>

Are the scarred ridges
<div style="text-align:center">his dented greaves</div>

do the trickling gullies
<div style="text-align:center">yet drain his hog-wounds?</div>

Does the land wait the sleeping lord
<div style="text-align:center">or is the wasted land</div>

that very lord who sleeps?[48]

The symbiosis of the landscape and the lord, of the soldier with Christ, of text and texture, are invested with the riches of Jones's ability to metamorphose images in his imagination, and transfer them into other mediums, namely painting and poetry.

Such synergy between both art forms is perhaps best articulated in Jones's painted inscriptions, which are the apotheosis of the union of image and word. In 'Ongyrede' (fig. 9),[49] which faces the page of text that sources the *Vexilla Regis* hymn, Jones quotes lines 39-41 of *The Dream of the Rood*. This

explains why it is Jones's only inscription entirely in Anglo-Saxon, and he introduces some letter forms based on those in Anglo-Saxon manuscripts. Examples are the *P* on line 2, and the *d* below it. Jones does not consciously imitate an historical document, being more concerned with evoking the 'feeling'[50] of the original text and 'the evocative nature of words as expressed in shapes'.[51] He achieves this by the strength and consistency of the letters which he weaves together by lengthening, or reducing, the strokes of many, so that each sits comfortably with its neighbours. The open *e*'s, the lower case *a*'s and *h*'s, the *d* characters and the curved *G* forms supplement the texture of the existing overall pattern. The whole design rests on a satisfying alphabetical base composed of two lines of lettering that are reduced in size for this purpose. Because the inscription was made for *The Anathemata*, the colours are limited to two – red and black. Both evoke the solemn meaning of the text, with red also symbolizing the redemptive blood of the Crucifixion.

The fundamental difference between the paintings and the inscriptions lies not in the content, but in the methodologies used to articulate the subject-matter in these differing art forms. In the latter, the letters form a scaffold; consequently they are strong, dominant forms which contrast with the background, even when Jones heightens our awareness of it by texturing the ground, or latterly, by over-painting in white and then burnishing the surface. Moreover, being composed of relatively slender lines, the structure of the inscriptions is readily apparent, displaying a simplicity which is absent from his later paintings. They, conversely, are often dense and complex, being composed of fragile lines and delicate colours, as in 'Vexilla Regis', the painting of the 'Tree beautiful and shining, made ornate with royal purple'.[52]

This is the text Jones quotes for 'Arbor Decora' (fig. 21),[53] which combines the Roman alphabet with that of Anglo-Saxon, and also Greek letter-forms. Despite the mix of alphabets, Jones avoids confusion by his ingenious arrangement of the distinctive characters of the letters. The main text, reading from left to right, is in the original language of the Latin hymn. The sobriety of these Roman forms contrasts with the ornamental Anglo-Saxon characters of the first part of the 'Ongyrede' quotation framing the Latin text on three sides. The centrally-placed Greek letters along the bottom provide a pleasing terminal to a design which expresses diverse tributes to the tree of the Cross.

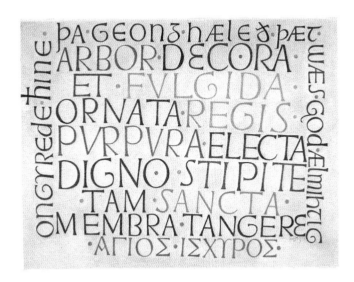

The composition combines the abstract with the representative. The former is obvious in the use of abstract symbols – letters – with which the work is constructed. Because the Anglo-Saxon poem surrounds the older Latin hymn, Jones implies that the latter is at the core of his argument. Beneath, as if to create a foundation for the ancient texts, are the Greek words from the Liturgy for Good Friday. The Roman text appears to grow out of these, and are like the stem or trunk of a tree, while the decorative Anglo-Saxon letters resemble spreading branches and foliage. The colours reflect the key words: 'fvlgida', 'sancta' and 'regis' are yellow, while 'pvrple' is mauve, with the Greek words in reddish brown tones. These are repeated in 'decora' and 'ornata' so that when the eye travels over the inscription it is guided to the top right, then to the left and then to the centre, before being finally drawn to the concluding horizontal base. The yellow punctuation marks separating the words are both functional and decorative.

This exploration of the interrelationship between Jones's art and poetry demonstrates that his visual sensibility is manifested in both art forms – he makes use of the entire surface in terms of both disciplines. When considered together as the art of David Jones, the cumulative power of his visual and verbal works reinforce one another, because Jones synchronizes their inherent differences. Ultimately, as he states in his essay 'Art and Sacrament',

> The work of art is 'a "thing", an object contrived of various materials and so ordered … as to show forth, recall and re-present, strictly within the conditions of a given art and under another mode … It is a *signum* of that reality and makes a kind of anamnesis of that reality.'[54]

21. David Jones: Arbor Decora (1956)

This investigation of Jones's capacity for imaging the imagination shows that far from being fanciful, his imagination was empowered by his fertile and creative, typological mind. In this consideration of the typological nature of his mind-set, it has emerged that Jones appears to consider that the form and content of what he creates in paint can be transcribed in his mind into another art form, namely poetry. In terms of merely reflecting the image in words, or vice versa, the one form could appear to be a superficial imitation of the other that would not advance Jones's notion of the thing signified, in either paint or text. This is not the case. Because Jones works with spatial patterns in his visual art, while the form of his poetry naturally works on a lineal plane, ultimately, he enhances both art forms with the characteristics of the alternative form. Hence, his poetry resonates with spatial qualities which are asssociated with his visual art, and the pictures themslves can be scrutinised and deconstructed, motif by motif, in the same way that we subject texts to close examination. Accordingly, although his initial concepts were determined by the image, his primary art, he succeeded in articulating these in words which in turn provided the source for further visual images. As this hypothesis has demonstrated, Jones's mind operates in both directions: what he delivers in poetic form is translated into paint, so that finally a reciprocity between the image and the word may be simultaneously perceived. In conclusion, it is Jones's notion of the interdependence of, as well as the unity between, image and text that contributes to his status as an exemplar of both image and word.

[1] 'Dancing Bear'(1903), pencil on paper, 50 x 26.5, private collection.

[2] David Jones, *The Anathemata: fragments of an attempted writing* (London, 1952), p. 41.

[3] David Jones, *Dai Greatcoat: a self-portrait of David Jones in his letters* (London, 1980), p. 249.

[4] David Jones, 'Art and Sacrament', *Epoch and Artist* (London, 1959), p. 30.

[5] H.S. Ede, *David Jones: a memorial exhibition* (Cambridge, 1975), unpaginated.

[6] David Jones, *The Dying Gaul and other writings* (London, 1978), p. 23.

[7] 'The Bear'(1921), wood-engraving, 6 x 9, E2, private collection.

[8] 'The Dove'(1927), wood-engraving no.9, 16.5 x 14, E170, for *The Chester Play of the Deluge* (Waltham St. Lawrence, 1927), private collection (AP-O)

[9] David Jones, 'Autobiographical Talk', *Epoch and Artist* (London, 1959), p. 30.

[10] 'River Honddu, Capel-y-ffin'(1926), pencil and watercolour on paper, 38.2 x 55.5, private collection.

[11] David Jones, 'Autobiographical Talk', pp. 29-30.

[12] H.S. Ede, *op.cit.* np.

[13] *Ibid.* np.

[14] *Ibid.* np.

[15] David Jones, 'Autobiographical Talk', pp. 31-2.

[16] David Jones, *In Parenthesis* (London, 1937), p.x.

[17] 'Frontispiece to *In Parenthesis*' (1937), pencil, ink and watercolour, 38.1 x 28, National Museums & Galleries of Wales, Cardiff.

[18] 'The Victim', Tailpiece to *In Parenthesis* (1937), pencil, ink and watercolour, 38.1 x 28, National Museums & Galleries of Wales.

[19] David Jones, *In Parenthesis, op.cit.*, p.vii.

[20] 'Dead rats shot in taking down an old dugout near Ploegsteert' (1916), pencil on paper, 4.75 x 6.75, Imperial War Museum, London.

[21] David Jones, *In Parenthesis*, op.cit., p. 54.

[22] The back inside fly-leaf of *In Parenthesis* reads:

ET VIDI … AGNUM STANTEM TAMQUAM OCCISUM./THE GOAT ON WHICH THE LOT FELL LET HIM GO FOR A SCAPEGOAT INTO THE WILDERNESS./WHAT IS THY BELOVED MORE THAN ANOTHER BELOVED./NON EST EI SPECIES NEQUE DECOR ET VIDIMUS EUM ET NON ERAT ASPECTUS./ERIT AUTEM AGNUS ABSQUE MACULA, MASCULUS ANNICULUS./THIS IS MY BELOVED AND THIS IS MY FRIEND./Apocalypse v, 6. Leviticus xvi, 10. Song of Songs v, 9. Isaias liii, 2. Exodus xii, 5. Song of Songs v, 16.

[23] 'The Curse' (1929), copper-engraving, 17.5 x 13.7, E187, illustration for S.T. Coleridge, *The Rime of the Ancient Mariner* in David Jones, *An Introduction to The Rime of the Ancient Mariner* (London, 1972), private collection (AP-0)

[24] Cf. Belinda Humfrey, 'David Jones and *The Ancient Mariner*: Diversity in Unity' in Belinda Humfrey and Anne Price-Owen (eds), *David Jones: Diversity in Unity* (Cardiff, 2000), p. 117-31 (124).

[25] David Jones, *In Parenthesis*, p. 184.

[26] David Jones, *The Anathemata*, p. 14.

[27] David Jones, *The Dying Gaul*, p. 141.

[28] 'Petra im Rosenhag' (1931), pencil, watercolour and bodycolour on paper, 76.2 x 56, National Museums & Galleries of Wales.

[29] David Jones, *The Anathemata*, p. 131.

[30] David Jones, 'Autobiographical Talk', pp. 31-2.

[31] David Jones, *The Anathemata*, pp. 28-9.

[32] *Ibid.*, pp. 130-1.

[33] René Hague, *A Commentary on The Anathemata of David Jones* (Wellingborough, 1977), pp. 39-40.

[34] *Ibid.*, pp. 190-1.

[35] David Jones, 'The Tutelar of the Place', *The Sleeping Lord and other fragments* (London, 1974), pp. 59-64 (59, 61).

[36] David Jones, *The Anathemata*, p. 9.

[37] David Jones, 'Autobiographical Talk', pp. 31-2.

[38] 'Flora in Calix-Light'(1950), pencil and watercolour on paper, 56.5 x 76.5, Kettle's Yard, Cambridge.

[39] H.S. Ede, 'David Jones', *Horizon*, 8, no.44 (1943), 125-36.

[40] 'Vexilla Regis'(1947), pencil and watercolour on paper, 76 x 55.9, Kettle's Yard, Cambridge.

[41] David Jones in a letter to Mildred Mary Ede, 28, August, 1949, *Kettle's Yard and its Artists* (Cambridge, 1995), p. 35. The letters referring to 'Vexilla Regis' are in the National Library of Wales, NLW MS 23537E.

[42] Cf. Michael Alexander (trans.), *The Dream of the Rood: the Earliest English Poems* (Harmondsworth, 1961): 'Stripped himself then the young man who was God Almighty, strong and courageous climbed he up on the high cross, proud in the sight of many, when he desired to redeem mankind'.

[43] Benedict Whitworth, '*Vexilla Regis*: *the Liturgical Genesis of a Painting*', *The David Jones Journal*, 4, nos.1 & 2 (2003), 20-30.

[44] David Jones in a letter H. S. Ede, 18 January, 1934. I have reproduced the bold emphases which appear in the published version from *Kettle's Yard and its Artists*, p. 34.

[45] David Jones, *The Anathemata*, p. 240.

[46] David Jones, 'The Sleeping Lord', *The Sleeping Lord*, pp. 70-96.

[47] *Ibid.*, p. 81.

[48] *Ibid.*, p. 96.

[49] 'Ongyrede'(1952), watercolour on paper, 49.5 x 30.5, private collection.

[50] Nicolete Gray, *The Painted Inscriptions of David Jones* (London, 1981), p. 107.

[51] *Ibid.*, p. 104.

[52] David Jones, *The Anathemata, op.cit.*, p. 240, n. 1.

[53] 'Arbor Decora'(1956), watercolour on paper, 38 x 51.5, private collection. 'Tree beautiful and shining, adorned with royal purple, elected tree worthy to touch such holy limbs, stripped himself then the young man who was God Almighty, holy strong one.'

[54] David Jones, 'Art and Sacrament', p. 174.

22. Gwen John A Corner of the Artist's Room in Paris (1907-9)

III

Words for painting
The Work of Gwen John

CERIDWEN LLOYD-MORGAN

The artist Gwen John (1876-1939) may not have written for publication, but both her personal archives and her paintings and drawings reveal that the written word was of central importance in her life and in her work as a visual artist.[1] This is the more striking when one considers how limited was her early education.

Like many middle-class girls in the late nineteenth century, Gwen John was taught partly at home, by governesses, partly at genteel private schools which prepared for a conventional female role in life. The curriculum included English, French, sewing and geography. Some of its deficiencies were compensated within the family, however, for Augusta John, Gwen's mother, was a competent amateur watercolourist and encouraged her children to draw, and both she and her husband, Edwin John, were musical and played the piano. Following his wife's early death in 1884, Edwin John became a distant, even withdrawn figure, whose company all four children found oppressive, but there is evidence that when the children were young he would regularly read aloud to them.[2] We may assume that a middle-class, English-speaking home would own a certain number of books which would be supplemented by subscribing to a local library. Certainly there is no shortage of evidence that Gwen and Augustus John, as well as their siblings Winifred and Thornton, read widely and constantly. The father's tastes seem to have run to popular fiction, for in 1901 Augustus John complains of his father's interest in the latest novel by Marie Corelli.[3]

Once Gwen John had left Pembrokeshire for London and enrolled at the Slade School of Art, her reading must have widened considerably. The earliest surviving notebook (NLW MS 22279B), perhaps predating by a little her departure to France in 1903, contains extracts from, and notes on, many standard works on art history, art theory and aesthetics. These include Hogarth's *Analysis of Beauty*, Jonathan Richardson's *Essay on the Theory of Painting*, and Alexander Walker's *Beauty*. That she started using this notebook in the spring of 1902, during her protracted stay in Liverpool after the birth of the first child of Augustus John and his wife Ida, is suggested by the inclusion of stories and other prose and verse in Romany. It was during this period that Augustus had begun to learn Romany through his friendship with John Sampson, librarian at the University and specialist in all gypsy matters. These few transcripts by Gwen of Romany texts are a rare example of Augustus's own interests having a direct influence on her as well as on others close to him.

Once in France, Gwen John continued to read widely. Correspondence between her and her most intimate friends, Ursula Tyrwhitt, her sister-in-law Ida, and Dorelia McNeill, who would become

Augustus John's lifelong companion after the death of Ida in 1907, gives a clear picture of a close circle of friends reading, borrowing books from each other, passing round the latest favourites. It was at this time that major Russian novelists such as Dostoyevsky and Turgenev had become available in French translation (they had not yet been translated into English) and they made a great impression on Gwen. It is no surprise, therefore, to find French translations of two novels by Dostoyevsky, *Le Crime et le Châtiment* and *L'Idiot* amongst the books believed to have belonged to her.[4] Writing to Ursula Tyrwhitt in August 1916, Gwen John refers to reading *L'Idiot*, adding: 'That wonderful book always makes me tremble'.[5] She also owned French translations of works by Turgenev, Gorki and Chekov. French writers of the nineteenth century such as Balzac and Stendhal were read by both Gwen and her sister-in-law, Ida.[6]

Gwen John's new life in Paris, where she worked as an artists' model as well as pursuing her own career as a painter, brought new influences and new directions in her reading. In 1904 she began to model for the sculptor Auguste Rodin, who soon became her mentor and lover. This brought her into contact with new ideas and theories, not least through the discussions that took place regularly in his studio, and in which models and assistants could participate. Amongst her notes from about 1910 are extracts she has copied from a draft of Rodin's *Cathédrales de France*, not published until 1914.[7] The significant textual variants from the published version suggest that Rodin had circulated this work at one of these informal discussions. Gwen John's letters to Ursula Tyrwhitt show that Rodin also set her to translate passages from a variety of works, though whether this was intended to improve her inadequate knowledge of French or to broaden her intellectual horizons is not clear.[8] In addition, Gwen John continued in France the habit of copying extracts from published works she had studied. Living on her own, she evidently made a practice of reading while eating her meals, for in thanking Ursula Tyrwhitt for a print she has sent, probably in 1921, Gwen states: 'I look at it chiefly at my meals instead of reading'.[9] She also set aside time to read in the evening, as she explains in a letter to her patron John Quinn, in March 1922:

> I paint till it is dark, and the days are longer now and lighter and then I have supper and then I read about an hour and think of my painting and then I go to bed. Every day is the same. I like this life very much.[10]

She thought very deeply not only about her paintings but also about what she read and she was keen to discuss with others her response to books she had been reading. It is not surprising, therefore, that the books apparently in her possession at her death should cover a wide range of subjects. She and her friends very often recommended books to each other, whether they bought them for each other or passed the same copy round from one to another. Gwen would buy French books in Paris for her friends in Britain such as Chloe Boughton-Leigh and especially Ursula Tyrwhitt, and they would send English publications in return, often commenting on them in a later letter. Publications relating to the work of individual artists, such as Cézanne, Chagall, Rouault, and Ensor, or to art movements such as the Futurists, are mentioned in the Tyrwhitt correspondence, as well as theoretical and critical works, especially by Gleizes and by Lhote, whose lectures Gwen John attended in the 1930s. She read attentively, noting in a letter to Ursula Tyrwhitt in June 1925, when reading Mauclair's book on Leonardo da Vinci: 'I am charmed by Camille Mauclair's style, and I think he has some intelligence'.[11] Throughout her life she maintained her interest in fiction, her correspondence revealing that she read works in English by D. H. Lawrence, Katherine Mansfield, Thomas Hardy, and the Catholic-convert R. H. Benson, and in French by authors as diverse as Verhaeren and Marcel Pagnol.[12]

Her surviving notebooks from 1910 onwards often include extracts from various authors, mainly philosophical and religious, but sometimes literary. Some of these works may have been suggested by Rodin, but more can be linked with her conversion to Catholicism: she was received into the Catholic Church in 1913. At times the hand of her spiritual advisors may be discerned in the choice of text. Her

23. Head of Gwen John photograph

godmother, who was Mother Superior of the convent at Meudon where Gwen John lived, may well have suggested certain titles. With the local priest, the artist discussed literary criticism (from a Catholic standpoint) as well as spiritual matters.[13] Books on psychology and literary criticism were found among the books in her possession at her death.

Consistent with these facts is the prominence given to books in her paintings. Given that Gwen John's paintings were always very carefully planned before she began to paint – she would sometimes spend hours, even days, adjusting an arrangement of objects or the pose of the sitter before she was satisfied with it – we can take it that the prominence of books in so many of her paintings is deliberate. Books and the act of reading are common in her paintings throughout her career, but their precise significance may vary. The very earliest example is 'Interior with Figures' (Langdale no. 7),[14] painted in the rented rooms in Paris where she stayed during the winter of 1898-9 with her friends Ida Nettleship and Gwen Salmond, who are the two women represented. Gwen Salmond stands reading, her right hand resting on a table where other open books can be seen, whilst Ida looks over her friend's shoulder at the book she holds in her hand. The room is grand but virtually empty of furniture. Books, the painting implies, are essential, but furniture is not a priority. This interpretation is consistent with Alicia Foster's suggestion that the books are included as a sign of culture, and echo work by other painters such as Van Gogh.[15] Two of Gwen John's earliest works after she moved to France, the two related oil portraits of Dorelia McNeill in the lodgings they shared at Toulouse during the winter of 1903-4, give prominence to books. 'The Student' (Langdale no. 11) and 'Dorelia by Lamplight, at Toulouse' (Langdale no. 10), both feature books in the foreground. In the latter, Dorelia sits absorbed in her reading, in the former she stands, apparently lost in thought, half looking down towards the books on the table, another volume held in her left hand. The title *La Russie*, on one of those on the table, is clearly visible in both paintings, perhaps a private message recalling the young friends' shared interest in Russian novels, but also hinting at the bohemian nature of the sitter.

Other sitters, in works executed after Gwen John had settled in Paris, are also often shown with books or in the act of reading. The seated girl who appears in the paintings known as 'The Convalescent' or 'The Precious Book' series, for example, is usually reading, in some instances showing the utmost respect for the

book by holding it in a cloth, so that her hands do not actually touch the binding. This detail Gwen John may have borrowed from earlier traditions, such as Rogier van der Weyden's early fifteenth-century painting of 'The Magdalen Reading', which she had very likely seen at the National Gallery in London. Significantly, surviving paintings of Gwen John by women artists for whom she modelled in Paris, show her in the act of

24. Mary Constance Lloyd 'Nude (Gwen John)'

reading. Ottilie Röderstein depicted her reading from a pamphlet or notebook (Langdale, plate 34) whilst a painting by her friend Constance Lloyd, another former Slade student, shows her posing nude, seated on a couch, her upper body turned rather awkwardly to allow her to read the book placed on the coverlet (see fig. 24) . Whether the decision to depict her reading was hers or that of the artists who painted these works cannot be proven, but reading was apparently an activity favoured by others within the community of foreign women artists in Paris. That Constance Lloyd and Gwen John had shared tastes in reading is suggested by their correspondence and Constance certainly lent books to Gwen, including English literary texts.[16]

Gwen John's later paintings continue this theme. 'A Corner of the Artist's Room in Paris (with open Window)' (1907-9, Langdale no. 17, fig. 22) again uses the open book on a simple table as one of the few signs of human occupation of the room. Only the book and the coat left on the chair tell us that the inhabitant is not far away. The open book becomes a symbol of the absent occupant possessing the space, but even when she is present, the act of reading can be seen as part of the close relationship between the subject – the artist – and the limited space she inhabits. In the two closely-related paintings, 'A Lady Reading' and 'Girl reading at the window' (1910-11, Langdale nos 24-5), the woman stands, in the same room as before, by the window, engrossed in the book held in her left hand; behind her other books lie on the table and others stand on shelves on the wall beyond the window. These themes continue in the late 1910s and the 1920s. The series of paintings of a young girl seated, which includes 'The Convalescent' and 'The Precious Book' (Langdale nos 111-20), depict the subject in the act of reading, often with a book lying on the table beside her, whilst the interiors and still-lives, such as the 'brown teapot' series again gives prominence to a book, this time in the very foreground, as well as to a newspaper on the table (Langdale no. 124, see fig. 25).[17] Again the room reflects the personality and habits of its occupant. Gwen John is known to have prepared every detail of her compositions with extreme care, so there can be no doubt that the selection and arrangement of objects in these interiors is deliberate. The presence of books is not, therefore, a matter of chance.

If books and reading were essential parts of her life, to the extent that they are so often represented in her work throughout her career, writing too was extremely important to her, whether in the form of notes and jottings or letters. The letters she wrote can be divided into two main categories: first, those which she

seems to have written with very little reflection and second, those which she worked at repeatedly. In the first category are those to her lifelong friend Ursula Tyrwhitt. Here the tone is usually direct and conversational, the words rush onto the page as thoughts come into her head. There are repetitions and apparent non-sequiturs, sudden leaps from one subject to another. As in a spoken conversation she switches abruptly, from describing the weather to discussing her working methods, her techniques and aspirations as an artist, then on to gossip about mutual friends or vignettes of her everyday life:

[...] I wish the winter was over, it has already seemed so long. I was so interested to hear of Alyne Bayley's marriage and 'Parmi' [Mabel Parmenter]. You do not say *what* you are painting now. When you come to Paris you must have a nice room and feel more settled. [...]

I dreamt of primroses last night. I am thirsty for the country and Spring. I have been working rather hard but there is nothing to show for it, and it only lasted a short time, but I shall begin again tomorrow. I painted in Miss Leigh's flat when she was in London but she came back and let her flat and I had not finished one picture I began [and which] she said I should have begun and finished.

I am doing some drawings in my glass, myself and the room, and I put white in the colour so it is like painting in oil and quicker. I have begun five. I first draw in the thing then trace it on to a clean piece of paper by holding it against the window. Then decide absolutely on the tones, then try and make them in colour and put them on flat. Then the thing is finished [...].[18]

At the other extreme, when writing to people with whom she felt less relaxed, such as gallery owners, she might produce several drafts before making a fair copy of her letter. If she had to write in French, a language which she never fully mastered, multiple drafts could be produced, suggesting that she took

25. Gwen John 'The Little Interior' (1926)

great care in wording, and that it took several attempts before she was satisfied with the tone and also the grammar and spelling. Thus in addition to the vast series of letters from Gwen John to Rodin now in the Musée Rodin in Paris, drafts survive of some fifty-seven letters, written between about 1908 and 1916, occupying over ninety sheets of paper (NLW MS 22303C, ff. 75-167). Similarly, over 180 drafts survive of letters to Véra Oumançoff, the neighbour with whom Gwen became embroiled from about 1927 to 1932 (NLW MSS 22301-2B). In such draft letters preceding a final or fair copy, Gwen John's handwriting is often very careful, even childish-looking in its attention to the forming of every loop and the layout of the text on the page, suggesting that she was concerned with the visual impact of her letter. Elsewhere she uses a fairly free, relaxed hand, for example in most of her letters to Augustus John and Dorelia McNeill. In writing to Ursula Tyrwhitt she frequently uses a very uninhibited, tearaway hand, not always easy to read, especially when the tone is particularly conversational.

The hardest letters to interpret are the draft letters found in Gwen John's notebooks. These are often very scribbly, and those written in her execrable French, to Auguste Rodin, or to Véra Oumançoff, also pose linguistic problems. The poor quality of writing materials adds to the difficulty of deciphering and understanding them. I believe, however, that most of these drafts were never intended to be read by the person to whom they are nominally addressed but were intended for Gwen John's own eyes only. It seems most unlikely that these apparent draft letters were ever intended as the basis of genuine letters to be despatched and they should probably be redefined as an epistolary *journal intime*, an interpretation which is confirmed by the fact that some of the rather similar ones addressed to Rilke or Rodin postdate their deaths. It seems likely that Gwen John used this form of writing as a kind of catharsis, perhaps because she did not always feel able to confide in people directly. In composing such texts she may have been influenced by two eighteenth-century epistolary novels, Jean-Jacques Rousseau's *La Nouvelle Héloïse* and Samuel Richardson's *Pamela*, both of which had left a deep impression on her.[19]

Although such drafts are often full of very raw emotion, they nevertheless contain material which helps our understanding of her attitude to her work. For example, Gwen John had converted to Catholicism in the early 1910s, and had taken up the habit of sketching her fellow-worshippers during services, using tiny

sketchpads or notebooks which she could use discreetly.[20] This habit outraged her neighbour Véra Oumançoff, who ordered her to stop it and concentrate on prayer and worship. But Gwen refused. She could not stop herself, but she was also unrepentant:

> When I told you that I'm going to continue to draw at Vespers, evening services and retreats, I wanted to vex you. I regret having told you that, because I'm going to carry on, I think, and now that you have written: the Church is a place of prayer, I shall be unhappy.
>
> Like everyone else I like to pray in church, but my spirit is not able to pray for a long time at a stretch.
> Now those moments where it looks at exterior things have become so long that not much time is left for prayer.
> The orphans with those black hats with white ribbons and their black dresses with little white collars charm me, and the others charm me in church.
> If I cut off all that there would not be enough happiness in my life.[21]

Such ripostes and self-justifications throw important light on the interplay of Gwen John's art and her faith. Considering that Véra was a complete Philistine as far as art was concerned, it is ironic that Gwen John not only presented her with so many watercolours but also discussed her work in some detail in her draft letters to her. Moreover, in one important series of documents, sketches are sometimes accompanied by scribbled fragments addressed to Véra. Most extant examples belong to the important series of tiny drawings which Gwen John made from about 1928 to 1933 on writing paper from the Grands Magasins du Louvre, a department store in Paris where there was a reading room and tea room where customers could ask for paper and pen and ink in order to write letters. These small sheets, measuring no more than about 210 x 135 mm, she divided up into smaller rectangles which she then used for sketches, sometimes of several subjects, sometimes repeating the same one. This practice may well hark back to her days at the Slade, where students were encouraged to make small compositional sketches, for there are clear affinities between these sketches by Gwen and those produced at the Slade by Edna Clarke Hall.[22] Nevertheless, the repetition of the same composition, with few or no variants, so as to create a patterning over the paper, is a new departure and reflects Gwen John's increasing concern with form as opposed to the conscientious representation of the subject of the

picture such as a sitter or an interior. This concern is documented both in her notebooks and in her letters to Ursula Tyrwhitt, notably in a letter probably written in August 1936, where she discusses the ideas of André Lhote and how they may be put into practice:

> For instance, I said 'a cat or a man, it's the same thing' you looked rather surprised. I meant it's an *affaire* of *volumes*. That's saying the same thing as l'Hote said when he said the object is of no importance.[23]

The combination of image and word found in the sketches from the Grands Magasins series was not unique to Gwen John. It was also a practice common to many artists of the Slade circle, including William Orpen and Albert Rutherston and of course Augustus John.[24] In his letters to friends and lovers, especially in the years preceding the First World War, Augustus John regularly included sketches, ranging from the rapid and scrappy to the carefully finished.

Judging by her surviving papers, Gwen did not normally add sketches to her *letters*, but in her notebooks and in what were originally unbound notes on single sheets of paper, a similar juxtaposition is not uncommon. She might combine notes on colours with rough sketches, for example (see fig. 26) whilst elsewhere (see fig. 27) she combines notes of personal meditations with a sketch of a priest seated on a park bench. Such jottings are characteristic of the period of her conversion but can also be found after she had been received into the Catholic church. Although

Jan.-Feb. 1919
You must leave everybody and be alone with God.

Sainte Thérèse in the church at Pléneuf.
I must be a saint too. I must be a saint in my work.

April-May 1921
leaves, arbuste
drooping mouth. ¾ Subject. pink rose on school-room table. Mademoiselle Daix à confession.
drawing, filling in.

May 1921
Work through suffering has another quality, not necessarily inferior to work through tranquillity.

May 1921
Read with reflexion and prayer

March 1932
The Book closed.
The New Life.
God has taken me.
'To enter into Art as one enters into Religion'.[25]

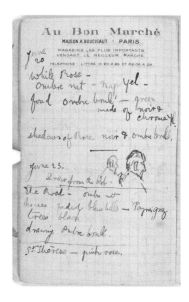

these notes often concern her life in general terms, she cannot exclude her work, and references linking her faith and her art abound (see p.73 above).

Many of Gwen John's personal notes can be difficult to interpret with confidence, precisely because they were for her own use, perhaps as an aid to clarifying her thoughts, and were thus often reduced to a kind of verbal shorthand. When writing to others, however, Gwen John often seems keen to express herself as clearly as possible, showing sensitivity to the possibilities of communication through language as opposed to visual expression. As early as 1902, in a letter to a close friend from the Slade, Michel Salaman, she deliberately contrasts the spoken and the written word. Expressing herself satisfactorily through talking was evidently difficult for her, or at least she perceived it as such, and writing gave her the uninterrupted opportunity to find the right words:

> To me the writing of a letter is a very important event! I try to say what I mean exactly, it is the only chance I have – for in talking shyness and timidity distort the very meaning of my words in people's ears.[26]

Once she had settled in France and many of her regular correspondents, including Rodin, Véra Oumançoff and the German poet Rilke, had to be addressed in French, a language of which her command remained shaky to the last, she became still more acutely aware of the difficulties of verbal communication, of the need to find the *mot juste* and the right linguistic register. In April 1922 she jotted down in one of her notebooks the following lines:

26. Gwen John leaf from notebook, *NLW MS 22278A, f.7ᵛ*
27. Gwen John notes with sketch, *NLW MS 22293C, f.166*

Flaubert's formulated theory of writing: think clearly, express precisely and read aloud to test the rhythm.[27]

A letter sent to Ursula Tyrwhitt in July 1927 again picks up the same theme:

No doubt all these words are not chosen well. It is difficult to express oneself in words for painters, isn't it?[28]

Writing again to Ursula only a week later, she returns to the same topic, this time juxtaposing it with the question of expression through their visual work:

I don't quite understand what you mean in your first letter and should like you to write it again more clearly. Perhaps art is the means we use to express something. Is that what you meant at all?[29]

Difficult it may have been at times, but her correspondence and notes reveal a constant urge to analyse thoughts, feelings and ideas in words as well as through drawing and painting. If words did not come easily, she was prepared to work at verbal expression, trying out different approaches and turns of phrase. Yet sometimes, as in her letters to Ursula Tyrwhitt, the words could drop from her pen in a smooth, uninhibited flow. At times, moreover, she achieves a strongly visual effect from a single sentence or a short paragraph, as in this following extract from a letter written about 1906-7 to Charlie McEvoy, another friend from Slade days:

[...] I have not been posing today, so I washed the floor and everything is brilliant in my room, do come and see my room soon – the floor is of red bricks, and there are tiles in the fireplace and two little grates and all the furniture is brand new, light yellow. [...] I've got an *armoire à glace* which is a wardrobe with shelves and a *glace* front, and white lace curtains at the window – yes I am *Parisienne* and I feel more at home with the French than the English now, I think, at least the English over here.[30]

This letter provides a clear verbal counterpoint to so many of the paintings of the artist's room in Paris, such as 'La Chambre sur la cour' (Langdale, no. 15)

Similarly her technical notes, where she analyses the steps in the production of a painting, from first impressions of the subject, and colour notes, to rules for the execution of the work, provide an extraordinary

insight into her technique and work practice. The examples given here from one of her notebooks (NLW MS 22278A) are typical.

Although such personal jottings can be difficult of interpretation, recent research by Mary Bustin has shown that, when used in conjunction with close observation and analysis of the paintings themselves, they can enable us to understand better both her technique and the meaning of the notes themselves.[31] The visual and written records thus complement and enrich each other. In order to understand fully Gwen John and her work as a visual artist, therefore, observation of the visual work alone is not enough, and the artist's written *Nachlass* should not be neglected. The case of Gwen John is rather different from that of other twentieth-century Welsh artists – she did not write for publication, did not make use of words or letter forms in her painting, and did not, as far as we know, paint in direct response to the work of a specific writer. Nonetheless, both reading and writing were essential to her and to the development of her work and she was undoubtedly highly conscious of the importance of verbal as well as visual communication of thought, feelings and ideas.

22 Oct. 1932
White rose:
1. Communicant
2. bouquet in spotted jug

Communicant:-
The green is made with chrome
yellow and black.
The white dress is umber nature
The ground is green and burnt umber.

The carnations of this scheme is in lakes
or a blue vermillion.

Jan. 1935
Method.
1. The colour of the light.
2. The strange form
3. Blobbing twice.
4. The tones
5. The colours
6. Blobbing three times.
Execution from the blobbing.

1. finding of tones.
2. finding of personal forms
3. drawing of personal forms in pencil
for eye training.
4. background painting (one side)
5. (1. hat or hair, personal form – face,
personal form blocked from hair – then drawn
 (2. body personal form, hands personal
form blocked from body, then drawn.
6. rest of body blocked in and rest of
background blocked in.

[1] In this chapter I have relied heavily on the Gwen John papers at the National Library of Wales, on which see *Catalogue of Gwen John Papers* (available on-line on the Library's website at www.llgc.org.uk), Ceridwen Lloyd-Morgan, *Gwen John Papers at the National Library of Wales* (2nd ed., 1995) and *Gwen John: Letters and Notebooks*, ed. Ceridwen Lloyd-Morgan (London, 2004).

[2] See for example, Cecily Langdale, *Gwen John* (New Haven and London, 1987), pp. 4-5.

[3] 'If attention is paid and indeed without any such encouragement he is ready to narrate the plot of M. Correlli's [*sic*] latest scripture or some work of like obscurity', letter to Charles Conder, NLW MS 23410C, ff. 14ᵛ-15.

[4] In November 1990 the National Library of Wales acquired about a hundred books presumed to have been in the possession of Gwen John. See Ceridwen Lloyd-Morgan, 'The Artist as Reader: Gwen John and her books', in *Ysgrifau a Cherddi cyflwynedig i/Essays and Poems presented to Daniel Huws*, ed. Tegwyn Jones and E. B. Fryde (Aberystwyth, 1994), pp. 385-93.

[5] *Gwen John: Letters and Notebooks*, p. 96.

[6] 'The Artist as Reader: Gwen John and her books', pp. 388-9.

[7] NLW MS 22294B.

[8] NLW MS 21468D, ff. 15-16V, written about 1904 or 1905; for text see *Gwen John: Letters and Notebooks*, pp. 37-8.

[9] NLW MS 21468D, ff. 129-30, see *Gwen John: Letters and Notebooks*, p. 122.

[10] *Gwen John: Letters and Notebooks*, p. 126.

[11] *Ibid.*, p. 141.

[12] These authors are all mentioned in the series of letters, [?1907]-1938, to Gwen John from Chloe Boughton-Leigh now NLW MS 22304C, ff. 54-177, and which are calendared in the unpublished NLW catalogue of Gwen John Papers, available on-line at www.llgc.org.uk.

[13] For example, in 1930, André Gide, *Les Nourritures Terrestres*, NLW MS 22303C, f. 52.

[14] Paintings and drawings by Gwen John will be identified by their numbers in Langdale's *catalogue raisonné*, for which see note 2.

[15] 'Gwen John in Paris', lecture given at Tate Britain, 19 November 2004; cf. Alicia Foster, *Gwen John* (London, 1999), p. 22.

[16] *Gwen John: Letters and Notebooks*, p. 112.

[17] One set of interiors (Langdale nos 49-52) was painted about 1915-16, two others, including that illustrated here, are dated by Langdale to the early to mid 1920s. The last two were painted at the artist's rooms at 29 rue Terre-Neuve, Meudon, the earlier ones may also have been made there.

[18] *Gwen John: Letters and Notebooks*, p. 49, letter to Ursula Tyrwhitt, 1909.

[19] Some of her draft letters are even addressed to 'Julie', recalling Rousseau's heroine. See also Alicia Foster, *Gwen John*, pp. 40-1.

[20] Surviving examples include NLW MSS 22298-9A, measuring 120 x 990 mm.

[21] My translation from the French. This letter was probably written in 1927. See *Gwen John: Letters and Notebooks*, p. 154.

[22] I wish to thank Emma Chambers, curator of the Strang Print Room and the Slade collections at University College London, for information and a very useful discussion on this point.

[23] *Gwen John: Letters and Notebooks*, p. 184.

[24] Examples are reproduced in Emma Chambers, *Student Stars at the Slade 1894-1899. Augustus John and William Orpen* (London, 2004), pp. 47-9, Daniel Huws, 'Some letters of Augustus John to Ursula Tyrwhitt', *National Library of Wales Journal*, 15 (1967-8), 15 and plates 7-8, and Ceridwen Lloyd-Morgan, *Augustus John Papers at the National Library of Wales* (Aberystwyth, 1996), plates I, III-X.

[25] *Gwen John: Letters and Notebooks*, pp.108-9, 117-18, 177.

[26] *Gwen John: Letters and Notebooks*, p. 22.

[27] NLW MS 22276A, f. 21.

[28] *Gwen John: Letters and Notebooks*, p. 151.

[29] *Ibid.*, p. 152.

[30] *Ibid.*, p. 40.

[31] Mary Bustin, 'The Rules or problems of paintings; Gwen John's later painting techniques', in David Fraser Jenkins (ed.), *Gwen John and Augustus John*, catalogue of the exhibition held at Tate Britain, 29 September 2004 –9 January 2004 (London, 2004), pp. 196-202.

28. Ceri Richards: Cycle of Nature (1944)

IV

Unifying Harmonies of Line: The Lyricism of Ceri Richards

PETER WAKELIN Ceri Richards and the Word

Ceri Richards never stopped investigating and exploring as an artist.[1] From the 1920s to his death in 1971 he was constantly searching for new means of expression and creation.

Throughout this artistic odyssey he returned repeatedly to the inspiration of sources that were in one sense or another 'lyrical': poems, stories, myths, traditions and ideas, that like songs possessed a concentrated and resonant expression of feeling. With these as catalysts he made paintings, drawings, prints and constructions that were themselves unifying expressions of experiences and feelings. His art was, in the words of Alan Bowness, 'an exploration of the poetic imagination – a private search for the origin and meaning of poetry, in the widest sense'.[2] Hardly any artist can have been more powerfully concerned with the creative interaction of image and word.

Lyric sources were so important to Ceri Richards that few segments of his output can be identified as not engaged with them. Even the great series 'La Cathédrale Engloutie' ('the submerged cathedral'), ostensibly inspired by Debussy's piano prelude of the same title, can be argued to have been informed by narrative from folk traditions. His series without literary themes were relatively short-lived: the Surrealist constructions, the beekeeper pictures, the costers, the nudes, the Trafalgar Square paintings. The most enduring was the series of interiors that Richards pursued in the 1940s and 1950s; but this was itself rich in cross-fertilizations from music.

Lyric sources ran as a strand throughout Richards's career. In 1928 he illustrated *The Magic Horse* from 'The Arabian Nights'.[3] From 1943 he began a series of masterpieces on the cycle of nature prompted by Dylan Thomas's poem 'The force that through the green fuse drives the flower', and initiated a life-long engagement with themes from Thomas's poetry. A sequence prompted by Rubens's painting 'The Rape of the Sabines' in the late 1940s was underpinned by the legend set down by Plutarch.[4] In the early 1950s, he re-visited the poetry of Dylan Thomas in 'Black Apple of Gower (Afal Du Brogwyr)' (1952) and drawings made in four copies of Thomas's *Collected Poems*. After Thomas died, Richards made a number of works in homage, drawing on his poetry and on folk tradition.

Richards designed sets and costumes for Lennox Berkeley's opera *Ruth* in 1956, then in 1958 the costumes for Benjamin Britten's *Noye's Fludde*, as well as collages to accompany Britten and Imogen Holst's book, *The Story of Music*, and religious commissions drawing on the Bible. The 1960s saw

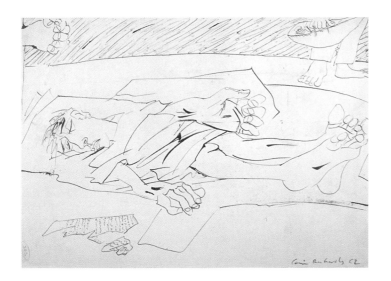

work on 'La Cathédrale Engloutie', themes from Dylan Thomas explored again in paintings and lithographs, and works prompted by the poetry of Vernon Watkins. Finally, in the last year of his life, Richards made lithographs for poems by Roberto Sanesi and illustrations to Thomas's *Under Milk Wood*.[5]

His concerns with Dylan Thomas and 'La Cathédrale Engloutie' were his most enduring and most complex. The resulting images appeared to be far from their source material and were often difficult for uninitiated audiences, but they established his originality and power as one of the leading British artists of the twentieth century.[6]

From Word to Image: motives and principles

Richards absorbed lyric sources deeply and cross-fertilised them with his own experience according to motives and principles developed throughout his life.

The Object in Art

Battle lines were drawn in the mid twentieth century between artists who saw the relevance of source-objects (whether physical or literary), and those who dispensed with them in favour of the purely abstract. For Richards, a lyric source was an objective concern, which could be enriched by further imagery from the world. He said, 'A subject is a necessity, for it presents a renewal of problems and discipline.'[7] Other prominent British artists such as Ben Nicholson and Victor Pasmore espoused pure abstraction at different times, and after the 1950s the influence of American Abstract Expressionism, for which Richards had little sympathy,[8] led objective interests to be considered irrelevant or even reactionary by many artists.

29. Ceri Richards: The Deposition (1962)

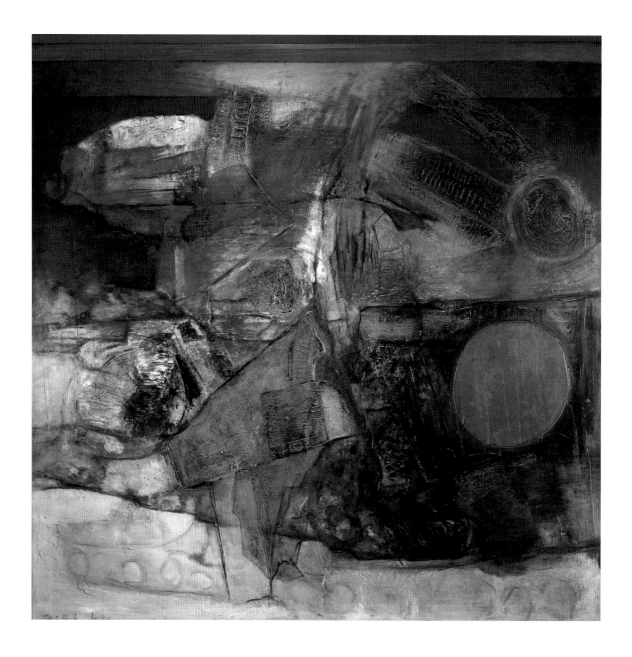

30. Ceri Richards: La Cathédrale Engloutie (1960)

Reform of the artists' group the 7 & 5 Society in 1934 to exclude its representational members produced a backlash in Myfanwy Evans's book *The Painter's Object* in 1937. This included, among other pieces, John Piper's essay, 'Lost, a valuable object', and an interview in which Picasso remarked, 'Abstract art is only about painting. What about drama?'[9] The rise of fascism and the tumble towards war re-focused some artists on political and objective content. Richards painted posters for Spain in 1939, and the Second World War was part of the emotional essence of his pivotal Cycle of Nature series. The horrors of war had been brought early to avant garde artists through Picasso's 'Guernica', a painting that affirmed the urgency of art addressing objective content. The bombing of Guernica took place on 28 April 1937 and the painting was finished on 4 June. Before the end of the year, it was exhibited in London and Myfanwy Evans reproduced it in *The Painter's Object*, writing passionately of Picasso's right 'to exploit the incredible ruin and inconsequence and purposelessness of the world to-day by actually breaking things down and making a new order out of the bits…'.[10]

The Paradigm of Unity

The synthesis of ideas into a single creative expression was a paradigm of progressive artistic thinking for many in Richards's generation, making it natural that literary or musical expressions could be linked to visual ones; and this was a driving force of Richards's art. Whilst the unity in the arts belonged to a long historical tradition, in painting it had been broken in the late nineteenth century by the growing achievement of naturalism, as exemplified by Impressionism and its concern with light and form above subject matter. However, in the early twentieth century many writers and artists sought to balance the art forms. *In Five Arts* (London, 1946), F.E. Halliday discussed poetry, music, painting, and even architecture and the applied arts in terms of interchangeable values. Vernon Watkins wrote, 'There is a bond between all the arts, and his response to music and to poetry is an integral part of Ceri Richards's painting.'[11] Moelwyn Merchant noted 'the rich complexity with which one art may comment on another, their symbiotic relationship as creative as any in the natural world.'[12] Richards himself said in 1964,

> There is certainly a deep link between music and painting – the proportions of time – the geometry of rhythms and the division of spaces. This is true also about architecture and poetry. The sensuous entity that a piece of music or painting becomes ensues from the special adjustments of these elements.[13]

Richards had grown up surrounded by all art forms in the working-class community of Dunvant, near Swansea. Classical music, song, poetry and theatre were ever-present at home and chapel. Learning to paint theatre backdrops, as he did, must have posed questions in his young mind about how visual images and spoken texts would go together. His linking of visual art with a wider creative world was apparent in Richards's choice of design rather than painting when he went to the Royal College of Art, and later in his teaching of illustration at Cardiff during the War.

While a student, Richards read Wassily Kandinsky's *Über das Geistige in der Kunst* (Concerning the Spiritual in Art), written in 1911 and translated into English in 1914.[14] Kandinsky's apprehension of colour was deeply concerned with synaesthesia: the idea that experience through one of the senses can evoke equivalent sensations in the others. He talked of colours having connotations of taste, texture, temperature, scent, and 'a power which directly influences the soul'.[15] Richards told his friend John Ormond that a passage relating colours to a keyboard to be played had a particular influence on him.[16]

As Bryan Robertson said, Richards was 'well read in art theory, which he never followed because of the determining pressure of his own purely intuitive approach to art',[17] and Kandinsky himself said that theory comes after practice not before it: 'Everything is, at first, a matter of feeling'.[18] However, Richards absorbed Kandinsky's ideas at an early age, and they confirmed and developed his own intuitions. There are striking synergies between Kandinsky's interpretations of particular colours that were used by Richards in responding to poems by Thomas and Watkins, and the poems' themes.

Principles of Association

Richards was allied to the Surrealist movement soon after its first appearance in British visual art in the 1930s. Its principles of freely associating ideas and images, often utilising dream and myth, strongly influenced the way in which he worked with lyric sources. He was taught by Paul Nash at the Royal College in 1925, and it would have been natural to follow the development in Nash's career a few years later, when he was one of the pioneers of Surrealism in Britain. In 1936 Richards saw the exhibition of the British Surrealist Group, which included works by Ernst, Dalí, Picasso and Miró. He adopted Ernst's

serendipitous mark-making techniques, for example frottage and the trailing of paint-laden string, to suggest new forms and associations.

Another influence on Richards's approach to associating ideas and images was David Jones, for whom symbol, myth and the word were vital ingredients of visual imagination. Richards thought continuously in mythic terms, but wished to allow viewers to divine their own associations. Moelwyn Merchant quoted a letter from him, '... a true work of art is a crucible which can contain the past, present and future, and we see its contents according to our sensibilities.'[19] The strongest associations were with nature, especially motifs from the sea, cliffs, hedgerows and woods of Gower. As for Paul Nash, Graham Sutherland, John Piper, John Craxton and other Neo-Romantic painters, nature and environment provided metaphors with which to explore literary ideas, in a Modernist development of the Romantic tradition. Richards commented,

> I have to refer directly to nature before I can start my painting. Once I have transferred to the canvas an expression of this stimulus, the painting grows on its own as an entity. [20]

The use of words within images, in the tradition of collage invented by Picasso in 1912, was another principle of association. The very process of writing fascinated Richards, as is indicated by one of his drawings in the *Collected Poems* of Dylan Thomas: flowers manifesting from the paper as the hand and pen travel across its surface (fig. 32). He began drawing in books at an early age, filling the spaces around poems on the page. (Sir Colin Anderson, for one, owned some eight books that Richards had decorated.)[21] Sometimes he would transcribe phrases into his drawings and paintings, or write out whole poems as part of the image, as in his lithographs of 'The force that through the green fuse' for *Poetry London*.[22] In other cases he would make signs for words – squiggles indicating text in manuscripts from the poet's desk, filling the air, or decorating a winding-sheet.

The Idea of Welshness

English critics were absorbed by an idea of ancient heritage, derived from nineteenth-century Romantic attitudes to Wales, and perceived in Richards a quality they referred to as Welsh or, more archaically, as

'Celtic'. Alan Bowness meditated: 'Welsh painters and sculptors are rare and singular: men with a bardic vision who stand apart',[23] and David Thompson referred to, 'That side of the Welsh temperament – with everything that is emotional, sensual and volatile about it, given to eloquence and bravura…'.[24] Richards himself felt that elements of his temperament and style derived from his heritage, and he developed rather than suppressed them.[25] He said, 'I'm a Welshman, a Celt, and what I find lacking in so many artists whose work I nevertheless love, is the Romantic spirit.'[26] Welsh poetry, Welsh traditions and the environment of Wales fed into Richards's work with extraordinary force.

One of the qualities carried by Richards into his responses to lyric sources, that can be related to a Welsh cultural tradition, was an earthy mysticism less associated with Englishness or the Metropolitan art world. Magic in nature is common in the mythological literature and the oral tradition of Wales, and generations have grown up hearing about transformations, magic animals, signs and wonders as parts of a readily-absorbed folk culture. How much more must this have been the case in a Welsh-speaking village in the early 1900s, where rural traditions still abounded.

Richards grew up speaking Welsh although it was discouraged at school, and his father wrote poetry in both Welsh and English. In later life, with an English wife and children who had been brought up in London, Richards felt he had lost his fluency. Even so, he continued to receive letters in Welsh and occasionally to speak the language.[27] All of this linguistic background deepened Richards's appreciation of language and poetry and enabled him to tap Welsh subjects.

The Lyric Sources and their Impact

The contrast between the literary works that Richards illustrated, such as *The Magic Horse* or *Under Milk Wood*, and the lyric sources that fed into the stream of his work as an artist make clear the intensity with which he responded to the sources that meant most to him. Richards always remained capable of a craftsmanlike illustration for a literary subject, for example *The Magic Horse*, where his graphic style recalled the work of David Jones, who had helped gain him the commission. Nearly all of the lyric sources which drew Richards into expanding series of paintings and prints could be said to have been 'difficult' in

the same way that his paintings were. They were often mystical and characterised by multivalent imagery and diverse reference. He was drawn above all to the metaphysical poems of Dylan Thomas and to sources in Classical myth, folklore and the Bible that were rich in ambiguity and emotion. Mel Gooding has noted that Richards marked out in one of his books a passage by Susanne Langer about the function of any good work of art: 'It formulates the appearance of feeling, of subjective experience, the character of so-called "inner life", which discourse – the normal use of words – is peculiarly unable to articulate…'.[28]

John Berger suggested that Richards sought a language of references with which to speak since there was no collective mythology or symbolism on which he could draw.[29] In the mid-twentieth century, Classical mythology still did provide a universal language for Western culture, yet Richards was compelled to reach into his personal and emotional responses to express feeling and spirituality.

Dylan Thomas

In Dylan Thomas, Ceri Richards found the poet whose works were most profoundly suited to his own vision. So deep was the artistic relationship that one cannot properly understand Richards's post-War work without referring to his sources in Thomas's poems, as Richard Burns has explored in his book, *Ceri Richards and Dylan Thomas: Keys to Transformation* (1981).

The abiding theme that fascinated both of them was the mystery of the life cycle: the genesis of all living things and their eventual death and decay. Richards had found a like mind to suggest a system of expression, symbol and metaphor. He and Thomas had both grown up on the fringes of Gower, and the poet's imagery of countryside, wildlife and the sea must have chimed immediately with the painter's own experience of nature. The distinctive, rhetorical voice of the Welsh chapel preacher that one can sense in Thomas's strong rhythms, alliterations, repetitions and religious imagery would also have been familiar to Richards. Stylistically, parallels can be drawn between the liberation of language that Thomas pioneered and his own instincts for the liberation of imagery through association and equivalence. The rhythm and musicality of Thomas's poems was matched by the same qualities in Richards's painting, especially his miraculously fluid line.

The decisive connection was made when Richards began his paintings concerned with the cycle of life, for the first time making allusive works which drew from poetry and music. Although Burns considered that Richards's first paintings on the cycle of nature were independent of Thomas's poem 'The force that through the green fuse', and that the two came together only in 1945 with Richards's illustrations for *Poetry London*, Mel Gooding has gleaned convincing evidence that the poem was the catalyst for the whole sequence of work, begun in 1943. Some of the paintings bore titles from the poem, such as 'The force that drives the water through the rocks' (1943)[30] and 'The force that through the green fuse: The Source' (1945). The masterpiece of the series was 'Cycle of Nature' (1944), oil on canvas, National Museum and Gallery, Cardiff (fig. 28). Its composition recalls Titian's 'Bacchus and Ariadne', National Gallery, London, itself concerned with the cyclic myth of the marriage of the god to Ariadne after her mortal death.

In each of these paintings, motifs of natural fertility form a circle against a cosmic infinity suggested by sky, clouds, rocks and water. Barely a single specific image from the poem is repeated, and yet the paintings are crammed with association growing from the painter's interpretation of its form and underlying meaning. Genesis is expressed in roots and tendrils, seeds and leaves, fruit and flowers, testicles, vaginas and wombs. Disembodied figures seem to be evolving and decaying within the elemental circle. These are archetypally Neo-Romantic references to nature, brought together in perhaps the masterpiece of British Surrealism.

One can see in these paintings Richards's need to respond to the subjects of life and death that were constantly in mind during the war. The key emblem is a vortex of energy which mirrors 'the force' in Thomas's vision. Kandinsky's interpretation of white could serve as a text for the key painting:

> … a symbol of a world from which all colour as a definite attribute has disappeared. This world is too far above us for its harmony to touch our souls. A great silence, like an impenetrable wall, shrouds its life from our understanding. White, therefore, has this harmony of silence, which works upon us negatively, like many pauses in music that break temporarily the melody. It is not a dead silence, but one pregnant with possibilities. White has the appeal of nothingness that is before birth, of the world in the ice age. [31]

What might be termed 'the force motif' was the longest-continued theme in Richards's oeuvre, from 1943-4 until his death. The illustration commission by Tambimuttu, the editor of *Poetry London*, which seems to have prompted his close reading of 'The force that through the green fuse' was carried out in 1945, and published in 1947, explicitly relating the imagery seen previously in 'Cycle of Nature' with the words of the poem, winding the natural forms around its lines (fig. 31). In 1952 the painting titled 'Afal Du Brogwyr (Black Apple of Gower)', oil on canvas, was inscribed in Welsh across the bottom 'Gwrogaeth i Dylan Thomas' ('Homage to Dylan Thomas'), and almost invisibly carried the sgraffito letters 'The force that through the green fuse drives the flower drives my green age'. Richards wrote about it to Gerhard Adler,

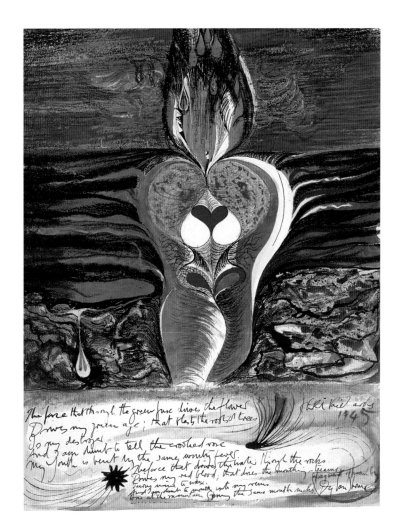

This seems to be a most obtuse sort of title – it is my own title and expresses for me the great richness, the fruitfulness and great cyclic movement and rhythms of the poems of Dylan Thomas. The circular image… is the metaphor expressing the sombre germinating force of nature – surrounded by the petals of a flower, and seated within earth and sea….[32]

31. Ceri Richards: The force that through the green fuse drives the flower (1945)

Author's Prologue

This day winding down now
At God speeded summer's end
In the torrent salmon sun,
In my seashaken house
On a breakneck of rocks
Tangled with chirrup and fruit,
Froth, flute, fin and quill
At a wood's dancing hoof,
By scummed, starfish sands
With their fishwife cross
Gulls, pipers, cockles, and sails,
Out there, crow black, men
Tackled with clouds, who kneel
To the sunset nets,
Geese nearly in heaven, boys
Stabbing, and herons, and shells
That speak seven seas,
Eternal waters away
From the cities of nine
Days' night whose towers will catch
In the religious wind
Like stalks of tall, dry straw,
At poor peace I sing
To you strangers (though song
Is a burning and crested act,
The fire of birds in
vii

This time the imagery is utterly different: the sun going down followed by the moon, the cliffs and beaches of Gower, an owl with a rabbit in its talons, and in the centre the huge circle of the 'black apple' itself. Once again, none of this imagery was quoted from the poem, but all was inspired imaginatively by the central theme. The sea and apple appear to have been suggested by words from another poem, 'I dreamed my genesis', '...fallen twice in the feeding sea, grown/Stale of Adam's brine...'.

'The force that through the green fuse' set the pattern for Richards's use of other lyric sources throughout his remaining career: to create a personal response in meditation prompted by the poem rather than illustrating its imagery. He met Thomas only in 1953, visiting Laugharne with their mutual friend Alfred Janes. The meeting inspired Richards to further consideration of the poems, and he started drawing in several copies of Thomas's newly published *Collected Poems* as Thomas lay dying in a New York hospital. Imagery emerged which Richards would use in subsequent work.[33] Among motifs that he continued to explore were flowers falling from the poet's pen, skulls and shrouds, a crane or heron, and the 'Black Apple', which he drew next to the poem 'I dreamed my genesis'.

After Thomas's death, the poet as much as the poetry became Richards's inspiration. Painting and drawing became a means to express grief and resolve ideas about the continuity of artistic works. There is a rare insight into Richards's method in a letter quoted by Moelwyn Merchant about his work on the great poem, 'Do not go gentle into that good night'. It was striking that the final paintings had no direct connections with the imagery or even meaning of the poem, but in representing a cadaver borne by owls and falling into the void they showed the artist's own feelings about death (see fig. 33). Merchant quoted Richards as saying,

32. **Ceri Richards:** Drawing in p.vii of *Collected Poems* by Dylan Thomas (1953)

I was profoundly moved by this poem and reflected deeply on it. What is most important, I didn't want to illustrate it superficially by keeping step literally with the obvious meaning of words like *rage, rage* (where I would render this by a fanfare of trumpets blasting away in the face of the Inevitable) – that rendering came into my mind most obviously and directly, but I felt this was superficial … My rendering is my personal one and a seriously felt one … I believe I was moved by the poem into feeling a quality of the pathetic and tragic futility of resistance to the natural cycles of life … I felt I could see the isolated and pathetic passivity of man on the threshold of Eternity … the body of man is tossed out of the shroud into the void – his resistance quietened … I believe I veered away from the literal force in Rage – and thought of the sensibility, the depth, in the words Do not go gentle into that good night.[34]

The shroud born by the owls is sometimes a manuscript. Richards told Mel Gooding that the resemblance to Thomas in the falling figure was not intended consciously, but he recognised it was there – 'It just happened like that.'[35] Gooding points out that the body is already textured like stone to suggest its metamorphosis.

Above all it was 'the force' motif that continued to be engendered in Richards's portfolio of prints based on Dylan Thomas, published in 1965, in a series of large paintings on the cycle of nature and the seasons in the mid to late 1960s, and finally in the 'Origin of Species' screenprint of 1971. These later works were cross-fertilised by new motifs such as the setting sun, skulls, hands reaching out to grasp at life, and blossoms falling through

33. Ceri Richards: Homage to Dylan Thomas II (1955)

the air. The 'Twelve Lithographs for Six Poems by Dylan Thomas' (1965) were carefully interrelated thematically, emulating a sequence of poems or musical variations. Half of the twelve were concerned with 'The force that through the green fuse', each, according to Gooding, identifying a major theme, such as man as a bodying-forth of primordial energy, man as part of the natural process, man in the image of natural objects, and man subject to cyclic patterns.[36] Others dealt equally metaphorically with poems such as 'Over St John's Hill', 'Poem on his Birthday' (fig. 34), 'Do not go gentle', 'And death shall have no dominion', and 'The Author's Prologue'.

Vernon Watkins and Roberto Sanesi

Richards and Vernon Watkins became the closest of friends from around 1947 until Watkins's death twenty years later. Richards wrote, 'For me and for my painting, it was a privilege to listen to him, and to what was really an affirmation of the creative processes although the character of our work was very different.'[37] Through long walks on the cliffs at Pennard, where Watkins lived and the Richards family had acquired a bungalow, they discussed art and poetry in depth. Richards was not transfixed by Watkins's poems in the way that he was by Thomas's, but he appreciated them. Tony Curtis has pointed out that many addressed the theme of cyclic nature which was at the core of so much of Richards's concerns, for example 'The Tributary Seasons', 'The Immortal in Nature' and 'The Mare'. Richards made drawings throughout a copy of Watkins's volume *Cypress and Acacia* (now lost),[38] and began to work from Watkins's poem 'Music of Colours, White Blossom', publishing a lithograph inspired by it in 1965 and making studies earlier.[39]

34. Ceri Richards : Poem on his Birthday (1965)

35. Ceri Richards: Music of Colours - White Blossom (1954)

After Watkins died, Richards made several paintings and prints in homage, engaging with an unpublished poem, 'Elegiac Sonnet', and again with 'Music of Colours'. The latter title and some of the content of the poem suggest that Watkins and Richards may have discussed Kandinsky. Both poem and painting allude to the transformation of Zeus into a swan to seduce Leda, another story of procreation. John Ormond pointed out that the poem was informed by Watkins's own private mythology of colour: he 'makes the swan black to suggest that without the redeeming force of Christianity the sexuality of love, even love itself, is without final purity.[40] Kandinsky wrote of black in a manner strikingly consistent with both poet's and painter's vision:

> A totally dead silence, on the other hand, a silence with no possibilities, has the inner harmony of black. In music it is represented by one of those profound and final pauses, after which any continuation of the melody seems the dawn of another world. Black is something burnt out, like the ashes of a funeral pyre, something motionless like a corpse. The silence of black is the silence of death.[41]

Fine sgraffito lines served to emphasise the all-enveloping quality of the blackness, barely cutting through it rather than modulating it with paint. Arthur Giardelli commented, 'Vernon Watkins's poem has to do with matters some of which are out of reach of painting. But such things as Richards shows never were, and cannot be, caught in the net of words.'[42]

Roberto Sanesi and Richards first met through Watkins in 1958. Sanesi was born in Milan in 1930, and was a poet, academic and theatre director. He translated Dylan Thomas into Italian in the early 1950s and later wrote about British artists, including Henry Moore, Graham Sutherland and Richards, publishing his complete graphic works in 1973.[43] Richards's seven lithographs for Sanesi's poems, *Journey towards the North*, prepared in 1971, were unique in Richards's work for being collaborations with a poet. They utilised all his skills of association, unified expression and use of objective motifs. Sanesi was able to observe the manner of Richards's working and the relationship he made with the poetry:

> He made dozens and dozens of sketches, temperas, water-colours, to interpret the meaning, the central themes, of a group of poems without sacrificing his own independent personality. Ceri was not an

illustrator, he was an 'interpreter', and therefore what interested him were hidden similarities, not the appearances of things: the poem had to become his poem. It was fascinating to engage in discussion with him, because of his exceptional quick-wittedness, intellect, sensitivity and subtlety. Through Ceri I myself began to understand certain aspects of my own poetry.[44]

Welsh Folk Traditions

Richards's use of folkloric sources is not directly documented, but the associations are strong. His most important series of works in the last years of his life was concerned ostensibly with Claude Debussy's piano prelude of 1910, 'La Cathédrale Engloutie' (fig. 30). Richards was fascinated by relating painting to music, and said, 'Debussy is a visual composer: his sounds and structures are derived from a visual sensibility. He gives me a feeling of the sounds of Nature, as Monet does.'[45] The words in Debussy's score also became important, and were used as titles: 'profondément calme', 'augmentez progressivement', 'jeux de vagues'. However, the essence of Richards's interest was the lyric idea taken by Debussy from the Breton legend of the cathedral of Ys or Ker Is, disappearing and re-appearing as the sea rose and fell. Watkins identified the core of this in terms which he and Richards would have discussed, as it was for a catalogue essay:[46]

> Art springs from conflict, and the conflict here is between two eternities, that of the sea assimilating all things into its movement towards ultimate oblivion and that of the cathedral embodying man's faith and mind, sinking through time, only to re-assert its weight and magnetic force.

The source of this idea was more than the Breton legend that informed Debussy's work. Its ancestry was probably a folk memory common to many parts of Europe inspired by catastrophic floods; perhaps even by the global rise in sea levels following the ice age. When Richards made his first 'Cathédrale Engloutie' painting in 1957, he had touched recently on the Biblical form of the story, in his opera designs relating to Noah and the flood. Other versions of it include the loss of Dunwich (which he had visited while working with Britten) and the inundation of Atlantis. However, these would have resonated with the version invariably told to schoolchildren in Wales, the traditional tale of Maes

Gwyddno or Cantre'r Gwaelod. References in the thirteenth-century Black Book of Carmarthen suggest that this story was current at least two hundred years earlier, and by the nineteenth century it had developed to include the idea that the bells of the engulfed church could still be heard chiming from the deeps.[47]

Richards never appears to have mentioned Cantre'r Gwaelod in conversation about his paintings, but it is hard to believe that the familiar legend did not deepen his feeling for the subject.[48] Certainly, the 'Cathédrale Engloutie' paintings could not have been what they were without Richards's visual experiences of the Welsh coast: the snaking patterns of the currents that cut the surface of the water, and the textures of the sea-edge rocks seen from the cliffs.

Owls appear in Richards's homages to Dylan Thomas, in 'The Black Apple of Gower' and in the paintings based upon the Thomas poem, 'And death shall have no dominion'. Richard Burns has examined the relation of the owl in these images to Middle Eastern harbingers of death and to the Welsh story of Blodeuwedd, the woman turned into an owl. Whilst there is no particular congruity between Blodeuwedd and the subjects of these paintings, in some Welsh popular traditions the owl is the foremost bird associated with death and the souls of the dead are said to take on the form of a bird to leave the body. A bird tapping at a window is often regarded as portending death, as is an owl seen during daylight hours. Such a bird was given a name in Welsh: 'Aderyn Corff' ('Corpse Bird') .

A long-legged bird also appears in the homages (see fig. 33). Burns refers to this as a heron – a bird regularly mentioned in Thomas's poetry and seen frequently in Gower. In later works such as his

36. Ceri Richards: And death shall have no dominion (1965)

lithograph to Thomas's 'Poem on his Birthday' (fig. 34), there is no doubt that a heron has been drawn. However in the homage drawings Richards's image more closely matches the egret, a spectral-white marsh-bird with a plume at the back of its head, or the crane. Although not seen in Wales today, the crane was known in ancient Celtic cultures as a bird that might appear on migration. Its pure whiteness and strange beauty associated it with other worlds and death.[50] Richards may have intended to create a generic creature not grounded by detail, but in doing so he found a form resonant of folk tradition.

37. Ceri Richards: Noah and the Dove (1968)

Classical Myth and the Bible

Classical myths and the Bible were lyric sources that Richards used from time to time, although seldom for extended series. Frequently, his response was mediated through earlier artists' interpretations of the themes. The story of the Rape of the Sabine Women was encountered first perhaps through Rubens, but its literary transmission included Theocritus, Ovid and Plutarch. The story of the kidnapping of women to re-invigorate the blood-stock of Rome was vital to Richards's purpose, for it engaged with the perennial theme of his own art, the cycle of nature. It was the most concerted of Richards's Classical pre-occupations, being re-visited in various idioms from the late 1940s onwards. Richards also explored the legend of Prometheus, creator of man, and the story of Diana and Actaeon, encountered in Titian but brought from Ovid as a literary source which engaged his imagination.[51] All of the selected myths addressed the subject of life, death and creativity.

Richards was a spiritual man all his life, and his upbringing in the daily life of the chapel gave him a thorough knowledge of the Bible. He worked on Biblical themes in his opera designs for the children's opera *Noye's Fludde*, the Deposition (at St Mary's Church in his home town of Swansea), and the Supper at Emmaus for St Edmund Hall in Oxford. Here too, however, Richards's works were personal responses rather than mere storytelling. The corporeality of 'The Deposition' was affected by his distressing period in hospital in 1952, which had produced paintings of patients (see fig. 29). His illustrations were some of the most effective in *The Oxford Illustrated Old Testament* in 1968,[52] particularly those showing Noah's Ark, tossed on great waves and under swirling clouds that suggested the 'Cathédrale Engloutie' paintings, Noah's hands reaching for the dove as it flew from rain to sun (fig. 37).

Conclusion

Richards engaged time and again with lyric sources, developing them in complex ways through his search for unity in the arts, his belief in the emotional impact of colour and form, his use of free association and objects taken from different arenas, and particularly Welsh responses. Among many lyric sources that he transformed into visual art, the poems of Dylan Thomas and the half-remembered folklore of his childhood were perhaps the most continuously rewarding. Whilst Classical mythology, the Bible and

works by other poets gave occasional 'renewal of problems and discipline', his personal response was everything. The theme of the cycle of nature and the mysteries of birth, love and death which were the overarching concerns of his career were central also to Thomas's preoccupations and the folklore that Richards knew.

It was a credit to the unifying harmonies of Richards's art that many poets and fellow painters drew inspiration from it. Particularly for those who were his friends, the impact was immediate. Sanesi said, 'Ceri had the ability to create quick and extraordinary associations of ideas. A word from him or a gesture could reawaken in me a series of sudden echoes…'. Richards not only achieved unity in the terms of his own work, but enabled others to embrace it. Watkins's poem, 'The Forge of Solstice' paid tribute to his imagery:[53]

> Singing like living fountains sprung from stone,
> Those unifying harmonies of line
> Torn from creative nature.

[1] I wish to thank, for advice, criticism and assistance with source material, Mel and Rhiannon Gooding, Ceridwen Lloyd-Morgan, Rex Harley, Gwen Watkins, The Martin Tinney Gallery, Glenys Cour, Tony Curtis, Anne Morris and Clive Hicks-Jenkins. The hospitality beyond the call of duty shown by Frances and Nicolas McDowall of the Old Stile Press made the writing of this essay possible.

[2] Alan Bowness, 'Ceri Richards', in *Ceri Richards*, Edinburgh International Festival (Edinburgh, 1975), pp. 5-8.

[3] *The Magic Horse, from The Arabian Nights*, illustrated with designs by Ceri Richards, trans. Edward W. Lane (London, 1930).

[4] Mel Gooding, *Ceri Richards* (Moffat, 2002), pp. 81-3.

[5] Dylan Thomas, *Under Milk Wood: A Play for Voices*, ed. Douglas Cleverdon, lithographs by Ceri Richards (London, 1972); Benjamin Britten and Imogen Holst, *The Story of Music* (London, 1958).

[6] Bryan Robertson placed Richards's work 'at the same level of radical achievement in British art as the sculptures of Moore or Hepworth or the paintings of Sutherland, Nicholson, Hitchens or Bacon.' Bryan Robertson, 'Introduction', in Tate Gallery, *Ceri Richards* (London, 1981), p. 9.

[7] 'Artist's Statement' in David Thompson, *Ceri Richards* (London, 1963).

[8] National Library of Wales, NLW MS 23006D, letter 2 August 1968.

[9] 'Conversation with Picasso' [trans. Christian Zervos], in Myfanwy Evans, ed., *The Painter's Object* (London, 1937), p. 82. Kandinsky too had emphasised that allusion and emotion could barely exist without the object: 'As every word spoken rouses an inner vibration, so likewise does every object represented. To deprive oneself of this possibility is to limit one's powers of expression.'

[10] Myfanwy Evans, 'The Painter's Object' in Myfanwy Evans, ed., *The Painter's Object*, pp. 9, 13.

[11] Vernon Watkins, 'La Cathédrale Engloutie' (1964), reprinted in Coleg y Brifysgol Abertawe, *Ceri Richards: An Exhibition to Inaugurate the Ceri Richards Gallery* (Swansea, 1984), p. 25.

[12] Quoted in W. Moelwyn Merchant, 'Ceri Richards's "Pagan Mystery"', in Coleg y Brifysgol Abertawe, *Ceri Richards: An Exhibition to Inaugurate the Ceri Richards Gallery* (Swansea, 1984), pp. 30-2.

[13] Quoted in Noël Barber, *Conversations with Painters* (London, 1964), p. 33.

[14] Wassily Kandinsky (trans. M.T.H. Sadler), *Concerning the Spiritual in Art* (New York, 1977).

[15] Kandinsky, *Concerning the Spiritual in Art*, p. 25.

[16] John Ormond, 'There you are, he's an artist', in Coleg y Brifysgol, Abertawe, *Ceri Richards: An Exhibition to Inaugurate the Ceri Richards Gallery* (Swansea, 1984), pp. 22-4.

[17] Tate Gallery, *Ceri Richards*, p.16.

[18] Kandinsky, *Concerning the Spiritual in Art*, p. 35.

[19] Quoted in W. Moelwyn Merchant, 'Ceri Richards's "Pagan Mystery"', pp. 30-2.

[20] Roberto Sanesi, *A Few Words for Ceri Richards* (Swansea, 1984).

[21] National Library of Wales, NLW MS 23007E, f. 46, copy letter from Sir Colin Anderson to Richard Burns 26 August, 1978. Bryan Robertson said, 'I believe that the printed words containing the meaning of certain lines of poetry had as much excitement for Ceri as the evocative chords and harmonies in particular pieces of music and in this sense the printed page with its white margins and space would act as a magnetic field for the artist's own calligraphy and decorative flair, aroused by his sense of the poem's inner meaning…. the passion for extending the life of a poem in this way persisted all his life.' Tate Gallery, *Ceri Richards*, pp. 11-12.

[22] *Poetry London*, 3, no. II (1947).

[23] Alan Bowness, 'Ceri Richards', pp. 5-8.

[24] David Thompson, *Ceri Richards*.

[25] John Ormond, 'Ceri Richards', in National Museum of Wales/Welsh Arts Council, *Ceri Richards Memorial Exhibition* (Cardiff, 1973), pp. 7-11.

[26] Quoted by Harry Fischer in Fischer Fine Art, *Homage to Ceri Richards 1903-1971* (London, 1972), p. 21.

[27] Correspondence and papers of Ceri Richards, NLW MSS 23005-14, National Library of Wales, Aberystwyth.

[28] Susanne Langer, quoted in Mel Gooding, Ceri Richards 1903-1971, *Poetry into Art: Graphic Works and Books* (Norwich, 1982).

[29] John Berger, quoted in Fischer Fine Art, *Homage to Ceri Richards*, p. 17.

[30] Mel Gooding, *Ceri Richards* (2002), pp. 67-76.

[31] Kandinsky, *Concerning the Spiritual in Art*, p. 39.

[32] Letter dated 2 August, 1968, quoted in Richard Burns, *Ceri Richards and Dylan Thomas: Keys to Transformation*, (London, 1981), p. 63.

[33] Ceri Richards, *Drawings to Poems by Dylan Thomas* (London, 1980). See also Ceridwen Lloyd-Morgan, 'Ceri Richards: Sketches for Dylan Thomas' *National Library of Wales Journal*, 24 (1996), 347-54.

[34] Quoted in W. Moelwyn Merchant, 'Ceri Richards's "Pagan Mystery"', pp. 30-2. The location of the original letter is not known.

[35] Mel Gooding, *Ceri Richards Graphics* (Cardiff, 1979), p. 20.

[36] Mel Gooding, *Ceri Richards Graphics*, p. 20.

[37] Quoted in Tony Curtis, '"Life's miraculous poise between light and dark": Ceri Richards and the poetry of Vernon Watkins', *Welsh Writing in English: a Yearbook of Critical Essays*, vol. 9 (2004), p. 86.

[38] Tony Curtis, '"Life's miraculous poise"', p. 89.

[39] Martin Tinney Gallery, *Ceri Richards 1903-1971: Centenary Exhibition* (Cardiff, 2003).

[40] John Ormond, 'Ceri Richards', in National Museum of Wales/Welsh Arts Council, *Ceri Richards Memorial Exhibition*, p. 9.

[41] Kandinsky, *Concerning the Spiritual in Art*, p. 39.

[42] Arthur Giardelli, 'An Artist in the European Tradition', in Coleg y Brifysgol Abertawe, *Ceri Richards: An Exhibition to Inaugurate the Ceri Richards Gallery* (Swansea, 1984), pp. 19-21.

[43] Roberto Sanesi (trans. Richard Burns), *The Graphic Works of Ceri Richards* (Milan, 1973).

[44] Roberto Sanesi, 'Two poetic fragments', in Coleg y Brifysgol Abertawe, *Ceri Richards: An Exhibition to Inaugurate the Ceri Richards Gallery* (Swansea, 1984), p. 26-9.

[45] Alan Bowness, 'Ceri Richards', pp. 5-8.

[46] Vernon Watkins, 'La Cathédrale Engloutie' (1964), reprinted in Coleg y Brifysgol Abertawe, *Ceri Richards: An Exhibition to Inaugurate the Ceri Richards Gallery* (Swansea, 1984), p. 25.

[47] Meic Stephens (ed.), *The New Companion to the Literature of Wales* (Cardiff, 1998), 86-7.

[48] Mel Gooding, personal communication 5 January 2005.

[49] Anne Ross, *Folklore of Wales* (Stroud, 2001), p. 139.

[50] Anne Ross, *Folklore of Wales*, p. 138; Miranda J. Green, Dictionary of Celtic Myth and Legend (London, 1992), p. 68.

[51] Arthur Giardelli wrote, 'The story still holds us with its fearful meaning, and so Richards tells it for us in line, colour and image. The arrow hisses in its flight from the quiver, we hear the rush of water, the crack of branches and the wordless groan of the man losing his humanity because, by mischance, he has come upon a goddess bathing.' Arthur Giardelli, 'An Artist in the European Tradition', pp. 19-21.

[52] *The Oxford Illustrated Old Testament, with Drawings by Contemporary Artists, Volume 1: The Pentateuch* (London, 1968); *The Oxford Illustrated Old Testament, with Drawings by Contemporary Artists, Volume 3: The Poetical Books* (London, 1969).

[53] Published in Vernon Watkins, *Cypress and Acacia* (1957), quoted by permission of Gwen Watkins.

38. Brenda Chamberlain: The Harvesters (1939)

V

Brenda Chamberlain
(1912-71) Artist and Writer

JILL PIERCY *'Emotionally, I was always tempted to drop*

the writing and concentrate on painting,

because, for some unknown reason, writing

has always been for me an unhappy

activity; while painting almost invariably

makes me happy. But however hard I tried

to discipline myself, sooner or later the

other form would take over, dominate

entirely for a time, then swing back again.'[1]

Although she admits a stronger attraction to painting, during her lifetime Brenda Chamberlain published three novels, a book of poetry, a book of poems and drawings, and an account of the making of the *Caseg Broadsheets*[2], as well as having a large number of poems and articles published in magazines.[3] The list of her unpublished writings is much longer and includes plays, short stories, poetry, letters and journals.[4] She was an inveterate writer of journals and much of her more fluid prose appears in these notebooks, Although her entries were not daily, Brenda Chamberlain enjoyed keeping a journal where events were recorded in fresh vivid detail often accompanied by a drawing or an idea for a poem. Writing poetry was a more difficult process:

> Becoming obsessed with the making of a poem, I would work at the words, always cutting away; trying to make little express much; condensing, clarifying and finally, forging. Page after page of the notebook would become covered with countless variations of the one poem that might be taken up and laid aside over a period of weeks, or months, or even years. The making of a poem is for me an almost endless process; even when at last it sounds to be complete, it seems best to put it away for further ripening and a more dispassionate assessment at a later time.[5]

As a young child in Bangor, Gwynedd, she had been encouraged to paint and write essays and poems by both her mother and schoolteachers, and by the age of six, Brenda Chamberlain had already decided to be an artist and writer, and nothing would dissuade her from this ambition.

It was in the garden that Brenda first discovered her enjoyment of drawing. She used fragments of stone and chalk to scratch patterns on the slate fence which enclosed their garden and revelled in the different patterns and textures she could create. Unlike many children of her age, she also strove to be seen as different. She sometimes wore her long hair with a band around her forehead as she imagined herself to be a Norwegian princess and often, she would borrow her father's old trilby which she would pull down over her ears. She was small for her age, and by dressing differently from her contemporaries, drew attention to herself, which she enjoyed and cultivated throughout her life.

Aged fifteen, while still at school, she was invited to join three of her school friends to work on a hand-written magazine they had been producing.[6] Initially drawn together by their interest in hill-walking, the

four girls took turns in editing the magazine(renamed 'Tetralogue' when Brenda Chamberlain joined them), which included articles on etiquette, handy hints, poems, prose and drawings. It was Brenda Chamberlain's first real exploration of developing her poetry and prose and combining drawings with her writings. When she left school, she decided to apply to study at the Royal Academy Schools in London and took the opportunity to stay with a family friend in Copenhagen for six months while she prepared a portfolio of drawings. Whilst there, she visited the Karlsberg Glyptotekh Museum and discovered paintings by Gauguin which were to inspire her for many years:

> …[It] was the first modern museum I had been into. Here, I loafed among the early paintings of Gauguin, painted on the roughest sacking. I knelt bemused at the feet of Gauguin.'[7]

On her return, she was accepted at the Royal Academy and studied there for five years. Although she found the style of study 'academic to the nth degree; it is as a melting pot for ideas and rebellion against the doctrines of the master that I remember its value'.[8]

Being in London opened her eyes to the work of many international artists who were being exhibited in the galleries and museums and she revelled in exploring the work of the Fauves, Cubists and German Expressionists amongst others. Two men entered her life during this time. A brief encounter with a German student, Karl von Laer, who was visiting Bangor on an exchange in the summer of 1932, stirred her to write, and her meeting with a fellow student, John Petts, in London led to their marriage in 1935.

Fellow students such as William Scott and Mervyn Peake also stimulated her ideas. John Petts had been in London for longer and had already gathered a colourful group of friends:

> There was tall Fred Janes from Swansea, his head full of theories, Bromfield Rees, his lean and studious friend from Llanelli, trying to paint like Braque, and the ubiquitous Mervyn Levy from the Royal College of Art, and a pudgy, fag-ended young jounalist in a cocky pork-pie hat and a dyed green shirt whose name was Dylan Thomas.'[9]

After studying art at the Royal Academy Schools in London, she naturally continued to combine words and drawings in her notebooks. It was only when the outside world wanted to categorise her either as an artist or a writer that Brenda Chamberlain found herself in a dilemma. She wanted to be both and throughout her life she searched for new ways to combine her talents in order to retain the status of artist *and* writer.

When they left the Royal Academy, John Petts and Brenda Chamberlain moved to north Wales to a small cottage, Tŷ'r Mynydd, in Llanllechid near Bethesda. They vowed to live by their art. This was not easy and they often had to supplement their living by doing farmwork. As they were so far from art galleries, they could not rely on selling their paintings. John had, however, already developed an interest in typography and printing, and so he established the Caseg Press at their home. He taught Brenda to engrave woodblocks and together they printed hand-coloured posters, greetings cards, hotel brochures and letterheads.[10]

In 1939 Gwyn Jones was setting up *The Welsh Review* and invited them both to submit articles and illustrations for this new magazine. Encouraged by his interest, Brenda sent off some engravings and was delighted when two were published in the next issue.[11] They both became regular contributors and by the November issue that year, they both had articles and engravings included. This was the first time that Brenda had a poem published. It was 'The Harvesters'(fig. 38), and was published alongside a lino-cut of the same title[12]. The image shows two sinuously lined women gathering armfuls of corn against a background of rugged mountains. Her revelling in the line and texture of the image echoes the alliterative rhythm of words and the shapes they make within the poem.

> Young girls bind into sheaves the short-stalked corn, won with much labour from the mountain soil.
> It has been beaten flat by wind and rain, but the straws are still yellow and the grain sweet.
> When they rest under the shadow of a wall on the stubble-edge, they wind oat-straws about their fingers and laugh, calling them golden wedding-rings.
> In the long afternoons they stook the corn and the air is full of the soft clashing of sheaves.

In that same issue of the magazine both Brenda and John were drawn to a short story, 'The Wanderers', by Alun Lewis. Within a year, all three were in correspondence and began to develop a series of Broadsheets together. These *Caseg Broadsheets*[13] which included poems with engravings were distributed widely at 3d.(1½p) a copy and are now collector's pieces (fig. 39). Brenda and Alun exchanged their poems and he gave her practical encouragement to develop her writing style.

Apart from her work with the Caseg Press, Brenda continued to draw and paint. While her style of drawing reflected her academic training, her painting grew increasingly bold and echoed the bold flat planes of colour she had so admired in Gauguin's work.

As the Second World War progressed, it began to disrupt even the peaceful life of Snowdonia. Alun Lewis died in 1942 and Brenda and John separated in 1943. It was the end of an era. Brenda turned to her writing and did not paint for about seven years. Her internal struggles were reflected in her poetry, which was dark and melancholy with images of death and drowning. The language was often awkwardly expressed and difficult to read, with a glut of hyphenated words such as 'grief-stones', 'death-scythes', 'a corpse-man's' and 'snow-green'.

Two important events happened to her after the end of the War in 1946: she renewed contact with her German friend, Karl von Laer,[14] and a

39. Brenda Chamberlain & John Petts: Caseg Broadsheet no.2 (1941)

40. Brenda Chamberlain: The Cristin Children (1952)

Polish friend took her on a two-day trip to Ynys Enlli (Bardsey Island), off the tip of the Llŷn Peninsula.

> The first restored my spiritual life-line, the well of poetry was refreshed; the second led me to the Atlantic waves which I had desired all my life, the sea which had been in the blood of my Irish and Manx forebears. From the restored link with my German friend, I began to see that there is a pattern in life, strong links we form are never really broken. The second wonder was, that after two days of running wild on Enlli, it was the only place for me to live, it became home after that brief contact.[15]

The bold decision to move to Ynys Enlli heralded one of the most prolific and creative periods of her life. A place of pilgrimage where reputedly 20,000 saints are buried, Enlli is a windswept, often fog-enshrouded island of 144 acres frequently cut off from the mainland by high winds and rough seas.[16] Amongst the community of twelve islanders, Brenda Chamberlain lived and worked for fourteen years. Conditions were very simple: there was no electricity or running water, driftwood had to be collected daily for the fire, and food needed to be found. Fish, rabbits and seagulls' eggs formed the basic island diet.

A new creative phase began in Brenda Chamberlain's life. The poetry stopped, the journals filled rapidly with rich descriptive prose and the painting sprang into life again.

Once again, influenced by the early work of Gauguin, Brenda Chamberlain's painting was solid and chunky with broad, flat areas of colour. She used the islanders as her models and through her portraits she developed the distinctive still poses, the long sad faces and the staring deep-set eyes which became a characteristic feature of her work (see fig. 41). A fine example of this is the painting 'The Cristin Children' (fig. 40), which won her the Gold Medal in Fine Art at the Royal National Eisteddfod in Rhyl in 1953.

41. Brenda Chamberlain: Children on a Hopscotch pavement (1951)

In her attempts to combine writing and painting, Brenda Chamberlain made drawings on sheets of newspaper, using the printed word as both texture and information. One particular drawing of children appealed to her and taking it a step further, she wrote a description of the children directly onto a canvas and then painted the composition on top (the text written on the canvas can be found in *Tide-race*, pp. 180-1). This gave her a greater freedom as, unlike with the newspaper, she could now place words exactly where she wanted to give dramatic effect or tone.

There are many variations of this composition, but in the final painting of 'The Children on the Seashore' (fig. 42), Brenda Chamberlain felt she had achieved a breakthrough. In a long description in one of her notebooks, she explains the process and development of this work in which she felt at last she had been able to combine her talents. Here the painting was not superimposed on the words but blended with them and with the spaces between the paragraphs. 'This painting gave a real sense of satisfaction', she wrote, ' because I could not imagine the painting without the words.'[17] While this amalgamation of painting and writing excited her, it was to be a temporary elation. She attempted to use the formula in other compositions, but apart from the successful 'Women in the Wind' (*c*1959, ink on canvas, private collection), she found herself unable to develop it.

During this period, Brenda Chamberlain felt equally at ease with her prose writing and her painting, and was able to work on both. However, she remained uncertain of which talent to pursue and longed to resolve her indecision. 'The struggle went on', she wrote in her notebook, '– a prose-book on which I had worked for many years (in between painting) was to be the touchstone, the sign, long-looked for. If a publisher took it, that would mean the sign had come, showing the direction – writing was to be the dominant.'[18] The

42. Brenda Chamberlain: The Children on the Seashore (1950) 43. Fish from *Tide-race* (1962)

sign did come, but it was not what she had expected. When Hodder and Stoughton agreed to publish her book, *Tide-race*, they also requested an exhibition of paintings to coincide with the publication. Brenda felt that the decision had been taken out of her hands:

> I was tempted to the belief that it was a sign from heaven: in fact it was a wonderful feeling, to be wanted for both forms of expression.[19]

As well as showing work in the exhibition, Brenda Chamberlain was able to illustrate the text of her book with line drawings of rocks, seals, fishes, boats, shells and the islanders themselves. In the original publication in 1962, there were also four colour plates of her paintings, which were typical examples from her time on Bardsey Island (cf. fig. 40, 44). The results of this fusion of words and images can be seen in *Tide-race*. Although it describes her experiences on Ynys Enlli, it is a hard book to categorise. It is neither fact nor fiction, but a blend of the two and it is written not as a single narrative, but as a collection of events and experiences taken out of

chronological order and context and woven together with myths and legends into one story. Many extracts had already been published in magazines and much of the prose, poetry and drawings can be traced in five of Brenda Chamberlain notebooks which cover the years 1947-61.[20]

44. Brenda Chamberlain: Fisherman resting (1962)

It is not an idyllic island that she describes, but one where human conflicts and dramas mingle with the joys of living close to nature. There is an underlying sense of tension and claustrophobia in *Tide-race*; the ongoing feud over the island boat, the trauma of being storm-bound for five weeks and the vigorous account of the Polish recluse who went mad and was removed from the island in a straitjacket.

Through the writing, Brenda Chamberlain's own struggle to be both fisher-farmer and artist-writer is apparent:

> This was at all times less than easy, but I gradually adjusted myself to constant and violent change of occupation: after hauling a boat or herding cows, to turn with minimum strain to painting or writing.[21]

Although the illustrations included in *Tide-race* were mainly figurative, the related exhibition held at Zwemmer's Gallery in London in 1962, showed a new style in Brenda Chamberlain's painting. Her work was about the sea and since the early 1960s had become more abstract and atmospheric:

> ... through the medium of paint and canvas I have in these latest paintings attempted (what I went after in words in *Tide-race*) to explore the 'theme of death into life', darkness overcome by dayspring; the unity of our universe: underwater and earthly.[22]

With such titles as 'His Loins have become a Stone Bridge' (1962, chalk, ink and gouache, private collection), 'Grey Breast' (1962, oil on canvas, bought on behalf of the Welsh Arts Council by Joseph Herman and Ceri Richards), and 'Man Rock' (1962, oil on canvas, National Museum and Gallery of Wales, Cardiff), Brenda Chamberlain explored the way a drowned torso could be transformed imaginatively into rock, shaped and sculptured by the action of the sea and the pull of the tides. Whereas drowning, a recurrent theme of her early poetry, had been treated as a depressing subject, she now saw it as a catalyst in the transformation of bodies into rock.

Shortly afterwards, in 1963, some of these abstract works, together with earlier figurative works were shown in a two-person touring exhibition show with Ernest Zobole which was organised by the Welsh Committee of the Arts Council.[23]

She was always keen to push the boundaries and explore new forms of expression. According to her friends, she lived frugally and when she made any money, she often used it to travel. During the 1950s, Brenda often went to France and Germany to visit friends and to paint. Drawings made on site in France were developed into richly-coloured paintings on her return to Wales. Her portrait of Picasso's mistress, Dora Maar, in 'Intérieur Provençal'(1952, oil on canvas, Glynn Vivian Art Gallery, Swansea) and 'Carnaval de Nice' (1952, gouache on paper, private collection) are two typical examples of this French series.

In Germany she visited her friend, Karl von Laer and his family and often stayed in a large, moated country house she called 'The Water Castle' near Osnabrück. There she drew portraits, wrote and made a series of frottage crayon drawings which included 'Free with Wings', 'The Way to Unity' and 'Insea in Lisabeth's Winter Coat'. The inspiration for this series of work came from the richly patterned Persian and Indian carpets as their maze-like angular forms of fishes, birds and abstract shapes had intrigued her for some time (see fig. 47). At first she copied the carpet-pattern designs, colouring them in with wax crayons, then began to develop them into her own angular form of expression combining words, symbols and recognisable images. She explained that these designs 'are an attempt to forge a new pictorial meaning from a combination of music signs, a personal feeling from the colour and shape of words and universal conventions of linear draughtsmanship.'[24]

Following the success of *Tide-race*, she decided to write a book about her first holiday in Germany. She found this easier to compile than *Tide-race* as she based it directly on her journals. Once again drawings were prepared to accompany the text but were not used. Presented as a novel, *The Water-Castle* was published in 1964. Although it was reviewed widely, it did not receive the same critical acclaim as her first book and Brenda Chamberlain felt disappointed that it was not fully illustrated and only included a few of the illustrations that she had prepared.

She was determined to redress this balance in her third book, *A Rope of Vines* (1965), a journal which explored her experiences on the Greek island of Hydra where she was then living. Whereas in *Tide-race*, the drawings illustrated the text, here they have an equal standing and many occupy full pages. The words and

drawings are an effective combination which portray the parched 'red-hot earth', 'white-hot wilderness' of prickly scrub and terraces of vines and olive trees, the white-sailed boats on a sea 'bluer than midnight', the screaming communications and extravagant gestures of the peasant people, the chirruping of crickets and shuffling of goats and donkeys. After a three-week trip to Hydra in 1962, Brenda Chamberlain returned in 1963 and stayed until the Colonel's coup in 1967, when she felt compelled to leave.

Like her arrival on Ynys Enlli, Brenda Chamberlain's move to Hydra heralded a new creative period in her life. She wrote prolific entries in her journals, filled her sketchbooks with drawings and began working with a Greek dancer, Robertos Saragas. She joined him at rehearsals, where she sat in a corner and drew his rapid movements.

She tried to capture his movement in her drawings, but realised that she was still trying to freeze the action into a position and make it static. Gradually, she relaxed a little and allowed her hand to move freely over the paper. The results were much better and she felt that 'someone looking at them could, with a little practice see what position the dancer had moved from, and to what position he was approaching.'[25]

This sense of movement can be clearly seen in the sketches she made of Robertos as he danced to the piano prelude, 'La Cathédrale Engloutie' written by Debussy (fig. 45). As it happens, this composition, based on the legend of a cathedral disappearing and reappearing as the tides of the sea rose and fell, echoed the themes of metamorphosis of bodies into stone by the action of sea that Brenda had explored in the abstract series of paintings she had made on Bardsey Island. The same piece of music had inspired many artists from Monet to Ceri Richards.[26]

45. Brenda Chamberlain: Sketch of Saragas dancing (1963-4)

46. Brenda Chamberlain: The Doves (1953)

While watching Robertos rehearse, Brenda developed her own form of music notation. Her notebooks became filled with this dance shorthand. For 'La Cathédrale Engloutie' her words begin:

> opens as it finishes
> positive and negative electricity
> the rigid body, the vibrating hands

Interspersed with the drawings it continues:

> The great swinging of the bell and the throwing down of the body and raising up to full stretch and then round and round to fixed position on flat heels. The grieving body, one hand to earth, the other to heaven raised – Back to the door – and out, with outstretched wings of purple cloth, to kneel and sway forward and back, and round and round, to door, and with raised hands, clutching and benediction! Back to start.[27]

Their collaboration led eventually to a dance recital in 1964 at the Lamda Theatre in London, where Saragas danced to both music and poetry. The words were written by Brenda Chamberlain and the writer, Michael Senior (also from north Wales and a friend from Hydra), and were read by the actress, Dorothy Tutin.

This performance broadened Brenda Chamberlain's ideas of how she could incorporate her talents and led her to other multi-faceted projects. Through Saragas, she met Halim El Dabh (b. 1921), an Egyptian-born American composer of electronic music who was at that time composing a large piece of music commissioned for the Athens Festival in 1965. He had previously composed the music for the opera-ballet *Clytemnestra* (1958) by the choreographer, Martha Graham, and so he was interested to hear how Brenda Chamberlain and Robertos Saragas had combined dance and music with poetry and drawing. When he saw the dance drawings he felt that he 'understood' them, and would be able to interpret their musical value sufficiently to play the piano from them.

Mystified, Brenda Chamberlain agreed to take part in an experiment with him. He wanted her to sketch freely as he played his own composition on the piano. An earlier experiment with the sculptor, Isamu Noguchi[28] had failed, but after seeing Brenda Chamberlain's drawings, El Dabh felt she would be sensitive

to his music. As he played, she scribbled in a notebook. Afterwards, El Dabh placed the notebook on the piano and was able to play from her notations. Brenda Chamberlain was excited about the results, but because she could not follow El Dabh's reinterpretation of her notations, she was not fully convinced that the results were valid. The experiment was repeated on two other occasions that week and Brenda Chamberlain found herself much more responsive to the music:

I had felt an absolute participation in the music, my whole body had vibrated with the notes, it was the most direct form of communication I could imagine.[29]

A preoccupation with art and writing which had led to one with art and dance was now concentrated on art and music. Brenda Chamberlain developed different techniques to express the mood, rhythm, speed and volume of the sounds. The challenge of working with a musical language inspired her to develop these small notations into larger drawings. Her aim was to make music on paper rather than drawing or illustration and she worked for months on this theme. By January 1966, she had finished the series and feeling depressed and exhausted, turned to writing poetry. She took earlier poems, edited and pared them down into shorter, more concise forms. Since living in Greece, both Brenda Chamberlain's art and writing had become simpler and less cluttered. Her art had been bleached of colour and now she worked only in monochrome. For four months she wrote; then, as her mood improved, she turned to her art once more. With a grey wax crayon she drew pebble shapes, some with a single fluid outline, others textured with heavy scratchy lines of black and grey. For Brenda Chamberlain, these shapes represented cells, stones, islands, the earth and the sun. Returning to the theme of metamorphosis, she sought to portray these

47. Brenda Chamberlain: Greeting Card (1960s)

elements in a universal form. Some of the textured pieces of card were cut out and used in collages, often arranged on a geometric grid.

In another attempt to combine her art and writing, she placed some of these collages alongside her recent poems and they were published in a limited-edition volume, *Poems with Drawings*, by Enitharmon Press in 1969. The book received a mixed reception: most people wanted to make connections between the words and their corresponding image, and were perturbed when they failed to do so. There were in fact only a few pages where the drawings and poems did obviously complement each other, and while, for Brenda Chamberlain, each arrangement of words and image held a vital significance, those connections were not easily communicable to others. Although aware of this – 'I can write. I have a lot to say, but the meaning may not be immediately apparent to more than a few people'[30] – she felt compelled to try to express the feelings which she felt were important.

This subjective viewpoint meant that she was often attracted to work on obscure threads of thought while omitting to address more fundamental questions. It is curious that she chose to ignore the importance of the spoken word which had played such a predominant role in her life. She was a poor linguist, but had chosen

THE DEAD WHISPER WITH THE DEAD
the living gossip with the dead
the dead speak of loneliness

THE LIVING TELL THE DEAD
of how hard it is to be alive
thereby destroying them a second time

9

48. Brenda Chamberlain: from *Poems with Drawings* (1969)

to live in situations where other languages were spoken. She wrote books set in Wales, Germany and Greece but nowhere mentioned the spoken language of these countries. Although her characters were based on real people, there is nothing in her books to indicate that they spoke a language other than English, whereas in *Tide-race*, the community she wrote about was predominantly Welsh speaking, in *The Water-Castle*, German, and in *A Rope of Vines*, Greek. In her books, difficulty of communication does not arise,whereas in reality few of Brenda Chamberlain's friends spoke English and often their conversations were stilted and punctuated with gesture, mime and long pauses.

Although obsessed by language, Brenda Chamberlain did not want to feel bound by it. She was born in Wales but wanted to be known as an international artist and was far more excited when her poetry appeared in magazines in Italy or New York than in Wales or England. While it is obvious from her journals that she was familiar with reading traditional Welsh verse and echoing some of the constructions and rhyming schemes in her poetry, she does not dwell upon these influences. The practical use of foreign languages had been difficult, but Brenda Chamberlain chose not to concentrate on that. She believed that there was some kind of universal language which could transcend the spoken word and communicate to all cultures and countries. Whether idealistic or naïve, these higher aims fuelled her urge to combine writing, music, dance and painting in an attempt to break free of convention to create a universal form of communication.

In an exhibition 'Word + Image', held in 1970 in Cardiff, Cwm-brân and Anglesey, Brenda Chamberlain made another attempt to fuse the two sides of her work. While the art was a result of her years on the island of Hydra, her poetry spanned a longer period as she explained in the exhibition catalogue:

49. Brenda Chamberlain: The Rams of Carreg (1955)

Some [of the poems] were written on the island of Bardsey [Ynys Enlli] (they have been worked on over a period of years.) Others were made in Greece. Poetry is too complex a process for me to pin down. Its roots are too obscure. It really *is* a great mystery, involving railway stations, lonely shores, strong attachments to places; but out of time, in any strict sense. None of these poems can be dated therefore.

The exhibition was not well received. Whereas the amalgamation of her art and writing in her early years had been popular, the public now found this departure from a figurative style and the pared-down poetry too esoteric and inaccessible, which disappointed Brenda Chamberlain. Although her art work and writing could and often did exist separately, Brenda Chamberlain was not truly content unless they were combined. Her determination to achieve this had driven her to experiment with the word on canvas, the spoken word, dance, music and, near the end of her life, plays (fig. 50) and films. It had been her struggle and inspiration. She had often succeeded and sometimes failed. When she died in 1971, at the age of 59, Brenda Chamberlain still had not resolved this dichotomy. As she herself admitted, she had chosen 'a split-minded state, and not one in which it is easy to live.'[31]

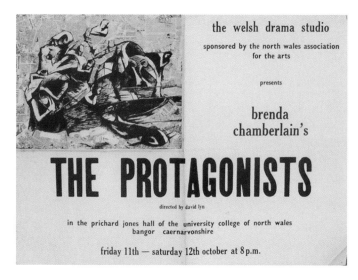

[1] National Library of Wales, NLW MS 21501E, f. 56. On the life and work of Brenda Chamberlain see Jill Piercy, 'Between Two Arts', *Planet*, 68 (April/May 1988), 77-86; Jill Piercy, 'Brenda Chamberlain – Island Artist', exhibition catalogue, (Llandudno, 1988); Kate Holman, *Brenda Chamberlain* (Cardiff, 1997).

[2] *The Green Heart* (London, 1958), *Tide-race* (London, 1962), republished (Bridgend,1987), *The Water Castle* (London, 1963), *A Rope of Vines* (London,1965), *Poems with Drawings* (London, 1969), *Alun Lewis and the Making of the Caseg Broadsheets* (London, 1969).

50. Brenda Chamberlain: poster for 'The Protagonists' (1968)

[3] Publications included *Poetry London, The Welsh Review, The Dublin Magazine, Mabon, Poetry Quarterly, Life and Letters Today, New York Times, The New Yorker, Poetry Chicago, Botteghe Oscure,* and *Athens Literary Review.*

[4] A large collection of manuscripts, unpublished writing and journals are held in the National Library of Wales, Aberystwyth. The remainder is held in private collections.

[5] *Tide-race* (London, 1962), p. 182.

[6] Extant copy seen in private collection.

[7] Brenda Chamberlain ,'Brenda Chamberlain', in *Artists in Wales*, ed. Meic Stephens (Llandysul, 1971), p. 45.

[8] *Ibid.*, p. 46.

[9] John Petts, *The 1983 Radio Wales Lecture: Welsh Horizons* (London,1984), p. 5.

[10] See Alison Smith, *John Petts and the Caseg Press*, (London, 2000), especially pp. 23-50.

[11] *The Welsh Review*, vol.1, no. 2 (March 1939), 'The Wild Riders' 71, 'The Poor Ones' 83.

[12] *The Welsh Review*, vol. 2, no. 4 (November 1939), 139.

[13] See Brenda Chamberlain, *Alun Lewis and the Making of the Caseg Broadsheets*, and Alison Smith, *John Petts and the Caseg Press*, pp.51-66.

[14] The correspondence between Karl von Laer and Brenda Chamberlain was to inspire much of Brenda's future work and was the basis of the series of poems she published in The Green Heart in 1958. Her letters to him are now National Library of Wales, NLW MS 22494D.

[15] Brenda Chamberlain, in *Artists in Wales*, p. 51.

[16] For a comprehensive account, see R. Gerallt Jones & Christopher J. Arnold (eds), Enlli (Cardiff, 1996).

[17] National Library of Wales, NLW MS 21501E, f. 56.

[18] National Library of Wales, NLW MS 21501E, f. 57.

[19] *Ibid.*

[20] Many of these can be found in, for example, National Library of Wales, NLW MSS 21484–525D.

[21] Brenda Chamberlain, *Tide-race*, p. 182.

[22] Letter to Tom Cross, Welsh Arts Council, 14 May, 1963. Tom Cross curated and wrote the catalogue essay for the touring exhibition, 'Two Painters: Brenda Chamberlain, Ernest Zobole'; see note 23 below.

[23] The exhibition included twenty-five works each by Brenda Chamberlain and by Ernest Zobole. Organised by Tom Cross, it opened at the National Eisteddfod of Wales at Llandudno in August 1963 and toured to Newport, Penarth, Bangor; Welshpool, and Swansea. See also Ceri Thomas on Zobole, chapter VI below.

[24] Brenda Chamberlain, Notebook dated 'Xmas 1954', private collection.

[25] NLW MS 21520B, f. 42.

[26] See Peter Wakelin on Ceri Richards's response in chapter IV above.

[27] NLW MS 21519C, ff. 42-3.

[28] Isamu Noguchi (1904-88), Japanese born, American abstract Expressionist sculptor, who designed many stage-sets including the same production of *Clytemnestra* for Martha Graham for which Halim El Dabh composed the music.

[29] NLW MS 21520B, f.117.

[30] Brenda Chamberlain, *A Rope of Vines*, p. 15.

[31] National Library of Wales, NLW MS 21501E, f. 56.

51. Ernest Zobole: The Castle no.1 (1986)

VI

Ernest Zobole, Painter, 1927-99
Out of and into the Blue

CERI THOMAS

Central to the oeuvre of the Rhondda-

based painter Ernest Zobole (1927-99)

is the notion of the primacy of the visual,

conceptual and imaginative over the verbal,

textual and literal – of a reality informed by

the imagination. As Zobole put it in the

1963 exhibition catalogue to accompany his

two-person show with the painter-writer

Brenda Chamberlain (1912-71):

'…what it comes down to in the end is to use paint rather than words – to do your talking or thinking with your medium.'[1] And he was saying much the same thing towards the end of his life, in the 1992 BBC Wales television documentary on him and his art: '…painting is a part of your life…your breathing I suppose…it is part of what you're about…part of your thinking.'[2]

Such assertions raised the questions of what was being said or thought about in his painting and how this was to be done. These were serious matters to which Zobole applied himself throughout his career and were first discussed with his fellow Rhondda Group art-student members in the late 1940s to early 1950s during their daily train journeys to and from Cardiff Art School.[3] Although they were an informal group with no manifesto, they did share the philosophy of 'make it true, make it new', which, coming partly from the writings of Ezra Pound, was espoused in Cardiff by the painters Ceri Richards (1903-71) and Joan Baker (b.1922) and in the Rhondda by the writer Ron Berry (1920-97).[4] The Rhondda Group talked primarily about art, but in the process they allowed a few select individuals from other walks of life into their railway compartment forum which considered many other subjects ranging from literature, music and film, to politics, medicine and sport. In this way, they were the natural (if unwitting) successors to Swansea's inter-war Kardomah Group which had included the painter Alfred Janes (1911-99), poet Dylan Thomas and composer Daniel Jones.[5] According to Zobole's friend and contemporary Charles Burton (b.1929), the Rhondda Group argued about the relative merits of Picasso, Matisse and Bonnard.[6] It is therefore perhaps not surprising that all three painters are cited in one of Zobole's notebooks of the period, the introduction to which hinges around the key issue of what to depict:

> When an artist paints a picture, he does not do so merely to describe to us the visible appearance of nature, but to tell us something about it. He may want to show us some observation, or he may want to share some particular emotion, which he has felt, or he may have discovered something completely original which he wishes to communicate to us.'[7]

Zobole then proceeds to consider drawing, perspective, composition, colour and the word 'decorative' before writing an aspirational yet cautious conclusion:

But when we paint, we must forget about all the little rules, ideas and conventions we may have, or have read about – we must paint. ...originality and greatness can only come, if it does, after much hard work. Everything springs from work. We must be humble and true to ourselves and work in a way that is natural to us.[8]

The first major indication of his originality was the early magnum opus, 'Llwynypia' (oil on canvas, fig. 52). At 97.5 x 154 cm, it was Zobole's largest painting to date and almost certainly made for the Open Exhibition of Contemporary Welsh Painting and Sculpture which toured Wales in 1953-4. Moreover, it was created at the end of his five years of art training and marked the culmination of a series of innovative blue-palette dominated paintings produced in 1952 and 1953, many of which sported the new phenomenon of the pedestrian crossing, with this canvas alone depicting an arrangement of no fewer than four zebra crossings.[9]

52. Ernest Zobole: Llwynypia (c1953)

It caught the eye of two of Wales's leading figures in the art world. The first of these was David Bell, who had been the first Assistant Director of the Arts Council in Wales and who referred to the picture in a newspaper review:

> Between [two paintings by Colin Allen] is a more daring fantasy by Ernest Zobole. This young painter from the Rhondda has made his picture out of a group of figures with a pram and an unruly bunch of flowers, some children frollicking [*sic*], a zebra crossing and a tarmac road, which have been transmuted by his vision into a harmony of blues.'[10]

The second figure operated through the medium of Welsh. This was the writer Saunders Lewis, who supplied a brief text, entitled 'Peintwyr Cymreig Heddiw' for the catalogue to accompany the follow-up 1954 exhibition, 'Thirty Welsh Paintings of Today', which included Zobole's painting, re-titled 'Llwynypia, Rhondda'. He described the image, along with three other selected pictures (by Evan Charlton, Colin Allen and John Elwyn respectively) in the following way:

> Am Gymru y soniant, am freuddwydusdod styrbiol dociau Caerdydd, neu ryfedd bwyso'r awyr i gymysgu ei lliw â lliw ei strydoedd hi, am firagl cynhyrfus gweledigaeth Llwynypia, am lowyr yn tramwy drwy'r diwetydd tyngedfennol.'[11]

He also prepared an English version of his text, in which he toned down what he saw as the religious connotations of Zobole's '[m]iragl cynhyrfus gweledigaeth Llwynypia' and, to a lesser extent, of the three paintings by Charlton, Allen and Elwyn[12]:

> They tell us about Wales, about the disturbing dream-quality of a Cardiff dock, about the strange pressure of the sky mixing its colour with the colour of the streets, the amazing vision of Llwynypia, and about miners walking under the destiny-laden evening clouds.[13]

A comparison of the differences and similarities between these readings of 'Llwynypia', related commentaries by Bell and Lewis, and Zobole's own words and imaging is worth making. For instance

Saunders Lewis, being both bilingual and a writer, revealed his sensitivity to the difference between disciplines when he went on to qualify his claim about the ability of these Welsh paintings by Zobole and colleagues to inform the viewer:

> But one cannot translate from paint to language. One must stare meditatively and eagerly to receive what the picture says. Perhaps one can discover an akin-ness between M. Eldridge's Corris pen and the poetry of R.S. Thomas, but what is told the eye and what is told the ear are two different things… [14]

His last phrase here relates to Ernest Zobole's statements, already quoted, that the painter '…may have discovered something completely original which he wishes to communicate to us' and '…to do your talking or thinking with your medium.'

David Bell's longer textual reference to 'Llwynypia' provides more linkages to Zobole's thinking as expressed in his notebook introduction. His description of it as '… a group of figures with a pram and an unruly bunch of flowers, some children frollicking, a zebra crossing and a tarmac road …' can be related to the painter's contemporary references to a picture containing 'some observation' and 'some particular emotion, which [the artist] has felt'. Similarly, when Bell writes that it is a '… daring fantasy … transmuted by [Zobole's] vision into a harmony of blues', he inadvertently touches upon the painter's concerns that '…he may have discovered something completely original which he wishes to communicate to us', and, as Zobole put it later on in the same notebook: 'It is only by becoming part of the design that colour in a picture is harmonious'. [15]

The problem with David Bell's newspaper review of January 1954 is that its author, who by then was the first full-time curator of the Glynn Vivian Art Gallery in Swansea and 'devot[ing] the…best years of a man's

53. Ernest Zobole: **Partridge Square, Llwynypia: Study** (c1953)

life to finding and creating' opportunities for artists in Wales, does not seem to have had the time to, as Lewis advises, 'stare meditatively and eagerly to receive what the picture says'. Most conspicuous is Bell's reference to only one zebra crossing. Less obvious is the emotion he alludes to via the words 'unruly' and 'frollicking'. These discrepancies would probably not have occurred had the coastal-dwelling Bell been more familiar with the Rhondda and the particular site depicted. It is the busy crossroads of Partridge Square, Llwynypia (fig. 53), which, among other things, provided access to the main hospital in the area, as the local communities would have known. This was Llwynypia Hospital, located just behind the bus shelter to the rear left of the composition. What even fewer people would have known was that it was the place in which Zobole's thirteen-year-old sister Rosie had died in 1929 from rheumatic fever, an illness which hit the artist himself as a schoolboy in about 1944. This insight informs the emotional tone of the painting and provides the viewer with an explanation for the middle-ground narrative: not 'some children frollicking' but three distressed little girls fleeing across the blue tarmac from the aggressive-looking flying toys they trail on strings and which they seem unable, or unwilling, to release.

If this reading of 'Llwynypia' is correct, it means that the painter is imaginatively incorporating memory and not just emotion into some of his early works – a practice previously deemed to apply mainly to his later ones. Indeed, the fact that Partridge Square was a historically-charged place – the significance of its proximity to the centre of the Tonypandy Riots of 1910-11 would not have been lost on the artist – might

54. Ernest Zobole: Rhondda Crossing (c1952)

have been a factor in his apparent decision to take from another artist's interpretation of another historically-charged place.[16] This was Ceri Richards's peopled and pigeoned 'Trafalgar Square' (1950, oil on canvas, Tate Britain, London), created for exhibition at the 1951 Festival of Britain. Zobole admired the work of Richards and there are distinct parallels between the two pictures. Firstly, there is the younger artist's cruciform composition which echoes the flattened quadrilobic form of the fountain basin in the London painting. Secondly, there is Zobole's 'harmony of blues', which was anticipated by Richards's interest in the music of colours. Next comes the motif of the running girls with flying toys which relates closely in style and content to the animated girl with fluttering pigeons in 'Trafalgar Square'.[17]

But whereas 'Trafalgar Square' was conceived of within the confident and celebratory atmosphere of the Attlee governments and the Festival of Britain, Zobole's 'Llwynypia' came when Churchill had been re-elected and so belongs to a different moment and mood. For we are presented with three generations who, on the one hand, move safely across the zebras which had been newly provided by the 'from-the-cradle-to-the-grave' Welfare State. These representative individuals include two soberly dressed men who are probably older or retired miners out walking, perhaps on a Sunday. One of these 'white-faced, bowler-hatted colliers' is so absorbed with the baby he pushes that he does not seem to notice the gesticulating, flower-bearing woman.[18] She is the pivotal figure of the composition and, perhaps also, of the enigmatic narrative because, whereas the two men and the second woman who approaches on the crossing to the left seem to be oblivious to the three frightened girls coursing alongside them, she appears to be shielding the alert infant from the bizarre drama. Finally, this juxtaposition of temporary security and comfort with the fear of impending threat is subtly reinforced by the painting's two dogs – the one large and resting, the other small and troubled.

Once all these elements are noticed, this major early work goes beyond what the exhibits of 1953-54 'tell us about Wales' and can be read as a visualization of the wider community of the time as treated in Aneurin Bevan's book *In Place of Fear* (published in April 1952), particularly with regard to the broader British issues of the competing costs of the National Health Service and defence expenditure at the time of the Korean War. Like his fellow Rhondda Group student-artists, Zobole had emerged during the ground-breaking Attlee governments of 1945-51 and was an enthusiastic supporter of it and the new Welfare State.

'Llwynypia' is therefore both description and vision. It synthesizes the personal and the general. Its originality in terms of form – Partridge Square's cruciform configuration is exaggerated through a flattening of the road surfaces implying a raised eye-level whilst a lower eye-level and conventional recession are retained for the figures and architecture – and content stems from 'much hard work' and his exhortation that 'we must forget about all the little rules, ideas and conventions we may have, or have read about'.[19] Its descriptive and imaginative use of blue adds to the sense of a heightened, emotional reality and probably accounts in no small part for the fact that Bell and Lewis both use the word 'vision' in their texts on the picture.

By 1953 then, Ernest Zobole had begun to move beyond the very early Rhondda Group style of his and his fellow Rhondda Group painters Charles Burton and Nigel Flower (1931-85) which was defined by Bell in 1951 as their 'trying sincerely in the simplest terms of representational painting to express their regard for their own background and environment'[20] and in 1957 as 'this awareness of environment [which] characterizes the painting which is being done in South Wales to-day'.[21] Admittedly a rootedness was crucially important to Zobole throughout his career. As he put it in 1963: 'To love a place strengthens me, it becomes the material for my painting. Any influence I am likely to undergo can then be used and adapted for my own ends'.[22] And in 1995, he wrote: 'Over the last few years my painting…has been about the place where I live essentially'.[23] But Bell, the pioneering art historian of modern Wales, was resorting to type-casting when, in his efforts to identify and encapsulate a new collective identity, he focused on content rather than form in order to pigeon-hole the young Zobole with the rest of the Rhondda Group.

Ernest Zobole was always interested in more than a Welsh environmentalism:

> The idea or subject, the formal constituents and the size the picture is to assume are linked together. I have found the question of size to be so important that it could stop me working on a picture whose size I would consider too large or too small. Things have to fit into a picture to remake a world.[24]

This attitude is evident in his next major series produced in 1960, entitled 'Ystrad and People' and based upon the nearest equivalent to a village square in his native Ystrad Rhondda. About ten pictures were

painted and their sizes and proportions vary. For example, 'Ystrad and People no. 8' (oil on board, fig. 55) is a larger landscape-format work which encompasses the parish church of St Stephen's whilst 'Ystrad and People no. 10' (oil on board, fig. 56) is a smaller, portrait-format one, which homes in on the central, bus-stop area. The other important feature to note in this series is the shift towards an increasingly neutralised palette:

> ...the kind of colour you actually use is for a technical reason not a descriptive one. Some of my earlier work is essentially monochromatic, mostly of a grey-blue colour. It had to be that way for me then because I was concerned with trying to find a form to work with, and a colour would have got in the way. [25]

55. Ernest Zobole: Ystrad and People no. 8 (1960)

This was because, as Picasso and Braque had done when developing Cubism fifty years earlier, Zobole was breaking away from the established conventions of unified pictorial space and anatomical correctness. Thus, the flagstone pavements in 'Ystrad and People no. 10' become almost vertical white surfaces, buildings and bushes are darkened and radically simplified and the figures are turned into mostly faceless manikins. In this picture, his growing interest in both the optical and tonal and the metaphoric and symbolic values of light and shade is evident.

Zobole the valley-dwelling painter was intrigued by all kinds of lighting and contrasts, though this was not usually verbalized. One of the few exceptions is a recently discovered untitled poem about the permanent and shifting reality of his Rhondda as he saw it in 1984:

1 It is rough and gentle
 Beautiful and ugly
 Very light and very dark.
 To see the light you have to look toward
5 the mountain tops; in the valley it is
 dark, even in summer.
 Most of the mountains are man made – from
 The Pits.
 Now they are greenish.
10 All the buildings tilt.
 There are no right angles.
 Windows are everywhere.
 Behind each window people are living.
 Out of each window – the moon.
15 Stars are near,
 and the sea is not far off.
 People live and sleep in rows.
 There's television.
 There is no perspective.
20 On a good night you can see everything.........[26]

56. Ernest Zobole: Ystrad and People no.10 (c1960)

It is not known what prompted him to write this one-off poem, though its various drafts indicate that he took it quite seriously. Four other versions of the two opening lines exist. The adjectives 'gentle' and 'beautiful' are fixed, whilst 'awful' and 'awesome' are considered instead of 'ugly'. The combination 'rough and gentle' is switched to line two in three cases, with the adjective 'harsh' noted as an alternative to 'rough' in another draft. Two variations to line six's 'in summer' were contemplated: 'when the sun is out' and 'in the daytime'. Line eight changed from 'black' to 'The Pits' and the following line from 'some are turning green' to 'Now they are greenish'. Lines twelve to sixteen were added to an early version and the last two lines crystallised in the later drafts.

A likely explanation for its creation is the fact that in the mid-1980s Poetry Wales Press started to use recent paintings by Ernest Zobole on the covers of several of its publications. The first of these was 'Some Trees and Snow' (1978, oil on canvas, National Museums and Galleries of Wales, Cardiff), for the Rhondda-born poet Joyce Herbert's book *Approaching Snow* (Bridgend, 1983). In the following year, his 'Landscape around December' (1977-8, oil on canvas, City & County of Swansea: Glynn Vivian Art Gallery) was reproduced on the front of Raymond Garlick and Roland Mathias's anthology *Anglo-Welsh Poetry: 1480-1980* (1984). This latter painting had inspired the poet Bryan Aspden to write a 'Landscape

57. Ernest Zobole: The Castle no. 2 (1986)

around December – Ernest Zobole' which was published in Aspden's collection of poetry *News of the Changes* (1984).

Unlike Zobole's poem, Aspden's uses the warm-toned night painting 'Landscape around December' to build on the idea already provided by the painter that returning to the Rhondda '… was like getting back into a warm bed.'[27] Interestingly it is 'Daffodils, Windflowers', another (rather bleak) poem in Aspden's book, which might in turn have stimulated Zobole to produce two new paintings. It contains a male character identified by the capital letter K who is a central or eastern European at odds with the alien environment in which he and his companion W find themselves:

> That night on the box, two refugees
> Who'd escaped from the camp
> Where the war's afterthoughts had penned them
> And landed on this farm in mid Wales.[28]

Thereafter, the poem strongly recalls the poet John Ormond's 1960 film 'Borrowed Pasture' which featured two Polish Army war veterans struggling to survive off the Carmarthenshire land.

The two paintings were 'The Castle no. 1' and 'The Castle no. 2' (oil on canvas, fig. 51 and 57), and created for the artist's one-person exhibition 'Recent Paintings by Ernest Zobole' held at Newport Museum and Art Gallery in 1986. Like Aspden's poetry and Ormond's films, they combine references to the word and imaging by others. The first clues were provided by their titles and the accompanying exhibition-catalogue introduction by David Fraser Jenkins, Assistant Keeper of Art at the National Museum of Wales from 1969 to 1980:

> The two versions of 'The Castle' seem an innovation, but are not really so far from some of the other paintings…The beginning of Kafka's novel as illustrated [*sic*], in which the curious occupants of the building resent the intrusion of the stranger from outside, who arrives exhausted and with his mouth open, gasping.'[29]

Zobole's personal library contained a selection of books by Franz Kafka and these two pictures depict quite closely an episode in chapter one of the novel *Das Schloss* (*The Castle*), first published in 1926:

> The door opened immediately…and there appeared an old peasant in a brown fur jacket, with his head cocked to one side, a frail and kindly figure. 'May I come into your house for a little?' asked K., 'I'm very tired.' He did not hear the old man's reply, but…in a few steps he was in the kitchen. A large kitchen, dimly lit. Anyone coming in from outside could make out nothing at first. K. stumbled over a washing-tub, a woman's hand steadied him. The crying of children came loudly from one corner. From another steam was welling out and turning the dim light into darkness. K. stood as if in the clouds. 'He must be drunk,' said somebody. 'Who are you?' cried a hectoring voice…'I am the Count's Land Surveyor,' said K., trying to justify himself.[30]

What Fraser Jenkins was unable to do in his short piece was compare text and image. Kafka tells his readers:

> Near the door clothes were being washed. But the steam was coming from another corner, where in a wooden tub … two men were bathing in steaming water. But still more astonishing … was the scene in the right-hand corner. From a large opening, the only one in the back wall, a pale snowy light came in, apparently from the courtyard, and gave a gleam as of silk to the dress of a woman who was almost reclining in a high arm-chair. … Several children were playing around her, peasant children, as was obvious, but she seemed to be of another class, although of course illness and weariness give even peasants a look of refinement.
>
> 'Sit down!' said one of the men, who had a full beard … . On the settle the old man who admitted K. was already sitting, sunk in vacancy … and the woman in the arm-chair lay as if lifeless staring at the roof without even a glance towards the child at her bosom.
>
> She made a beautiful, sad, fixed picture, and K. looked at her for what must have been a long time. … the other … man … had a much smaller beard … and it was he who said: 'you can't stay here, sir. Excuse the discourtesy.' 'I don't want to stay,' said K., 'I only wanted to rest a little.' K. … approached the woman in the arm-chair, and noted that he was physically the biggest man in the room.[31]

In many respects, Zobole presented the viewer with a fairly faithful representation of this account. However, one key difference was the insertion of an aggressive-looking dog in both paintings. Another addition was the drum-playing child towards the top right corner of 'The Castle no. 1'. No such dog or child occurs anywhere in the book and whereas dogs appear throughout Zobole's oeuvre, aggressive ones were very rare and children drumming are non-existent. A plausible explanation for the former variation is that the dog compensates for the absence of dialogue and therefore conveys the fact that K.'s presence is not welcome. The drumming child is more problematic because it does not directly correspond to the crying and playing children mentioned by Kafka.

But this second motif provides a minor clue about another reference in Zobole's two pictures. It is enhanced by the central figure and the emphasis upon hands. Kafka tells us that 'a woman's hand steadied him' as K. stumbled upon entry into the dark interior. But this is not what Zobole gives us. If anything, the additional pair of hands which occurs at the level of K.'s head in 'The Castle no. 1' appears to exist in a time lapse and to belong to K. himself. Indeed, the blue hand within the doorway itself can be read as a reflection of the protagonist's right hand. In 'The Castle no. 2' Zobole discards, as it were, this additional pair of hands by placing them to the left of the door frame and turning K.'s head away from the menacing dog and busy washerwoman towards the seated woman whose room no longer overlaps the door but is receding to the right.

These elements bring to mind the Orpheus myth as provided by Ovid's *Metamorphoses* and Jean Cocteau's 1926 play and 1949 film versions entitled 'Orphée'. Thereby, Zobole's dog is also a single-headed version of Ovid's Cerberus and the drum a reference to Orpheus's musicality and fate at the hands of the Bacchantes. Likewise, K. is also Orpheus, the dark kitchen is Hades, the 'woman in the arm-chair' who 'lay as if lifeless' is Eurydice and the additional hands are also death's rubber gloves used, in 1949, by Orphée. Cocteau employed a door-sized mirror as the entrance to and from the underworld in his play and film based on the Orpheus story. Furthermore, Zobole is known to have seen and admired the Frenchman's films soon after their release during his early Rhondda Group years and to have watched foreign language films thereafter. Of especial note here is the lingering camera shot of the doomed poet's head in left profile

and his raised hands pressed to the mirror-door immediately prior to his passage into the beyond, because it was used as the motif for the original film poster and it is this same pose which is adopted by Zobole for his protagonist in 'The Castle no 1'.[32]

All this begs the question as to why Ernest Zobole might have chosen to weave this orphic subtext into the Kafka. An answer lies in the 1986 Newport exhibition and the catalogue text:

> … the older Rhondda has suffered: there has been the long period of the miners' strike, and finally the last pit of the valley, Trehafod, has closed. This has obtruded into the paintings, and suggests a more careful reading of the actions and moods of their subjects.[33]

Fraser Jenkins prefaced these words by referring to Zobole's retirement, also mentioned in the exhibition catalogue by Newport Museum and Art Gallery's Keeper of Art, Roger Cucksey, who wrote that the artist's 'fears for [Rhondda's] future are transmitted to all those who view and become involved with the paintings in this exhibition.'

These observations serve to pinpoint the strong sense of ending, exclusion and loss which the painter clearly felt due to the combination of his premature retirement from Newport College of Art in 1984 and the unsuccessful Miners' Strike of 1984-5. Moreover, such feelings had been intensified by the early retirement of his wife, Christina Zobole, at the same time, due to serious illness which had led to cardiac surgery and which,

58. Ernest Zobole: People and Dogs, Ystrad (c1958-9)

he knew, would ultimately lead to her death. When this context is known, Kafka's 'woman in the arm-chair' who 'made a beautiful, sad, fixed picture' also represents Eurydice and Christina who, as depicted in 'The Castle no. 2', once looked at begins to fade away.

This story of the power of sight again underlines the centrality of the seer and the primacy of imaging for Zobole – 'to do your talking or thinking with your medium'. The eye is invasive and visionary, and its living beauty resides in its ultimate vulnerability. This is why, in the two 'Castle' pictures he paints the animated 'Land Surveyor'-intruder in vital, viridian green surrounded by contrasting blue blacks, whites and yellows. Similar dualities of light and dark, life and death, freedom and restriction are explicit and implicit in his 1984 poem where the visual dominates the vocabulary: 'To see' and 'to look' in line four and the rhyming 'sea' in line fourteen; 'Windows' in line ten, reinforced by the repeated 'each window' in the following two lines; 'television' in line sixteen; 'no perspective' in line seventeen; and culminating with 'you can see everything' in the final line.

Zobole's shift away from the conventional perspective of fixed, monocular vision towards a more conceptual, kinetic and filmic approach had begun some twenty-five years earlier in 'People and Dogs, Ystrad' (oil on canvas, fig. 58), where its combination of two differing viewpoints – a tilted foreground with figures, canines and a background seen in normal elevation – superseded that employed in the earlier 'Llwynypia'.[35] And the devotion of the lower half of the picture to this aerial view and to two free-roaming, territorial village dogs with their all too-human eyes is telling because it brings to mind the opening and

59. Ernest Zobole: People and Dogs, Ystrad: Study (c1958-9)

closing (daytime) sequences of similar dogs seen from an upstairs window in 'Mon Oncle' ('My Uncle') (1958) by the French film-maker Jacques Tati, whose verbally sparse creations were much admired by the painter. Furthermore, just as the marked contrast between the canines' world and the more conventionally populated one in the upper half of the canvas echoes a similar division in Tati's classic film, so Zobole's motif of a dark head enclosed within the loop of the lamp-post reflects another (night-time) sequence in the film where two watching silhouetted heads appear in a pair of illuminated circular windows, like a pair of eyes.

60. Ernest Zobole: A Painting about myself in a Landscape (1994-5)

Eventually though, the hierarchy of metaphorical apertures connoted by window and eye is enhanced by the figure-in-the-door which becomes a defining leitmotif in the late paintings of Zobole from 'The Castle no. 1' and 'The Castle no. 2' onwards. It rapidly evolves into an isolated, figure/watcher in a portal which can be read as doorway/mirror/ coffin.[36] A good example is 'A Painting about myself in a Landscape' (oil on canvas, fig. 60), in which the all-seeing bespectacled artist surveys in his mind's eye his native Ystrad. Crowned by the hilltop community of Penrhys, he gazes over a nocturnal Ystrad towards the dark hillside of Llwynypia Mountain and Mynydd y Gelli edged by the pale, starlit profiles of Nantygwyddon tip, and within which the not-too-distant streetlights of the writer Rhys Davies's Clydach Vale are suggested. The dark hillside area which counterbalances the painter evokes a sense of absence not entirely unlike the final 'empty' illustration in Antoine de Saint-Exupéry's classic book *Le Petit Prince* (*The Little Prince*) (London, 1945; Paris, 1946). Here, Zobole is like a *Mabinogion* narrator or an early Sienese painter whose visual mapping enables him to preside over his recreated world.[37]

Finally then, in his 'nocturnes' of the 1990s, from 'In a Surrounding Landscape' (oil on canvas, fig. 61) – via 'A Painting about myself in a Landscape' – to 'A Painting about the Land' (oil on canvas, fig. 62), Zobole returns to the colour blue he used forty years earlier, though now it is accompanied by an encroaching blue-black. In a breathtaking parallel to the special effects blue screen used in film and television, the ageing Zobole employs blue and black pigments for his last, rooted and imaginative imaging:

61. Ernest Zobole: In a Surrounding Landscape (1993)

62. Ernest Zobole: A Painting about the Land (1997)

Looking at night, the lit-up parts only are visible, scattered in a dark blue background, and this has suggested the form the painting could take. Partly by working in this way I'm not asking you to fill in the gaps; I'm using this as a formal method of putting things where I want. They don't have to be architecturally correct or whatever. I like the idea of your moving about the picture, moving about space.

Blue is indicative of space, something not solid. It allows me to move about in the space of the painting. If a painting describes something literally, then the colour has to go along with it, and if you don't describe literally, and you draw your idea of a thing, rather than the thing itself, then some other non-objective colour has to be used, colour which relates to your idea – and since this thing that you are making in a painting is not a real object at all, I use blue.[39]

These brief 'explanations' allude to the inner from outer world also proposed in the last, open-ended line of his poem – 'On a good night you can see everything.........' – and upon the creation of which Ernest Zobole had expended 'much hard work' throughout his fifty-year career.[40]

[1] Ernest Zobole was quoted by Tom Cross, 'Ernest Zobole', *Two Painters: Brenda Chamberlain Ernest Zobole* (Cardiff, 1963), catalogue to accompany the 1963-64 touring exhibition organised by Welsh Committee of the Arts Council. In the foreword, Cross wrote that the two painters '… share…an ability to interpret through painting the places in which they work and their approach is lyrical and poetic.'

[2] Ernest Zobole, *Ernest Zobole: Seeing and Remembering*, BBC Wales television (filmed 1992 and broadcast 1993).

[3] The core group consisted of six males all residing in Rhondda Fawr. The first of these was Charles Burton (b. 1929) who came from Treherbert and started at Cardiff Art School in 1946. He was followed there in 1947 by Nigel Flower (1931-85) from Treorchy and Robert Thomas (1926-99) from Cwmparc. The next year brought Zobole himself, from Ystrad, and Gwyn Evans (b. 1931) from Tonypandy. Lastly, there was David Mainwaring (1933-93), another resident of Treherbert, who attended from 1949. They were joined by a seventh man from Ynyshir in Rhondda Fach: this was Tom Hughes (1923-88) whose art training had been interrupted by the war.

[4] See Robert Thomas, 'Make it true, make it new', *New Welsh Review*, 38 (Autumn 1997) 13-14; Ceri Thomas, *Branching Out*, University of Glamorgan, (Pontypridd, 2002), pp. 6, 14; Ceri Thomas, 'Introduction', *Ernest Zobole: a retrospective*, University of Glamorgan, (Pontypridd, 2004), p. 5.

[5] See Alfred Janes, Daniel Jones, Dylan Thomas et al. in *Swansea and the Arts*, facsimile BBC script broadcast, Home Service (Wales), 24 October 1949 (Swansea, 2000); Dylan Thomas, 'Return Journey', *The Dylan Thomas Omnibus* (London, 2000), pp. 318-19; Ceri Thomas, 'Alfred Janes: maker of pictures', *New Welsh Review*, 44 (Spring 1999) 13-15; Ceri Thomas, 'From School of Art and Crafts to College of Art – inside and out', in *Drawn from Wales: a School of Art in Swansea 1853-2003*, ed. Kirstine Brander Dunthorne, (Cardiff, 2003), pp. 58-71.

[6] Charles Burton, *Ernest Zobole: Seeing and Remembering*, BBC Wales television broadcast, 1993.

[7] Ernest Zobole, 'Introduction', in unpublished notebook 'Drawing and Painting', *c*1952-3 (private collection).

[8] Ernest Zobole, 'Conclusion', in 'Drawing and Painting', *c*1952-3.

[9] The very first zebra crossing in Britain had appeared in Slough on 31 October, 1951 and the feature had spread to Wales by 1952. A simpler, early example of his was 'Rhondda Crossing' (*c*1952), oil on canvas, University of Glamorgan, Pontypridd (see fig. 54).

[10] David Bell, 'Welsh School of Painting', *South Wales Evening Post*, 9 January 1954.

[11] Saunders Lewis, 'Peintwyr Cymreig Heddiw', *Thirty Welsh Paintings of Today* (Cardiff, 1954), catalogue to accompany the 1954 touring exhibition organised by Welsh Committee of the Arts Council.

[12] The original Welsh version '[m]iragl cynhyrfus gweledigaeth Llwynypia' (literally the 'stirring miracle of the vision of Llwynypia' – my translation) has religious connotations which were perhaps suggested to Lewis by the decidedly cruciform composition of Zobole's painting, its colour mood and the presence of Saint Cynog's church in its top right corner. Zobole was the youngest artist to be singled out by Lewis and 'Llwynypia' was one of only five works that were both illustrated and written about by Lewis, the remaining four being works by Colin Allen, John Bowen, Evan Charlton and Mildred Eldridge.

[13] Translation by Saunders Lewis, quoted in Peter Lord, *The Visual Culture of Wales: Industrial Society* (Cardiff, 1998), p. 261.

[14] *Ibid*.

[15] Ernest Zobole, 'Colour', in 'Drawing and Painting', *c*1952-3.

[16] For a detailed study of the Riots (including Winston Churchill's involvement as Home Secretary), by Zobole's former Rhondda Group colleague Gwyn Evans, see Gwyn Evans and David Maddox, *The Tonypandy Riots* (Mid Glamorgan, 1992).

[17] Likewise, Zobole's motif of a woman with 'an unruly bunch of flowers' can be linked to other contemporary works by Richards such as 'Bouquet' (1952).

[18] For the phrase 'all those white-faced, bowler-hatted colliers' derived from Bert L. Coombes's *These Poor Hands*, see Dai Smith *Aneurin Bevan and the World of South Wales* (Cardiff, 1993), p. 95.

[19] This 'forget[ting] about all the little rules' is indicated in part by the artist's surviving small sketches on paper of the crossroads site of Partridge Square, Llwynypia, which are much more literal and include, for example, Belisha beacons which are subsequently eliminated. His understanding of the need to go beyond mere descriptive content and deal with something more emotional and original was influenced by his contact at this time with the painter Heinz Koppel (1919-80) and his transformational paintings.

[20] David Bell, 'Contemporary Welsh Painting', *The Welsh Anvil/Yr Einion*, 3 (July 1951), 28.

[21] David Bell, *The Artist in Wales* (London, 1957), p. 172. Unfortunately, Bell did not live long enough – he died in 1959 – to witness the artist's development from 1960 onwards whereas twenty-five years later a younger art historian was able to write that Zobole and the Rhondda Group 'began to see their native environment through the filter of a kind of magic realism, tinted with the ideas of Chagall as transmitted by Koppel.' (Eric Rowan, *Art in Wales: An illustrated History 1850-1980* [Cardiff, 1985] p. 122.)

[22] Ernest Zobole, as quoted by Tom Cross, 'Ernest Zobole', *Two Painters: Brenda Chamberlain Ernest Zobole*.

[23] Ernest Zobole in *Intimate Portraits*, ed. Alison Lloyd, (Bridgend & Swansea, 1995).

[24] Ernest Zobole, as quoted by Tom Cross in 'Ernest Zobole', *Two Painters: Brenda Chamberlain Ernest Zobole*.

[25] Ernest Zobole in Tony Curtis, *Welsh Painters Talking* (Bridgend, 1997) pp. 174-5.

[26] Ernest Zobole, untitled and unpublished poem (1984), collection of University of Glamorgan, Pontypridd – discovered by Ceri Thomas in 2004.

[27] Ernest Zobole, as quoted by Tom Cross, 'Ernest Zobole', *Two Painters: Brenda Chamberlain Ernest Zobole*. See also: David Fraser Jenkins, *Y Bryniau Tywyll Y Cymylau Trymion/The Dark Hills The Heavy Clouds*, (Cardiff, 1981) p. 51.

[28] Bryan Aspden, 'Daffodils, Windflowers', *News of the Changes* (Bridgend, 1984).

[29] David Fraser Jenkins, 'Introduction', *Recent Paintings by Ernest Zobole* (Newport, 1986). For a fuller consideration of Zobole and Kafka's *The Castle*, see Ceri Thomas, 'The material for my painting?', *New Welsh Review,* forthcoming in no. 67 (Spring 2005).

[30] Franz Kafka, *The Castle*, trans. Edwin & Willa Muir, (Harmondsworth, 1974), p. 18.

[31] *Ibid*, pp. 18-19.

[32] I am grateful to a former pupil of Zobole, the painter Ken Elias (b. 1944), for having drawn my attention to this similarity.

[33] David Fraser Jenkins, 'Introduction' in *Recent Paintings by Ernest Zobole*.

[34] Roger Cucksey, [Foreword] in *Recent Paintings by Ernest Zobole*.

[35] The flattening of perspectival recession in the near pavement and dark, rough ground is established by the directional brushwork and by the vertical mark-making employed in the various ink studies for the painting such as 'People and Dogs, Ystrad: Study' (*c*1958-9), ink on tinted paper, University of Glamorgan, Pontypridd (see fig. 59).

[36] For references to the motif as coffin, see: 'Ernest Zobole' in Tony Curtis, *Welsh Painters Talking* (Bridgend, 1997), pp. 179, 181. The painter's personal library contained a copy of *David Jones* (Harmondsworth, 1949) which includes a reproduction of 'Manawydan's Glass Door' (1931), the original watercolour of which was owned by one of Zobole's artist-associates. It, together with its source in *The Mabinogion*, may have provided him with yet another inspirational influence.

[37] For the artist's references to *The Mabinogion*, Penrhys and early Italian art, see: Ernest Zobole in *Welsh Painters Talking*, pp. 175, 177 & 180. For a discussion of these, see Ceri Thomas, *Ernest Zobole and Ystrad*, University of Glamorgan, (Pontypridd, 2004), pp. 13-15; Ceri Thomas, 'Around and About – The Nocturnes: 1990-99', *Ernest Zobole: a retrospective*, University of Glamorgan, (Pontypridd, 2004), p. 38.

[38] Ernest Zobole in *Welsh Painters Talking*, p. 180.

[39] Ibid, pp. 172-173.

[40] The artist had referred to the imaginative potential of the black night in *Ernest Zobole: Seeing and Remembering*, BBC Wales television broadcast, 1993: '… looking around now you can see objects illuminated and they crop up at different levels of a black curtain, as it were, … and I imagine this big black area is the canvas where you can put things where you wish so that the landscape can spread all over the place. That again helped to get this form that enabled me to travel around in space and time.'

63. Iwan Bala: Gwales (2003)

VII

Visual Voices and Contemporary Echoes

Osi Rhys Osmond *While there are now many more*

ways of making visual art than the

traditional methods of painting

and sculpture, it is painting and

other two-dimensional image-

making which best reflect the

relationship between the image

and the word in the visual culture

of contemporary Wales.

And as this book is primarily concerned with the relationship between painting and the word, it is painters and their work that will be discussed at greater length. This chapter will examine the ways in which some contemporary visual artists use literature and language as a source of, and a catalyst for, the development of ocular imagery and the manner in which actual words and text are essential to the functioning of certain images, even becoming embodied within the surface of the work. I shall consider how the parameters of permissibility have changed, allowing artists to engage with their work in new ways and with new priorities, and question where and how does their work begin? How do words inform the image, and vice versa? Which comes first? And where and how does the creative process start and develop?

Painting is both lucid and miraculous, coming as it does from knowledge, sensibility and intention. In consideration of this we must examine how these elements combine in the artist's creative processes and in the action of making. Although we are discussing the relationships that may exist between the written word, particularly poetry, and the visual arts, particularly painting, we must see the differences as well as the similarities. The very physicality of paint as a substance distinguishes it from the inert matter of the printed or written word. Language can of course be rich, moving and sensual by association and while our response to certain uses of language is anything but inert, the words themselves are still, and excepting the remembered, fixed on the page and require the voice, spoken or silent, to bring them into life. And although typographical and calligraphic acrobatics may move us emotionally, as we make or decipher them, the writer or reader does not have the same fluid, tactile experience of them as the painter has with his materials. Paper, pen and the tangible means are of course important to writers as to readers, but this is a much more discrete relationship than the physicality of the painter's corporal engagement. The awareness of time, to both the writer and the painter has a significant effect on the way they both construct their work. Both must consider time past in time present, and be aware of time passing, future time and time frozen, and the moment of the work's abandonment, which becomes the moment of its future being and contemplation. And whereas the poem takes time to read, the painting can essentially be seen in a moment. And yet both also fix parallel though differing aspects of time: time recalled, the time of making, the time of interpretation and of reflection.

Many of the artists cited in this chapter are concerned with a strongly defined political and cultural agenda. The way that they may use words and language in their practice as artists is clearly very different from those who work from a more personal or even spiritual source. That is not to claim that one stance is superior, but it is important to see the critical distance that lies between them. Iwan Bala, Ivor Davies, Tim Davies and David Garner can certainly be placed in the first group; their work tends to be driven by a commitment to radical change in society and by a deep concern for cultural loss. Language is prominent, dominant and even critical to the functioning of much of their output. Sue Williams, Christine Kinsey and Shani Rhys James are painterly confessionalists. They work from an interior state and their painting becomes the incarnation of an inner struggle, with memory and self-image battling to resolve deep-seated existential conundrums, and, excepting Sue Williams, words lie behind their images, not upon them. Brendan Burns treats landscape with a poetic involvement that seeks on the canvas an equivalent visual sensation to the beach-walking that is the starting place for his painting, while John Selway operates as a cultural bi-valve, creatively filtering all the literary, actual, filmic, personal and poetic stimuli that pass through his particular orbit.

The artists discussed in this chapter have shown work publicly in Wales during the last two years and have illustrated the relationship between the word and the visual image in differing ways. There are many others worthy of inclusion, and they have not been overlooked. Catrin Webster's work and practice, for instance, is essentially poetic, involving writing, notation and painting, while lyrical landscape artists like Peter Prendergast and Mary Lloyd Jones work directly from nature. The META group, which recently exhibited work inspired by the poetry of contemporary poets, establishing links with writers like Elinor Wyn Reynolds and Menna Elfyn, has done much to further the links between artists and poets. Writers such as Gillian Clarke, Robert Minhinnick, Nigel Jenkins and Grahame Davies have in their poetry demonstrated a dynamic, vividly visual language that has influenced many artists. Much current poetic output shows a tactile, physical presence, as in Gwyneth Lewis's poetry, where hedges uproot themselves and constellations fall, laying out plans for the golf courses of the new Wales.

Our contemporary and recent poets have provided a great deal of the essential matter with which, and about which to think, vital to visual artists in their deliberations. Dylan Thomas, Waldo Williams and R. S. Thomas

were all acutely visual, while Dylan Thomas used drawing as a critical adjunct to his creative thinking and its development.[1] Thomas's early friendship with Mervyn Levy sparked a lifelong fascination with the visual arts, and in inspiring Ceri Richards to some of his finest work directly extended his influence to contemporaries like Iwan Bala. This of course has not just been one-way traffic: poets have moved closer to artists in their modus operandi and the benefits have been mutually sustaining. This is demonstrated in the National Eisteddfod commissions of poems to accompany the visual art exhibitions, where art makes matter for poetry, and vice versa too, as Elin Huws shows in her astonishing tapestries incorporating the words of Waldo Williams. Established conceptual artists like Cerith Wyn Evans or Bethan Huws and newer names like Carwyn Evans and Bedwyr Williams push forward the word-image agenda in installation, photomontage, Morse code, searchlights, cardboard bird-boxes and autobiography.

In a world increasingly dominated by visual stimuli, it is salutary to note that many artists, when asked about the sources of their work often respond with the name of a poet or poem, an author or a book. The word appears to be an important spur for visual imaging. Words and images work in concert, becoming one; what is seen and read, what is remembered and what is imagined co-exist and become mutually informing. Words and images function as the matter of conscious and unconscious thought. As well as the experience of our immediate personal environment, we are now informed and entertained by film, television, magazines and other media, which also act as tools of mediation, allowing us to see the world differently from each other and from our forebears, for we have conditional perceptions. We also become the authors of visual and audio production, for the electronic revolution's ease of access and manipulation has made auteurs of us all, as art in the age of digital reproduction has drastically altered our living and its interpretations. And although the moving image is clearly primarily visual, it is often the language spoken and the sound that painters or other artists refer to when describing their particular reading of television or film, rather than merely the visual sequencing or editing. Philip Nichol manages to make a visual 'novel noir' out of the forgotten, overlooked vistas of urban Cardiff, revealing the strange poetry that lies behind the unconsidered (fig. 64). He does this with a chemical luminosity, painting sharply on the edges of acidity. His reading and reflection take in the detective story and film, mediating them through a painterly sensibility as he relentlessly quotes from fiction in his interpretation of the everyday. He cycles

to his studio, deliberately choosing the back roads: he paints as he moves through the world, for much of the thinking that artists engage in happens away from the studio. In the same way that writing does not necessarily begin at the desk, or film-making behind the camera, the act of painting is an ongoing consideration of the painter, wherever he or she may be.

Methods of thinking and means of thinking are much debated. How do we think and what do we think with? If, as is claimed, we need words to think, where do images fit in and where do they come from? Where are they stored? What, is the relationship between thought and the imagination? Imagination, it is said, lies between perception and reason, and is dependent on perception but also requires thought. The life of Helen Keller, who was blind and deaf from infancy, yet managed to think, imagine, communicate and demonstrate a sophisticated intelligence, illustrates the possibility that thinking initially functions independently of language, and her experience contradicts much of what is still held to be the reality of the life of the mind.

Can we think with forms that are not bound by words? Painters operate from intentions that are ultimately visual, but in our times the means of achieving their aims, are, it seems, highly word-dependent. Many assume that thinking is an autonomous, enclosed activity, done privately; others see thinking more as happening as a result of our connections to a culture, adding that thinking always occurs within a

64. Philip Nicol: Bend (2004)

structure. Does thought require ingredients? What are they? What part do the senses play? Do they provide the substance and grammar of thought? Thinking is more than just a neurological process; it is not a thing, it is an event, and the perceptions are not merely sense-specific: some people are able to detect and sense colour through touch and proximity, whilst others compensate for failure in one sense by the more focussed use of those that remain. The poet Anne Stevenson when losing her hearing wrote these lines in her poem, 'On going deaf':

> I've lost a sense. Why should I care?
> Searching myself, I find a spare.
> I keep that sixth sense in repair
> And set it deftly like a snare.[2]

These four lines succinctly illustrate the experience of both artists and poets equally. Both have to develop a kind of sixth sense, an all-embracing perceptual system that is as penetrating as possible and in which all the available and functioning senses combine to present an effective response to the exterior and interior worlds. And in the later re-presentation of this in the making of the poem or painting, it is sometimes necessary to approach subject matter and materials as though planning an ambush or setting traps, that is, with stealth.

Paintings are, after all objects, which have an independent existence free from the painter who made them. They offer the viewer an experience that like poetry does not depend entirely on understanding. They are present, manufactured from inanimate material and drawn in being and spirit from those impenetrable spaces where thought, desire, perception, reason, memory and the imagination meet.

Iwan Bala's *Darllen Delweddau* ('Reading Images') (2000) juxtaposes the words of poets, in Welsh, with the images of artists, both sculptors and painters. Bala has argued that the duty of the contemporary Welsh artist who is serious and conscious of the national question is to put the old iconographies of Wales behind us and to devise them anew through researching the past, describing the present and foreseeing the future.

He adds that this is also the territory of the poet, where the poet and artist are connected to similar purpose. Not all poets or artists feel this way, but in the absence of a dedicated visual-arts platform, the main meeting-point for discussion for both art and poetry are the magazines *New Welsh Review* and *Planet* in English and *Barn, Taliesin* and *Golwg* in Welsh. Many of the leading writers on visual art are poets: Tony Curtis has published widely in English and Iwan Llwyd has written extensively in the Welsh media. Most of our prominent native artists, however, do concur with the above statement by Iwan Bala, who, since emerging in the early 1980s, has become firmly established as a leading artist and polemicist. His visual work, almost always being related to the historic and present predicament of Wales, exploits literary sources, while more recently his own writing has made a vital contribution to the examination of our contemporary visual culture. This is hardly surprising when we examine his arrival and development as an artist, emerging at the same time as the new Welsh-language television channel, S4C, established in 1982 after a protracted struggle by language activists, who included the artist. He began with an agenda that was not simply concerned with art in the aesthetic or abstract sense but with an art that has as its primary concern the vicissitudes of a culture and language struggling to survive in an increasingly homogenised cultural reality. The necessity to refer to or remake the mythologies of Wales has been one of the continuing rationales behind his prolific output.

As well as painting he creates installation, sculpture, print and assemblages, collaborating with theatre director Ed Thomas,[3] putting on drama in the exhibition space, and organising international exchanges, for his view is not simply narrowly nationalistic but sympathetic to all minorities. His work as an artist is

65. Iwan Bala: Cara Walia Derelicta (2004)

inseparable from his activism, forming a seamless whole with his writing and lecturing, while by brilliant positioning he has established an influential and important role for himself and his ideas. Simultaneously, he has pushed at the boundaries of acceptability in subject matter, taste and in the means of making images. For this artist, the word is essential as he constructs an eclectic visual 'agitprop' that asks the complacent Welsh to rethink their identity, history and cultural iconography.

In 'Gwales'(fig. 63) he uses the noun as a visual device, drawing the outline shape of Wales like a leaking diagram of meteorological open-heart surgery conducted on a geological scale. He is referring, of course, to the legendary island of Gwales, where the heroes of the Mabinogion lived in an oblivious, timeless reverie until they opened the glass door to the real world. The familiar story is co-opted by the artist, sending a clear message to contemporary Wales. On the surface of the painting are words from the *englyn* 'Y Gorwel' by Dewi Emrys refashioned by Mererid Hopwood and appropriated by the artist, thus linking an ancient spoken myth via the painting of David Jones to the contemporary dilemma of Wales.

> Wele rith fel ymyl rhod - o'n cwmpas,
> Campwaith dewin hynod;
> Hen linell bell nad yw'n bod,
> Hen derfyn nad yw'n darfod.
>
> (Look, a mirage, like a round rim, a strange
> Wizard's masterpiece about us;
> An old line that's not there,
> A boundary that never ends.)[4]

This relationship with the word is very direct, didactic and entirely dependent; the image alone will not suffice. Humour, irony and the prejudices of our neighbours are turned around as the old horse is whipped along in 'Chwipio ceffyl wedi marw', a difficult and thankless task. In Bala's work, Welsh tourist images, ladies in tall hats, leeks and daffodils, the usual clichés and stereotypes have been examined,

deconstructed, stripped of old meanings and reinvented to carry a direct, particular and liberating message of a culture fighting back. The work 'Gair' uses images of drowning, highlighting the exploitation of Wales by England and the loss of communities like Capel Celyn. In this image, the artist repeats a common feature of his work, associating water and the 'leak' with watering down, cultural dilution and the haemorrhaging of language (the movement of English immigrants is referred to in Welsh as the *mewnlifiad* or 'inflowing'). The appropriation of existing work is a common feature of present practice, and in 'Cara Walia Derelicta' (fig. 65) Bala is again alluding to the work of David Jones, the writer/artist, whose inscription 'Cara Walia Derelicta' is a lament for Llywelyn ap Gruffudd: Wales is deserted and abandoned, Jones quotes from Virgil's *Aeneid* and Bala quotes Jones.

Ivor Davies, like other artists discussed in *Darllen Delweddau*, has contributed a great deal to critical practice, writing articles, editing books and using ideas from the literature and poetry of Wales as a starting point for his work.[5] Since 1962, when the sudden realisation of the severity of the national cultural crisis led to the formation of the Welsh Language Society, he has incorporated words and phrases into the actual body of his work, which is often painting but can also be an amalgam of paint and other materials or objects deemed appropriate. Physical action and interventions are familiar aspects of the output of this former Situationist. The Art and Destruction symposium, which he helped organise in London in 1966, naturally complements many of the more direct protests of both the Language Movement and the second-home arson campaign. The writings, meditations and especially the direct actions of Saunders Lewis are central to his artistic philosophy and the use of language, text and poetry is a common element in his imagery. The work which won him the Gold Medal in the St David's National Eisteddfod of 2002 featured the use of text as an extension of the picture surface and included images of Saunders Lewis and quotations from anti-war and anti-English grafitti. In his reactions to what he perceives as the slights of English imperialism, he has created a body of work, 'Yr Ysgrifen ar y Mur' ('The Writing on the Wall'), that reminds the viewer of the injustices in the relationship between Wales and England, with Wales losing her moral, religious and cultural values (fig. 66). Each of these works has a textual element critical to its effective functioning and while being exhibited at St David's was accompanied by poetry from Mererid Hopwood, printed alongside the images:

Hwn yw mur y malurio,
lle bu llaw ufudd
yn llifio
drwy'r Gair
a'r stori gudd....[6]

For the language activist, the word obviously takes on a greater significance and in the work of Bala, Ivor Davies and other politically

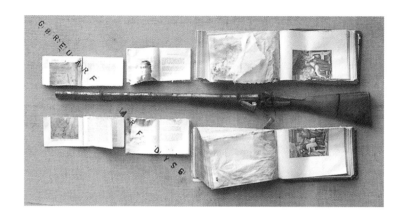

vociferous colleagues, text supports image in a very direct way. Fortunately, national and cultural anxiety has come to be officially-approved subject matter in these postmodern times. The local is now acceptable. The consent granted to ethnic minorities and marginalized cultures has allowed a reappraisal of what is permissible in the arts and indeed in society as a whole. Thus Welsh subject matter passes unchallenged through the canonical gatekeepers in the company of gay, ethnic and fringe representations. What was previously seen as embarrassing is now of necessity worthy of consideration, even the stereotype needs examination, and it takes its place as an appropriate focus for artistic concern.

Post-industrialization and cultural exploitation form the basis of David Garner's practice, which fiercely highlights the trauma of the abrupt changes in employment and consequent social upheavals in the south Wales valleys. Language and its erosion features strongly in his angry polemic against the ravages of late capitalism and cultural loss, where words and slogans, usually ironic and often poetic, carry intended meanings beyond ambiguity. In his work dealing with Aberfan, Tryweryn and also the Palestinian dilemma, he uses text and familiar militant-group names to construct an iconography of fear and deep and hopeless despair. In our climate of consumerism and anxiety, much contemporary practice celebrates and appropriates the ubiquitous presence of the word. David Garner has used an LCD screen to display the warnings broadcast in American international airports alerting travellers to the signs of terrorist intent in other travellers, for example 'behaviour is consistent with no future'. Such texts become the accidental,

66. Ivor Davies: Yr Ysgrifen ar y Mur 1: Dinistr Iaith a Chymuned (2001)

sometimes inadvertently humorous poetry of modern life and are the visual and aural eavesdropping of which many scripts, dramas and visual-arts videos are now composed.

Tim Davies often uses industrial means to create much of his work, and uses a wide range of materials in series of images that he revisits from time to time. He has collaborated with Ian Rowlands on *Love in Plastic*, scripted and directed by Rowlands and performed by Theatr y Byd, and with the poet David Greenslade in text-based projects. Davies's own limited-edition, artist's book, *A Place I know well* (2004), appropriates the jargon of estate agents to comment on the destruction of Pembrokeshire by the pressure of incomers. Among his two-dimensional work is an ongoing sequence of pieces using words and letters from the Welsh alphabet scorched on to blanket material to illustrate his sense of personal loss as the language of his father was not passed on to him (fig. 66). However, he is reclaiming it himself and ensuring that his own child remakes the broken link. The burning might be seen as a deliberate cauterising of deep personal wounds.

In some kinds of art, personal and autobiographical elements link it to the written and spoken word in a very direct way. Sue Williams, who reflects on and re-presents the trials and traumas of childhood as they are mediated through memory and the zeitgeist, uses words as images and as prompts to communication. The fact that today we are increasingly aware of the problems of abuse, premature sexuality, communication, identity and vulnerability in childhood, and a whole host of related issues, gives Sue Williams's work an additional poignancy. Much contemporary writing also deals with these questions, as does film and television. Modern crime-reporting acquaints us

67. Tim Davies: Polarities (2001)

68. Sue Williams: Wish U were here 1 (2003)

with the awfulness of much human experience, and children seem to be more exposed than ever before. We come before the paintings, therefore, in some state of readiness. Nevertheless, the images are still shocking (fig. 68 and 69). They surprise us by their content and subject-matter and they surprise us further by their method of execution. They are the products of an obviously aggressive or perhaps expressive action or series of actions by the artist. Whereas an artist like John Selway might depict a scene of some

violence or unpleasantness, he will paint it in the same way he paints any other kind of image, the life of the paint being independent of the story, mood or scenario the painting is recalling or creating. In Sue Williams's case, the images are focussed on the fear, distress or suppressed violence which also seem part of the process of their making. The images have their physical genesis in their spiritual genesis as persistent memory and are made with physical blows, their gestures frozen and immobilized on the canvas. The paintings carry the scars of their making and of their naissance as events; childhood and juvenile sexuality are on display, sometimes defiantly as though the artist is catching up with past fears, sometimes aggressively as though acting out a long-sought revenge.

Many of the titles refer to newspaper headlines, such as 'She must have flaunted herself', 'She trusted him'. These are gnomic, both playful and threatening. Actual words appear, mocking, taunting and heightening the emotional drama of the marks and images. Sue Williams touches our darkest fears, and, in her reading, she traces complementary concerns in writers like Sylvia Plath and Michèle Roberts, writers whose starting-point is similarly a particular psychological standpoint. The question of form in literature and in painting deeply concerns Williams and informs her deliberations as to how the issues she is dealing with can best be expressed and how literary and visual language are, or can be, compatible.

69. Sue Williams: No Angel (2002), *detail*

70. Christine Kinsey: Ymson 1 (2001)

What of the female voyage through life: who are we, where are we going? Where are you? These are questions she is asking of the viewer and of herself. She does not expect answers, for the paintings are a rhetorical and somewhat ambiguous cross-examination of past experience, its traumas, terrors and disappointments. Moreover, they are interrogations of the moment of remembering and of the act of painting.

The publication of this book has come about almost entirely as the result of Christine Kinsey's long-held fascination with the relationship between the image and the word (fig. 70 and 71). In addition, she makes the word the starting point of her own working process as a visual artist. She questions the form that thinking takes and explores this in the creative act, especially in her preparations, which involve reading, making extensive notes and preliminary drawings. Her creative

ambitions are informed by the consideration of texts ranging from Plato to the Gnostic Gospels, Jung and the poetry of R.S. Thomas, among others. Her imagery poses opposites (inner/outer self, physical/spiritual, human/divine) in a restructured landscape, which is partly based on past observation, partly invented. This is further developed compositionally to create a pictorial platform on which archetypal figures address one another and the viewer, while the juxtaposition of symbols, characters and events generate an atmosphere of mystery and intense spiritual reflection. Memory is an important element, and since painting has that special ability, denied other media, of allowing an instantaneous yet benevolent and coherent collision of thought, action, memory and meditation, the result is a highly complex image, readable on many levels. It is within this imagined space that the particular qualities she desires in her work are given their material being, all at once the painting becomes thought, spiritual realisation and religious experience, leading the viewer into a deep metaphysical space. Colour and form co-exist in a poetic

71. Christine Kinsey: Yr Adwy 3 (2004)

72. Shani Rhys James: Caught in a Mirror (1997)

iconography that depicts an ambivalent world caught between reality and the spiritual depths of the soul. The following lines from R. S. Thomas's poem 'Via Negativa' are indicative of the artist's search for a comforting God, one who can soothe the pain of conscious existence and parallels the quest for a visual statement that carries the same religious power:

> Why no! I never thought other than
> That God is that great absence
> In our lives, the empty silence
> Within, the place where we go
> Seeking, not in hope to
> Arrive or find.[7]

For many years now she has been engaged in her own writing, particularly poetry, which has given the word an even greater importance in her visual practice. Furthermore, the titles of her paintings and exhibitions reveal the significance of language in her objectives as an artist. The paintings often have a literary starting-point and are concerned with filling the void, easing the yearning for attaining the spiritual equilibrium. They are embodied as permanent physical witness to realisations, contrastingly informed and intuitive, personified epiphanies. These are paintings that demand our journeying into them, they represent somewhere unexplored but somewhere becoming known, created by the artist's imagination; they require assimilation rather than understanding, they ask similar things of us as might a poem by R. S. Thomas.

Often the paintings that have the strongest relationship with literature and the word are those where there is no very obvious reference to, or apparent dependence upon, the word. In the paintings of Shani Rhys James[8] there are no words to be seen on the canvas, but in her childhood, the artist, as the daughter of a theatrical family, was totally immersed in the world of the word. Her memory of loud domestic declamations, rehearsals, and of poetry read and remembered from school, informs her conscious and unconscious thought. Past experience has fused with present circumstance and become material for the dramas of her paintings. The figures enclosed in her pictorial mise en scène might at first appear cosily

homely, but the titles are revealing, referring to writers ranging from Shakespeare and Keats to Gerald Manley Hopkins, Lewis Carroll and Samuel Beckett.

Malone Dies (1956) is the inspiration for 'Caught in a Mirror or Dish/Pot' (fig. 72), where the artist uses Beckett's story of a man trapped in a room with only a stick to indicate the edges of the room. The dish on the table symbolises the food entering the body, the bucket on the floor the food coming out:

> what matters is to eat and excrete
> Dish and pot, dish and pot,
> these are the poles.[9]

In this painting the artist is seen dwarfed by her working paraphernalia, trapped within her own ambitions, diminished by the intensity of her own gaze. As the artist appears in most of her paintings, we can perhaps assume that the frustrations and anxieties evident in her work are personal. They are also part of an imaginative fermentation that is driven by her deep reading, pictorial ambition and literary thought-patterns, image and word pushing each other forward in a continuous stream of aesthetic desire. Eating and excreting is what children do most and what mothers attend to most often; as a woman and as an artist she has a dual inner rage against the constraints and predictability of family life, whilst knowing that as a mother she must support it.

In 'She seized the tablecloth with both hands' she violently strips the cloth from the table, using Lewis Carroll's *Through the Looking-Glass* as her source. She identifies with the anarchic child-woman, Alice, who like her, is 'fettered by dresses but released by imagination'. Scale plays an important role in her compositional requirements highlighting and reinforcing her own position as a mother who sees life

73. Shani Rhys James: When the Melancholy Fit shall Fall (1987)

from multiple viewpoints, as adult and child. In 'And as for you' the Red Queen is reduced to the size of a pepper pot and is now controllable by even the smallest child. Here we are reminded of Keats's 'Ode to Melancholy', which describes the onset of depression as a cloud: the artist uses dark shadows across her face and the body of her child as a painterly equivalent in 'When the Melancholy Fit shall Fall' (fig. 73):

> But when the melancholy fit shall fall
> Sudden from heaven like a weeping cloud
> That fosters the droop-headed flowers all,
> And hides the green hill in an April shroud[10]

Shani Rhys James's paintings have a voluptuous richness, even a necessary excess of paint, and she has of late developed a richer, yet more discrete palette with subtle nuances and balanced explorations of shade and hue. The drama, as always, dominates, so, frequently, does the scale, but below the glistening, energetic surface, her regard for the poetic pulses. These are ambitious, moving and metaphoric works.

Brendan Burns, although working from the same Pembrokeshire landscape for the past ten years or more, paints as though seeing it for the first time, while his field-notes reveal a dreamlike intoxication as he celebrates the delight and excitement of the newly discovered. He wanders the coastal strip between Marloes and Solva, watching as the sea rises and falls, tracking and plotting the geological and tidal rhythms of the beach. As he moves and draws he writes and annotates a continuous lyrical response, part map and part measurement, an elegiac survey articulated through the nervous system (fig. 74).

74. Brendan Burns: Pages from Drawing Books (2003)

Experiencing the totality of landscape with all faculties acutely attuned, he works through an inclusive sensibility towards an abstracted multiple image of the landscape, a landscape image that he himself is part of, but in which he is never seen (fig. 75).

This piece, like much of the artist's output, provokes and energises our perceptual processes while offering a sharing of his own responses; the colours reflect and echo those of the rock pools, the surface texture mimics their feel and conveys that sense of salty opalescence we witness in those stranded habitats.

How exactly does the artist come to these conclusions, and how exactly do we experience such paintings? We experience them, I believe, as a phenomenological event; we stand at a remove from the original site and from the artist who is trying to speak through and to more than one of the senses simultaneously. He is speaking first of all to himself; as spectators we are incidental, but we too, in looking at the work, can undertake a similar numinous journey. The all-

embracing nature of his painterly aspirations requires a pictorial outcome that will carry and communicate a corresponding sensation to that of the original experience, one where he moves from being the recipient of that experience and in the process becomes the privileged viewer. It is possible to describe these paintings as experiences and sensations collaged and recalled, orchestrated to fix and isolate moments of deep consciousness. We have in these works a poetic equivalent, paintings that are made in response to a lyrical impulse. He is not, however, directly influenced by poetry, as he rarely reads outside the area of art and cultural history. Nevertheless, he feels and fashions like a poet in his meditations and as he paints. Brendan Burns is a painter for whom the word is important, not as a source but as an adjunct to his visual notations, fixing his analysis of and response to his subject. He traps his insights, which may be fleeting, within language and responds poetically, arranging his forms and colours to make permanent and communicable the transient revelations of his engagement with a particular place.

I have described John Selway's work as 'Illuminated from within'. His painting is deeply self-aware in its regard for its own formal origins in art history and tradition, but is uncompromisingly contemporary in its concerns. John Selway works from the philosophy of the vigilant imagination; he is continuously alert to every stimulus, possessing sweeping aesthetic antennae, and nothing passes without intense scrutiny. Words are vital and fundamental to his pictorial examinations of memory and history; he reads extensively – newspapers, novels and poems, watches film and television and trawls the visible and imagined world in constant watchfulness. J.G. Ballard's novel *Cocaine Nights* (1996) and Bertolucci's film 'The Conformist' (see fig. 76) have provided him with a potent source of image and incident and he has recently depicted, in a series of complex and compelling paintings, Dylan Thomas's poem 'Fern Hill', explored in the light of personal experience and memory:

> ... And nightly under the simple stars
> As I rode to sleep the owls were bearing the farm away,
> All the moon long I heard, blessed among stables, the nightjars
> Flying with the ricks, and the horses
> Flashing into the dark.[12]

In his reading and re-reading of the poem, John Selway revisits his own childhood and discretely teases out the pictorial elements of poem and memory (fig. 77). The painting depicts a boy asleep in a large, old-fashioned bed, taking us back to the artist's summer visits to his grandfather's farm in the Golden Valley on the Herefordshire-Wales border. The bedroom is illuminated by a pale, eerie glow from the moon and on the floor in a pool of moonlight is a nocturnal view of the sky, both real and unreal, referring perhaps to the mystery of the afterlife. Through the window we see the moon and the orchard with the owl in a tree, which is reflected in the mirror of the dressing-table. We see the strange furniture of the old family home, the dark corners that hide ancient secrets and the lost dreams of a young boy, the artist, who has himself been visited by premonitions of mortality, fighting his own battles with life-threatening illness. To him 'the swallow-thronged loft' of Thomas's poem is more than metaphoric, it is a real place, with real fears; it is a place he has visited and returned from. In one corner, the cat kills a bird, a reminder that death awaits us all. The reflections in the mirrors of the dressing-table and wardrobe are not only compositional devices, they replay and echo the poetic drive of the painting. John Selway's paintings are not illustrations of the events he may be alluding to, rather they establish a comparable dynamic that expands and advances their literary sources: even as the most novelistic of paintings, they are evidently to be seen rather than simply read.

Since the onset of Postmodernism, the function of the artist has been transformed and the reasons for making paintings have changed. Paintings now have no claim to usefulness, as they once did. They generally have no rhetorical, religious, educational, illusionary or didactic purpose, and whatever claims to value they may once have had are challenged by newer, more easily manipulated media. Being released

76. John Selway: The Conformist (2001)

77. John Selway: As I rode to sleep (2003)

from these somewhat onerous expectations and responsibilities has given painting and painters new freedoms and new opportunities. Paintings, like poems, may be brought into being as a means of expression, as exorcism, or simply as activity, confession, therapy, as evidence of intellectual agility, propaganda or even as extensions of vanity. The principal remit of serious painting now is to give shape to the inchoate, to bring into physical form those thoughts, images and realisations for which no other means of being apprehended exist. In themselves, in both their making, and in the contemplation of them, serious paintings create a critical predicament that is in part caused by their dimensional boundaries. This is something that they share with poetry, for as art in a time of digital reproduction expands the possibilities and means of expression, both painting and poetry remain empowered by their limitations. Natural constraints – their physical flatness and two-dimensionality – generate additional creative demands on the maker and the spectator, demands which media with additional dimensionality overcome by utilising a greater range of options, so that greater imaginative effort is required in considering them. It would appear that the fewer the dimensions, the more elusive, but more rewarding, the victory in the desire to convince.

The position of painting and poetry has evolved and been transformed as society has changed. Now, in our increasingly secular society, with politics discredited and many other cultural certainties crumbling, painting and poetry offer an alternative to the dogma and ideologies that haunt the current spiritual and political void. Although contemporary poetry takes time to filter through into the deeper recesses of the sensibility, and painters may still work largely from earlier sources, paintings and poems summon novel realisations and invoke necessary landscapes for the spirit and this is the reason they have never been more necessary and important than today. These developments have enabled contemporary art-practice in Wales, particularly painting, to enjoy a substantial and growing relationship between the word and the visual image in the conceptual and creative ambitions of our poets and visual artists.

[1] See, for example, the map he drew of the imaginary village of Llanreggub while working on *Under Milk Wood*, now available on the website of the National Library of Wales at http://www.llgc.org.uk/drych/drych_s086.htm.

[2] Anne Stevenson, *Granny Scarecrow* (Newcastle-upon-Tyne, 2000), p. 48.

[3] See, e.g., the catalogue *Hiraeth. Peintiadau newydd gan Iwan Bala, gyda drama gan Edward Thomas/New paintings by Iwan Bala with a play by Edward Thomas* (Cardiff, 1993).

[4] Thomas Parry (ed.), *The Oxford Book of Welsh Verse* (Oxford, 1962), p. 535, translated by Tony Conran, see Tony Conran (ed. and trans.), *Welsh Verse* (Bridgend, 1967), p. 305.

[5] See also Ivor Davies, 'Displaced Memories', in Iwan Bala (ed.), *Certain Welsh Artists. Custodial Aesthetics in Contemporary Welsh Art* (Bridgend, 1999), pp. 88-98.

[6] Poem and picture were published together in *Taliesin*, 117 (2002), 84-5.

[7] 'Via Negativa', R. S. Thomas, *Collected Poems 1945-90* (London, 1993), p. 220; first published in Thomas's *H'm* (1972).

[8] On Shani Rhys James and her work see, e.g., *Facing the Self* (Llandudno 1997), catalogue of a touring exhibition; and Edward Lucie-Smith and Eve Ropek, *Shani Rhys James. The Black Cot* (Llandysul, 2004).

[9] Beckett's English text, *Malone Dies*, was translated by the author from his original French novel, *Malone Meurt* (1951).

[10] 'Ode to Melancholy', in John Keats, *Complete Poems* (Harmondsworth, 1973), p. 348.

[11] Osi Rhys Osmond, Illuminated from within', *Planet*, 147 (June-July 2000), 17-23.

[12] 'Fern Hill', in Daniel Jones (ed.), *Dylan Thomas. The Poems* (London, 1971), p. 195.

Conclusion

Osi Rhys Osmond *The purpose of this book is*

to demonstrate and illustrate

the historic and contemporary

relationship between the word,

particularly poetry, and

the image, particularly painting,

in the culture of Wales.

The very thorough introduction and the extremely perceptive historical overview clearly establish this long-standing relationship, interpreting the present in the context of the past, while at the same time, however, describing a cultural evolution that reveals an unbalanced development within the area of our concern. The chapters describing individual artists are all focussed on twentieth-century figures, which is itself revealing. There is no doubt in my mind that for the majority of the time there has been a society that could be described as Welsh, words, spoken or written, have had predominance over images. This is perhaps what makes it distinctive, and after all, poets have thought and continue to think in ways similar to that of many artists, especially painters, and poets were for a long time the chief celebrators and recorders of our society. In earlier times, and certainly since the early Romantic period, the desire or even the need to become an artist was driven by a comparable motivation as that necessary to become a poet.

The hymn-writer Ann Griffiths offers a good example of someone with a powerful visual imagination limited by cultural circumstances to poetic opportunity. Taking the Word from the Bible, she developed visual images from her poetic imagination. These might well have pre-empted Salvador Dalí, for the pictures created in her ecstatic hymns reflect a similar passion and erotic energy. This may be the result of the compression of her pictorial and physical desire, combined with the effect of the landscape on her

inner imaginings as she walked declaiming her hymns. Like her, many of the people who might have become our artists, became our poets.

During the last century the pace of visual art production in Wales increased as, for the first time, the majority began to use English as their first language, which was a massive transformation. Our history has, it seems, created a strange and somewhat unequal nation, being at once both very old in one language and yet very young in the other. Consequently, some practitioners feel their sense of Welsh identity as being deeply rooted, and thus more central to their experience and mission as artists or poets. As the old language of Wales is doubly threatened by the immediate and global hegemony of English, the crisis is interestingly paralleled in painting itself, which is under increasing pressure from critics and curators, and sometimes damagingly considered passé, even if only by those whose own sensibility has been dazzled by the glare of Postmodernism and its easy ironies. Tripling the equation, we have writers and artists now living and working here who feel no particular allegiance to Wales or its culture in either language.

David Jones's attachment to both our languages was one of the distinguishing features of his work and life. He maintained a commitment to both English and Welsh as inseparable elements of his intellectual life, and to his working methods both in writing and painting, also making use of others, Latin and Greek in particular, where he felt it necessary. In her chapter, Anne Price-Owen emphasises this crucial link between visual, written and spoken language, as, for example, in the case of the 'Bear' of Jones's childhood drawing that consistently reappears in his later creative life as form, as idea and as word; word that permeates and connects forms, moves seamlessly between languages, expanding and reinforcing new realities, releasing the metaphors and poetic currency of his abundant imagination. Jones, like many of the artists discussed earlier continues to provide a potent pool of influences for present practitioners.

The observed private world of Gwen John is depicted in her painting, but it is in her notebooks that we see another, perhaps more revealing, picture of her creative thinking and working method. Ceri Richards, certainly the most ebulliently poetic of our twentieth-century artists worked primarily from literary and musical sources. Even when his subject appears to operate independently of them, as in his

'Costermongers' and 'Pearly Queens' series, he still utilises their structures in his pictorial construction and execution.

Brenda Chamberlain's wanderings took her from Ynys Enlli to the Greek Islands, but wherever she practised writing was as important to her creative impulse as painting and drawing. Ernest Zobole was not a voyager in the physical sense, even if in his paintings he floated metaphysically above his native valleys. His perplexingly tilting picture-plane rises and falls in inspired collisions of anecdotal images. Never one to intellectualize, he relied on his images to speak for him.

In each of the featured artists a symbiotic relationship exists between the image and the word, each with a variable personal correlation, the proportionality changing according to aesthetic requirement. We have been carefully guided through the history of the evolution of our poetic and visual culture, noting their rapport and examining their mutual importance in the work of contemporary practitioners. The current multiplicity of working means and media has brought more practitioners, poets and artists, into closer creative proximity to one another, both materially and intellectually, and publishing, television and film have accelerated these developments.

The word-image relationship in our culture is now clearly established, both historically and contemporarily. Artists, particularly painters, and writers, primarily poets, think and visualise in related ways, the thought processes of both requiring active visual imaginations, where forms, images and words can coexist interdependently in their mental exertions. Since the *Mabinogion* and the *Gododdin*, which are among the earliest of our surviving poetic images, we witness a dynamic and, in some odd sense, a thoroughly modern visual awareness at work. If there is a sensibility that characterizes us as a people it may be revealed in the cinematic dynamics that pervade our cultural production. Traditionally, it appears, it has been largely in our words that our images would be found; now it seems, we shall be found in both our visual images and our words.

notes on contributors

Christine Kinsey is an artist and poet. She has had one national and three international solo touring exhibitions and, as well as having paintings and drawings in public and private collections worldwide, she has been the recipient of numerous awards. She was co-founder and artistic director of Chapter, Centre for the Arts, Cardiff 1968-76 and worked as an artist and teacher on Sint Maarten, Netherlands Antilles, Caribbean 1976-80. Since her return to Wales she has lived and worked in Carmarthenshire and Pembrokeshire. Her recent paintings have been influenced by the poems of R.S. Thomas and her forthcoming exhibition 'Colloquy', which will also include her poems, continues to explore her fascination with the relationship between the image and the word.

Ceridwen Lloyd-Morgan is currently Head of Manuscripts at the National Library of Wales, where she has specialised in artists' archives. She has published extensively on artists and writers of Wales and her most recent works include *Margiad Evans* (1998), *Delweddau o'r Ymylon. Bywyd a gwaith Mary Lloyd Jones* (2002) and *Gwen John: Letters and Notebooks* (2004). She is an Honorary Research Fellow in the School of Welsh, University of Cardiff.

Osi Rhys Osmond is an artist, writer and teacher living at Llansteffan, Carmarthenshire. Educated at Newport School of Art and the University of Wales, Cardiff, he now teaches at Swansea Institute and Trinity College, Carmarthen. He is a regular contributor to Planet Magazine, has published extensively on the arts and culture and frequently contributes to radio and television in Welsh and English. His own work as a painter takes the form of a studio-based practice that involves the examination of contemporary confrontations through the exploration of mythological themes, while also using water-colour drawing to record direct responses to the environment. During the course of his work, he has travelled widely in East Africa, Europe and the Middle East. He is currently writing on the life and work of the Swiss artist Alberto Giacometti and the influence it has had on his own artistic philosophy.

Jill Piercy is an exhibition curator and writer specialising in contemporary art and craft in Wales. She has written for numerous publications and has prepared catalogue essays for many galleries in Wales. For six years, she was Art and Crafts Officer for the National Eisteddfod of Wales and her exhibitions include *Brenda Chamberlain – Island Artist* for Oriel Mostyn (1988) and the recent *Farming in the Welsh Landscape* featuring forty-two artists and curated for the Centenary of the Royal Welsh Agricultural Show (2004).

Anne Price-Owen is a Senior lecturer in the Faculty of Art & Design, University of Wales, Swansea Institute of Higher Education. She has written extensively on the relationship between text and image, specializing in the work of David Jones. She is Director of the David Jones Society, and editor of its *Journal*, and is currently researching a book on David Jones and Dreams. She has served on the executive committee of the Contemporary Art Society for Wales, is an advisor to the Arts Council of Wales, trustee of the Swansea Arts Forum Trust and is a member of the steering committee for the new National Waterfront Museum of Wales, Swansea.

Ceri Thomas is an artist and art historian whose pictures have been shown in the National Assembly for Wales, the National Library of Wales and the National Museum and Gallery Cardiff.

In 1999 he won the Gwyn Alf Williams Memorial Award to further his work on art in modern Wales, and is a contributor to *New Welsh Review* and *Planet*. In 2000, he was a researcher/consultant for the BBC Wales television series 'Painting the Dragon' and in 2002 he was elected to the Welsh Group. Currently he is a Research Fellow at the University of Glamorgan and lives in Swansea.

M. Wynn Thomas is Professor of English and director of CREW (Centre for Research into the English Literature and Language of Wales), University of Wales, Swansea. He is the author of some twenty books, in Welsh and in English, on the two literatures of Wales and on the poetry of the USA. Forthcoming from the University of Iowa Press is *Transatlantic Connections: Whitman US – Whitman UK*. He is a Fellow of the British Academy and a Fellow of the *Academi Gymreig*.

Peter Wakelin is Secretary of the Royal Commission on the Ancient and Historical Monuments of Wales. He is an historian who writes regularly on art for *Planet*, *The Guardian* and *Art Review*. His books, *Creating an Art Community: 50 Years of the Welsh Group* and *An Art-Accustomed Eye: John Gibbs and Art Appreciation in Wales*, are published by the National Museums & Galleries of Wales. He is an Honorary Fellow of the School of Art, University of Wales, Aberystwyth.

Bibliography

1. Primary sources

Aspden, Bryan, *News of the Changes* (Bridgend, 1984).

Swansea and the Arts, facsimile BBC script broadcast, Home Service (Wales), 24 October 1949 (Swansea, 2000)

The Caseg Broadsheets, 1-8 (Llanllechid, 1941-2)

Canu Maswedd yr Oesoedd Canol. Medieval Welsh Erotic Poetry, ed. Dafydd Johnston (Cardiff, 1991)

Chamberlain, Brenda, *Alun Lewis and the Making of the Caseg Broadsheets* (London, 1969)

Chamberlain, Brenda, *The Green Heart* (London, 1958)

Chamberlain, Brenda, *Poems with Drawings* (London, 1969)

Chamberlain, Brenda, *A Rope of Vines* (London, 1965)

Chamberlain, Brenda, *Tide-race* (London 1962, new ed. Bridgend,1987)

Chamberlain, Brenda, *The Water-Castle* (London, 1963)

The Dream of the Rood: the Earliest English Poems, trans. Michael Alexander (Harmondworth, 1961)

Elen Egryn: Telyn Egryn, ed. Ceridwen Lloyd-Morgan & Kathryn Hughes (Dinas Powys, 1998)

Y Frythones (1879-91)

Y Gymraes (1896-1934)

Howard-Jones, Ray, *Heart of the Rock: poems 1973 to 1992* (Blewbury, 1993)

John, Augustus, *Chiaroscuro* (1952)

John, Augustus, *Finishing Touches* (1964)

John, Gwen, *Letters and Notebooks*, ed. Ceridwen Lloyd-Morgan (London, 2004)

Jones, David, *The Anathemata: fragments of an attempted writing* (London, 1952)

Jones, David, *Dai Greatcoat: a self-portrait of David Jones in his letters* (London, 1980)

Jones, David, *The Dying Gaul and other writings* (London, 1978)

Jones, David, *Epoch and Artist* (London, 1959)

Jones, David, *[engravings for] The Chester Play of the Deluge* (Waltham St. Lawrence, 1927)

Jones, David, *In Parenthesis* (London, 1937)

Jones, David, *An Introduction to The Rime of the Ancient Mariner* (London, 1972)

Jones, David, *The Sleeping Lord and other fragments* (London, 1974)

Jones, Thomas, *Memoirs*, ed. A.P. Oppé, Walpole Society Publications, vol. 32 (London, 1951)

Kafka, Franz (trans. Edwin & Willa Muir), *The Castle* (Harmondsworth, 1974)

Llanover, Lady, *The First Principles of Good Cookery* (1867, repr. Tregaron, 1991)

The Magic Horse, from The Arabian Nights, illustrated with designs by Ceri Richards, trans. Edward W. Lane (London, 1930)

Morgan, Robert, 'A Day's Work, Coal', (Jan. 1949), 24-5

Poetry London, 3, no II (1947)

Richards, Ceri, *Drawings to Poems by Dylan Thomas, with an introduction by Richard Burns* (London, 1980)

Ruck, Berta, *The Immortal Girl* (London, [1925])

Ruck, Berta, *A Story-teller tells the truth. Reminiscences & Notes* (London, 1935);

Thomas, Dylan, 'Return Journey', *The Dylan Thomas Omnibus*, Phoenix Press (London, 2000)

Thomas, Dylan, *Under Milk Wood: A Play for Voices*, ed. Douglas Cleverdon, lithographs by Ceri Richards (London, 1972)

Villon, François, *Oeuvres*, ed. Auguste Longnon & Lucien Foulet (Paris, 1967)

Watkins, Vernon, *Elegiac Sonnets* (Milan, 1970)

Vernon Watkins, *Cypress and Acacia* (London, 1959)

Williams, Kyffin, *Across the Straits* (London, 1973, 2nd ed. Llandysul, 1993)

Williams, Kyffin, *The Land and the sea* (Llandysul, 1998)

Williams, Kyffin, *Portraits* (Llandysul, 1995)

Williams, Kyffin, *A Wider Sky* (Llandysul, 1991)

2. Secondary sources

Abertawe, Coleg y Brifysgol, Ceri Richards: *An Exhibition to Inaugurate the Ceri Richards Gallery* (Swansea, 1984)

Abse, Dannie and Joan Abse (eds), *Voices in the Gallery: Poems and pictures* (London, 1986)

[Baines, Menna], 'Abertawe ddoe : lluniau Jack Jones', *Barn* 370 (1993), 19-21

Bell, David, *The Artist in Wales* (London, 1957)

Bell, David, 'Contemporary Welsh Painting', *The Welsh Anvil/Yr Einion*, 3 (July 1951), 28

Bell, David, 'Welsh School of Painting', *South Wales Evening Post*, 9 January 1954

Bowness, Alan, 'Ceri Richards', in *Ceri Richards*, Edinburgh International Festival (Edinburgh, 1975), pp. 5-8.

Britten, Benjamin, and Imogen Holst, *The Story of Music* (1958)

Burns, Richard, *Ceri Richards and Dylan Thomas: Keys to Transformation* (London, 1981).

Bustin, Mary, 'The Rules or problems of paintings; Gwen John's later painting techniques', in David Fraser Jenkins (ed.), *Gwen John and Augustus John*, catalogue of the exhibition held at Tate Britain, 29 September 2004 –9 January 2004 (London, 2004), pp. 196-202

Chambers, Emma, *Student Stars at the Slade 1894-1899. Augustus John and William Orpen* (London, 2004)

Cross, Tom, 'Ernest Zobole', *Two Painters: Brenda Chamberlain Ernest Zobole* (Cardiff, 1963)

Cucksey, Roger, Foreword to *Recent Paintings by Ernest Zobole* (Newport, 1986)

Curtis, Tony, '"Life's miraculous poise between light and dark": Ceri Richards and the poetry of Vernon Watkins, *Welsh Writing in English: a Yearbook of Critical Essays*, vol. 9 (2004) 80-100

Curtis, Tony, *Welsh Painters Talking* (Bridgend, 1997)

Duggan, E. J. M., 'Notes concerning the "Lily Crucifixion" in the Llanbeblig Hours', *National Library of Wales Journal*, 27 (1991), 39-47.

Ede, H.S., 'David Jones', *Horizon*, 8, no.44 (1943), 125-36

Ede, H.S., *David Jones: a memorial exhibition* (Cambridge 1975)

Edinburgh International Festival 1975, *Ceri Richards* (Edinburgh, 1975)

Elfyn, Menna and John Rowlands (eds), *Modern Welsh Poetry. 20th century Welsh-language poetry in translation* (Tarset, 2003)

Evans, Gwyn,and David Maddox, *The Tonypandy Riots* ([Bridgend], 1992)

Evans, Mark L., *The Derek Williams Collection at the National Museum of Wales* (Cardiff, 1989)

Evans, Myfanwy (ed.), *The Painter's Object* (London, 1937)

Fischer Fine Art, *Homage to Ceri Richards* 1903-1971 (London, 1972)

Foster, Alicia, *Gwen John* (London, 1999)

Gooding, Mel, *Ceri Richards* (Moffat, 2002).

Gooding, Mel, *Ceri Richards Graphics* (Cardiff, 1979).

Gooding, Mel, *Ceri Richards 1903-1971, Poetry into Art: Graphic Works and Books* (Norwich, 1982)

Gray, Nicolete, *The Painted Inscriptions of David Jones* (London, 1981)

Green, Miranda J., *Dictionary of Celtic Myth and Legend* (London, 1992)

Gwyn, Richard (ed.), *The Pterodactyl's Wing* (Cardigan, 2003)

Hague, René, *A Commentary on The Anathemata of David Jones* (Wellingborough, 1977)

Harvey, John, *The art of piety : the visual culture of Welsh Nonconformity* (Cardiff, 1995)

Holman, Kate, *Brenda Chamberlain* (Cardiff, 1997)

Humfrey, Belinda, *John Dyer* (Cardiff, 1980)

Humfrey, Belinda, and Anne Price-Owen (eds.), *David Jones: Diversity in Unity* (Cardiff, 2000)

Huws, Daniel, *Medieval Welsh Manuscripts* (Cardiff and Aberystwyth, 2000)

Huws, Daniel, 'Some letters of Augustus John to Ursula Tyrwhitt', *National Library of Wales Journal*, 15 (1967-8), 236 and plates 7-8.

Jenkins, David Fraser, *Y Bryniau Tywyll Y Cymylau Trymion/The Dark Hills The Heavy Clouds*, (Cardiff, 1981)

Jenkins, David Fraser, 'Introduction', *Recent Paintings by Ernest Zobole* (Newport, 1986)

Jones, R. Gerallt & Christopher J. Arnold (eds), *Enlli* (Cardiff, 1996)

Kandinsky, Wassily (trans. M.T.H. Sadler), *Concerning the Spiritual in Art* (New York, 1977)

Kettle's Yard and its Artists (Cambridge, 1995)

Langdale, Cecily, *Gwen John* (New Haven and London, 1987)

Lewis, Saunders, 'Peintwyr Cymreig Heddiw', *Thirty Welsh Paintings of Today* (Cardiff, 1954)

Lloyd-Morgan, Ceridwen, 'The Artist as Reader: Gwen John and her books', in *Ysgrifau a Cherddi cyflwynedig i/Essays and Poems presented to Daniel Huws*, ed. Tegwyn Jones and E. B. Fryde (Aberystwyth, 1994), pp. 385-93

Lloyd, Alison (ed.), *Intimate Portraits* (Bridgend & Swansea, 1995)

Lloyd-Morgan, Ceridwen, *Augustus John Papers at the National Library of Wales* (Aberystwyth, 1996)

Lloyd-Morgan, Ceridwen, 'Catalogue of Gwen John Papers' (typescript catalogue, National Library of Wales, 1987)

Lloyd-Morgan, Ceridwen, 'Ceri Richards: Sketches for Dylan Thomas' *National Library of Wales Journal*, 24 (1996), 347-54

Lloyd-Morgan, Ceridwen, 'A local institution: the day-to-day life of the Ladies of Llangollen', *Planet*, 91 (Feb.-March 1992), 28-35

Lloyd-Morgan, Ceridwen, *Margiad Evans* (Bridgend, 1998)

Lloyd-Morgan, Ceridwen, 'More written about than writing? Welsh women and the written word, in Huw Pryce (ed.), *Literacy in Medieval Celtic Societies* (Cambridge, 1998), pp. 149-65

Lloyd-Morgan, Ceridwen, 'Not just the Welsh Barbara Cartland: Berta Ruck (1878-1978) of Aberdyfi', *Journal of the Merioneth Historical and Record Society* (forthcoming, 2006)

Lord, Peter, *Arlunwyr Gwlad. Artisan Painters* (Aberystwyth, 1993)

Lord, Peter, *Y Chwaer-dduwies: Celf, crefft a'r Eisteddfod* (Llandysul, 1992)

Lord, Peter, *Hugh Hughes, Arlunydd Gwlad* (Llandysul, 1995)

Lord, Peter, *Gwenllian. Essays on the Visual Culture of Wales* (Llandysul, 1994)

Lord, Peter, *The Visual Culture of Wales: Industrial Society*, (Cardiff, 1998)

Martin Tinney Gallery, *Ceri Richards 1903-1971: Centenary Exhibition* (Cardiff, 2003)

Mathias, Roland, 'Robert Morgan', *Poetry Wales* 30/4 (1995), 4-5

National Museum of Wales, *Ceri Richards Memorial Exhibition* (Cardiff, 1973)

New Dictionary of National Biography (Oxford, 2004)

The Oxford Illustrated Old Testament, with Drawings by Contemporary Artists, Volume 1: The Pentateuch (London, 1968)

The Oxford Illustrated Old Testament, with Drawings by Contemporary Artists, Volume 3: The Poetical Books (London, 1969)

Petts, John, *The 1983 Radio Wales Lecture: Welsh Horizons* (London, 1984)

Piercy, Jill, 'Between Two Arts', *Planet*, 68 (April/May 1988), 77-86

Piercy, Jill, 'Brenda Chamberlain – Island Artist', exhibition catalogue, (Llandudno, 1988)

Ross, Anne, *Folklore of Wales* (Stroud, 2001)

Rowan, Eric, *Art in Wales: An illustrated History* 1850-1980 (Cardiff, 1985)

Sanesi, Roberto, *A Few Words on Ceri Richards: An Address at Taliesin Arts Centre* (Swansea, 1984)

Sanesi, Roberto (trans. Richard Burns), *The Graphic Works of Ceri Richards* (Milan, 1973)

Sinclair, Nicholas and Ian Jeffrey, *Kyffin Williams* (Aldershot, 2004)

Smith, Alison, *John Petts and the Caseg Press* (London, 2000)

Stephens, Meic, *Artists in Wales* (Llandysul, 1971)

Stephens, Meic (ed.), *The New Companion to the Literature of Wales* (Cardiff, 1998)

Swansea, University College, *Ceri Richards: An Exhibition to Inaugurate the Ceri Richards Gallery* (Swansea, 1984)

Smith, Dai, *Aneurin Bevan and the World of South Wales* (Cardiff, 1993),

Tate Gallery, *Ceri Richards* (London, 1981)

Thomas, Ceri, 'Alfred Janes: maker of pictures', *New Welsh Review*, 44 (Spring 1999) 13-15

Thomas, Ceri, *Branching Out*, (Pontypridd, 2002)

Thomas, Ceri, *Ernest Zobole and Ystrad*, University of Glamorgan (Pontypridd, 2004)

Thomas, Ceri, 'From School of Art and Crafts to College of Art – inside and out', in *Drawn from Wales: a School of Art in Swansea 1853-2003*, ed. Kirstine Brander Dunthorne, (Cardiff, 2003), pp. 58-71

Thomas, Ceri, *Ernest Zobole: a retrospective* (Pontypridd, 2004)

Thomas, Robert, 'Make it true, make it new', *New Welsh Review*, no. 38 (Autumn 1997) 13-14

Thompson, David, *Ceri Richards* (London, 1963)

Two Painters: Brenda Chamberlain Ernest Zobole (Cardiff, 1963)

Warner, G. F., *Descriptive Catalogue of Illuminated Manuscripts in the library of C. W. Dyson Perrins*, (Oxford, 1920)

Whitworth, Benedict, 'Vexilla Regis:the Liturgical Genesis of a Painting', *The David Jones Journal*, 4, nos.1 & 2, (2003) 20-30

Williams, Ralph M., *Poet, Painter and Parson: the life of John Dyer* (New York, 1956)